A type primer

A type primer

John Kane

Prentice Hall, Inc., Upper Saddle River, NJ 07458

Published 2003 by Prentice Hall Inc.
A Division of Pearson Education
Upper Saddle River, New Jersey 07458

10 9 8 7 6 5 4

ISBN 0-13-099071-x

This book was designed and produced by
Laurence King Publishing Ltd, London
www.laurenceking.co.uk

Every effort has been made to contact the copyright
holders, but should there be any errors or omissions,
Laurence King Publishing Ltd would be pleased to
insert the appropriate acknowledgement in any
subsequent printing of this publication.

Editor: Nell Webb
Picture Researcher: Peter Kent
Cover designer: Frost Design, London

Printed in China

Picture credits

Acknowledgments

This book arose out of my experiences teaching typography, so first I want to acknowledge the people who encouraged my work in the classroom: Dietmar Winkler at the University of Massachusetts at Dartmouth, Sue Morison and Geoffrey Fried at the Art Institute of Boston at Lesley University, and Elizabeth Cromley and George Thrush at Northeastern University. I have benefited over the years from the generosity of my fellow instructors, and particularly want to thank Cyndi Barron, Tom Starr, and Ann McDonald for their advice and support. Northeastern student John Di Napoli aided me with my early research. And nothing (this book included) happens in the Department of Visual Arts at Northeastern without the welcome involvement of Judy Ulman. Thanks to all.

I also want to acknowledge the two mentors in my professional life: Chris Pullman at WGBH Boston and Roger Sametz of Sametz Blackstone. Their careers demonstrate that design is a subject worthy of both intellectual and practical engagement. For the education they provided in the day-to-day practice of our discipline, I also thank Stuart Darsch, André Secours, David Horton, Terry Swack, Abby Yozell, Will Cook, and Tim Blackburn.

Susan Glover Godlewski, Curator of Rare Books and Manuscripts at the Boston Public Library, cheerfully gave me access not only to the unexpected treasures of the institution, but also to her own encyclopedic knowledge of the development of the roman letterform.

From our first encounter, Lee Ripley-Greenfield and Nell Webb at Laurence King Publishing Ltd have been the editors a first-time author dreams of. Their gentle guidance and assurance helped this tyro far more, probably, than they know. I hope we get to do it again sometime, not least for the chance to work again with Peter Kent and Kate Tuckett.

I have leaned, probably too heavily, on the goodwill and broad experience of my family and friends. I especially want to thank Carole Kane, Nancy Richard, and Sandy Leonard for their generous support and kind encouragement. Thanks to Mark Reed for wanting this book even when I didn't.

Finally…
Living with me, Mark Laughlin has had no choice for the last four years but to live with this book. His candor and abiding good humor sustained this project (and me) every step of the way. David Dunlap, my partner in petty literary crime since our anarchic nights putting together the 1972 Yale yearbook, provided the benefit not only of his professional experience as journalist and author but also of his personal experience in the solitary business of writing. Co-conspirator Nina Pattek's wit, insight, and plain old nagging provided both leavening and much needed perspective throughout this process. And Julie Curtis, for 25 years my pal and colleague through our many life and career changes, has worked her way through this project as if it were her own. Every page of this book bears the unmistakable mark of her wise counsel and boundless affection. To them, then, this book is dedicated.

JK

Contents

Design is solving problems. Graphic design is solving problems by making marks. Type is a uniquely rich set of marks because it makes language visible. Working successfully with type is essential for effective graphic design.

That said, I can tell you that

this is a practical book.

Over the last 20-odd years of teaching typography, I have been unable to find a text that spoke clearly to beginning students about the complex meeting of message, image, and history that is typography. Some of the best history texts are weak in examples; some of the best theoretical texts speak more to the professional than the novice. And no text provides background information to the student in a sequence that supports the basic exercises in any introductory type course. My intention here is to present the basic principles and applications of typography in a way that mirrors what goes on in the classroom and to back up that information with a series of exercises that reinforce the acquired knowledge.

My intent here is to get you, the beginning student of graphic design, to the point where you can understand and demonstrate basic principles of typography. If instinct is the sum of knowledge and experience, this book is an attempt to broaden both in order to strengthen your own typographic instincts.

I should also point out that this is an autodidact's book. What I know about typography I learned from reading, from practice, and from observation. I was lucky enough to read Emil Ruder first. And I was also lucky enough to work in Boston at a time when dozens of gifted practitioners were trying to solve the same problems I was confronting daily, as we all moved from metal type through photoset type to digital type off our Macs. What I learned from them was constant application of theory to practice, unflagging respect for the letterform, and a ceaseless search for that moment when the personal met, or at least approached, the platonic.

Paul Rand once wrote: 'Typography is an art. Good typography is Art,' and therein lies the problem for both teacher and student. Craft can be taught. Art lies within the individual. Many beginning students are frustrated by the fact that there are no hard and fast rules in typography, no foolproof map to success. The pedagogic difficulty is that type has a system of principles, based on experience, and those principles keep evolving as language and media evolve. Countless times, students have asked, 'Is this right?' when in fact there is no such thing in typography as 'right.' The question they should be asking themselves is, 'Does this work? Is it useful?' Designers use type as a response— to a message, to an audience, to a medium. The only way to recognize successful typography is through informed, direct observation. It takes time, trial and error to know what works and to lose anxiety over what may or may not be 'right.'

Once you have completed the exercises in this book, you should have enough experience to test your own ideas in typographic applications. After all, it is what each designer brings to a project—the sum of what he or she knows and feels, his or her unique experience—that guarantees that variety, excitement, and, occasionally, brilliance will continue to enliven typographic design. This book is not about style—a characteristic expression of attitude—so much as a clear-headed way of thinking and making. Style belongs to the individual; delight in thinking and making can be shared by everyone.

The guiding attitudes behind what follows are those that have vitalized most twentieth-century art:

Content dictates form.
Less is more.
God is in the details.*

These three tenets neatly identify the typographer's job: appropriate, clear expression of the author's message, intelligent economy of means, and a deep understanding of craft.

* The first idea is a variation of architect Louis Sullivan's famous dictate, 'Form ever follows function.' The second, although popularized by architect Ludwig Mies van der Rohe, was first articulated by Robert Browning in 'Andrea del Sarto,' 1855 (and, in fact, the idea has existed in literature since Hesiod's 'Works and Days,' 700 B.C.E., in which he writes, 'They do not even know how much more is the half than the whole.') The third, although attributed to architect Louis Kahn, has no source that I have been able to uncover.

Bembo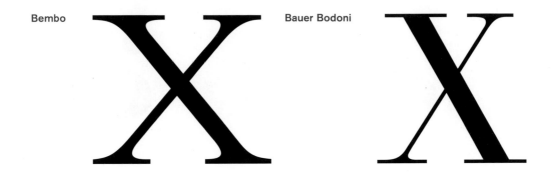

Bauer Bodoni

Serifa 55

Univers 55

Syntax

Image, history, and meaning meet
in every aspect of typography,
even the simplest of letterforms.

Bembo

Bauer Bodoni

Serifa 55

Helvetica

Futura

As Eric Gill said, letters are things, they are not pictures of things. While the generic letter 'A' may indicate a variety of sounds, the lowercase 'a' as rendered in Bembo is a specific character, different in form and sensibility from the lowercase 'a' rendered in Bauer Bodoni, Serifa 55, Helvetica, or Futura. All five convey the idea of 'A'; each presents a unique esthetic.

The basic thinking behind this book comes out of two simple observations. First,

type is physical.

Until quite recently, any study of type would necessarily begin by handsetting metal type. There is still no better way to understand the absolute physicality of the letterform—its 'thingness.' With each day, however, working with metal type becomes less and less possible. To approximate the experience of handling type, there are exercises in this book that require careful hand-rendering of letterforms. (I've suggested these exercises primarily for readers who don't have, as I did not, the benefit of a classroom experience. They are not intended to supplant working with a capable instructor, although I certainly hope that they can enhance that process.) These exercises help you not only to hone your hand–eye coordination, but also to develop a typographic sensibility. You cannot achieve this sensibility merely by looking and thinking. The only way to appreciate the reality of type is first to make your own.

For some of the beginning exercises, the best technique is working with a good copying machine. Aside from providing fast, clear copies and reasonably reliable enlargements and reductions, it also allows you to work with letterforms within a frame—a dim but audible echo of the letterform cast on a slug of lead.

The second observation, particularly in terms of text type, is that

type evolved from handwriting.

While there are any number of things you can do with text type (particularly on a computer), your work will have the most integrity when what you do reflects the same impulse that leads us all to put pen to paper—effective, direct, useful communication.

Particularly in later exercises, I have assumed that people using this book have a working familiarity with Adobe Illustrator and Quark Xpress or Adobe InDesign. You should also have at least one font from each of the classifications described on pages 47–49; in fact, you could do a lot worse than to choose the ten typefaces highlighted on page 12. They provide a rock-solid foundation for any typographic design problems you may encounter in the future.

I've used numerous examples to demonstrate the points I raise, because one of the joys of working with type is that you can see immediately what is successful and what isn't (for that same reason I've tried to keep text to a minimum). I have designed virtually every example in this book to reflect what was, and still is, possible on a simple type press. I've kept these examples as simple as possible for two reasons:. Firstly, 'simple' is deceptively difficult (and, in typography, often desirable). Secondly, as I said earlier, this book is about intent and content, not affect or style.

Finally, as the title suggests, this book is just a beginning. These pages, at best, describe a series of small steps toward developing a well grounded typographic sensibility. I encourage you to use the bibliography to learn what other people have to say and show about typography. Beyond that, look around. Every time you see language, you are looking at type. Test what you do against what other people do, and learn how to articulate the differences. Keep a sketchbook, and note all your observations. Include your own examples. And take advantage of every opportunity, however humble, to put type on paper. I hope this book prompts an ongoing exploration of a dynamic and demanding craft. With luck, it will stimulate a process that leads to type becoming an integral part of your professional life.

■ **Throughout the book, exercises are set in boldface and indicated with an exdented dingbat and a toned field.**

Basics

2 As with any craft that has evolved over 500 years, typography employs a number of technical terms. These mostly describe specific parts of letterforms. It is a good idea to familiarize yourself with this lexicon. Knowing a letterform's component parts makes it much easier to identify specific typefaces.

(In the entries that follow, **boldface** text indicates terms described elsewhere in the list.)

Stroke
Any line that defines the basic letterform.

Apex/Vertex
The point created by joining two diagonal **stems** (**apex** above, **vertex** below).

Arm
Short **strokes** off the **stem** of the letterform, either horizontal (E, F, T) or inclined upward (K, Y).

Ascender
The portion of the **stem** of a lower-case letterform that projects above the **median.**

Baseline
The imaginary line defining the visual base of letterforms (see the diagram below).

Median
The imaginary line defining the **x-height** of letterforms (see the diagram below).

X-height
The height in any typeface of the lowercase 'x' (see the diagram below).

Barb
The half-**serif** finish on some curved **strokes.**

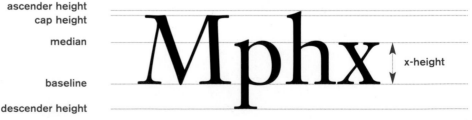

ascender height
cap height
median
baseline
descender height

x-height

Beak
The half-**serif** finish on some horizontal **arms.**

Cross Bar
The horizontal **stroke** in a letterform that joins two **stems** together.

Ear
The **stroke** extending out from the main **stem** or body of the letterform.

Bowl
The rounded form that describes a **counter.** The bowl may be either open or closed.

Cross Stroke
The horizontal **stroke** in a letterform that intersects the **stem.**

Em/en
Originally referring to the width of an uppercase M, an em is now the distance equal to the size of the typeface (an em in 48 pt. type is 48 points, for example). An en is half the size of an em. Most often used to describe em/en spaces and em/en dashes.

Bracket
The transition between the **serif** and the **stem.**

Crotch
The interior space where two **strokes** meet.

Finial
The rounded non-**serif terminal** to a **stroke.**

Counter
The negative space within a letterform, either fully or partially enclosed.

Descender
That portion of the **stem** of a lower-case letterform that projects below the **baseline.**

Leg
Short **stroke** off the **stem** of the letterform, either at the bottom of the stroke (L) or inclined downward (K, R).

fi fi fl fl hn O O e e

Ligature
The character formed by the combination of two or more letterforms.

Shoulder
The curved **stroke** that is not part of a **bowl.**

Stress
The orientation of the letterform, indicated by the thin **stroke** in round forms.

 g

Link
The **stroke** that connects the **bowl** and the **loop** of a lowercase G.

S

Spine
The curved **stem** of the S.

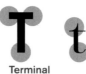 ATW

Swash
The flourish that extends the **stroke** of a letterform.

 g

Loop
In some typefaces, the **bowl** created in the **descender** of the lowercase G.

 b q G

Spur
The extension that articulates the junction of a curved and rectilinear **stroke.**

 Q j

Tail
The curved or diagonal **stroke** at the finish of certain letterforms.

 ATM

Serif
The right-angled or oblique foot at the end of the **stroke.**

 TVbp

Stem
The significant vertical or oblique **stroke.**

T t

Terminal
The self-contained finish of a **stroke** without a **serif.** This is something of a catch-all term. Terminals may be flat ('T', above), flared, acute, ('t', above), grave, concave, convex, or rounded as a ball or a teardrop (see **finial**).

See **Appendix A** for Macintosh keyboard layouts.

The full font of a typeface contains much more than 26 letters, 10 numerals, and a few punctuation marks. To work successfully with type, you should make sure that you are working with a full font and you should know how to use it.

Uppercase
Capital letters, including certain accented vowels, the c cedilla and n tilde, and the a/e and o/e ligatures.

A Å Â Ä À Á Ã Æ B C Ç D E É
È Ê Ë F G H I Ì Í Î Ï J K L M N
O Ó Ò Ô Ö Ø Œ P Q R S
T U Ú Ù Û Ü V W X Y Z

Lowercase
Lowercase letters include the same characters as uppercase plus f/i, f/l, f/f, f/f/i, and f/f/l ligatures, and the 'esset' (German double s).

a á à â ä å ã æ b c ç d e é è ê ë
f fi fl ff ffi ffl g h i ï î ì í j k l m n ñ
o ó ò ô ö ø œ p q r s ß
t u ü û ù ú v w x y z

Small capitals
Uppercase letterforms, drawn to the x-height of the typeface. Small caps are primarily found in serif fonts as part of what is often called an expert set. Most type software includes a style command that generates a small cap based upon uppercase forms. Do not confuse real small caps with those artificially generated.

A Á À Â Ä Å Ã Æ B C Ç D E É È Ê Ë
F G H I Í Ì Î Ï J K L M N Ñ
O Ø Ó Ò Ô Ö Œ P Q R S Š
T U Ú Ù Û Ü V W X Y Ý Z Ž

Aa
Baskerville
small cap
artificially
generated

Aa
Baskerville
small cap
from the
font

Typeface shown:
Monotype Baskerville

Uppercase numerals

Also called lining figures, these numerals are the same height as uppercase letters and are all set to the same kerning width. They are most successfully used with tabular material or in any situation that calls for uppercase letters.

1 2 3 4 5 6 7 8 9 0

Lowercase numerals

Also called oldstyle figures or text figures, these numerals are set to x-height with ascenders and descenders. They are best used wherever you would use upper- and lowercase letterforms. Lowercase numerals are far less common in sans serif typefaces than in serif.

1 2 3 4 5 6 7 8 9 0

Italic

Most fonts today are produced with a matching italic. Small caps, however, are almost always only roman. As with small caps, artificially generated italics are not the same as real italics.

Note the difference below between a 'true' italic and what is called an 'oblique.' The forms in a true italic refer back to fifteenth-century Italian cursive handwriting. Obliques are typically based on the roman form of the typeface. Contemporary typefaces often blur the distinction between italic and oblique, but you should be aware of the differences.

A Å Â Ä À Á Ã Æ B C Ç D
E Ë Ê È É F G H I Ï Î Ì Í J K L M
N Ñ O Ø Ö Ô Ò Ó Œ P Q R S T
U Ü Û Ù Ú V W X Y Z
1 2 3 4 5 6 7 8 9 0
a å â ä à á ã æ b c ç d e ë ê è é f fi fl ff
ffi ffl g h i ï î ì í j k l m n ñ o ø ö ô ò ó œ
p q r s ß t u ü û ù ú v w x y z
1 2 3 4 5 6 7 8 9 0

a *a*

Baskerville roman with italic

a ***a***

Univers 55 (roman) with Univers 56 (oblique)

Punctuation, miscellaneous characters

Although all fonts contain standard punctuation marks, miscellaneous characters can change from typeface to typeface. It's important to be acquainted with all the characters available in a typeface before you choose the appropriate type for a particular job.

! * - – — _ () { } [] " " ' ' . : ; …
/ ? ¿ † ‡ § ‹ › « » ¶ & # $ ₵ ¢ £ ¥
™ © ® @ ∞ ᵃ ᵒ ᵐ < > ≤ ≥ + ± √
= ≠ ÷ • ≈ ° ∑ ∏ π ∂ ƒ · Δ ° ¬ Ω ∫
μ / ¤ ¯ ˘ ´ ˝ ◊ ₁ Þ
% ‰ ⅛ ¼ ⅓ ⅜ ½ ⅝ ⅔ ¾ ⅞

Dingbats

Various symbols and ornaments that are intended for use with type are called dingbats. The majority of dingbats are marketed as their own fonts and not in conjunction with any particular typeface.

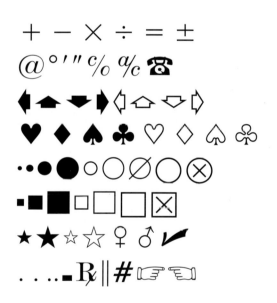

8

Once you can recognize the parts of the letterform, you can apply what you know to identify different typefaces. Beyond the characteristic gestures of a typeface, however, there are also style applications that you should recognize. Keep in mind that some, all, or combinations of these styles may be found within one type family.

Roman
The basic letterform style, so called because the uppercase forms are derived from inscriptions on Roman monuments. When used to describe a type style, the term 'roman' is always lowercase. In some typefaces, a slightly lighter stroke than roman is called 'book.'

Italic
Named for fifteenth-century Italian handwriting on which the forms were based. (See page 6 for a description of 'oblique.')

Boldface
Characterized by a thicker stroke than the roman form. Depending upon the relative stroke widths within the typeface, it can also be called 'semibold,' 'medium,' 'black,' 'extra bold,' or 'super.' In some typefaces (notably Bodoni), the boldest rendition of the typeface is referred to as 'poster.'

Light
A lighter stroke than the roman form. Even lighter strokes are often called 'thin.'

Condensed
As the name suggests, a condensed version of the roman form. Extremely condensed styles are often called 'compressed.'

Extended
Exactly what you would think. An extended variation on the roman form.

Roman
Italic
Boldface
Light
Condensed
Extended

The confusion of styles within families of typefaces may seem daunting to the novice; it certainly remains a small nuisance even to the experienced designer. The only way to deal with the profusion of names—like learning irregular verbs in French—is memorization. See page 44 for Adrian Frutiger's attempt to resolve the naming problem.

Adobe Caslon SemiBold

Akzidenz Grotesk Regular

Akzidenz Grotesk Medium

Bodoni Old Face Medium

Futura Book

Helvetica Compressed

Gill Sans Heavy

Gill Sans Extra Bold

Gill Sans Ultra Bold

Grotesque Black

Meta Normal

Univers Thin Ultra Condensed (Univers 39)

Whenever you open a computer program that involves typesetting, make sure you set your default measurements to points and picas.

10

Along with its own lexicon, typography also has its own units of measurement. Originally, type size was determined by the height of actual pieces of lead type. Obviously, we no longer commonly use lead type in setting type; however, the concept of letterforms cast on small pieces of lead remains the most useful way of thinking of type size. Although type size originally referred to the body of the type (the metal slug on which the letterform was cast), today we typically measure it from the top of the ascender to the bottom of the descender.

Similarly, the space between lines of type is called 'leading' because it was originally strips of lead placed between lines of metal type.

We calculate the size of type with units called 'points.' A point as we use it now is $1/72$ of an inch or 0.35 mm. The 'pica,' also used extensively in printing, is made up of 12 points. There are 6 picas to an inch.

When writing out a dimension in picas and points, the standard abbreviation is **p.**

6 picas
is written
6p or **6p0**

6 picas, 7 points
is written
6p7

7 points
is written
7 pts., 0p7, or **p7**

When specifying type size and leading, use a slash between the two numbers.

10 point Univers with
2 point leading
is written
10/12 Univers

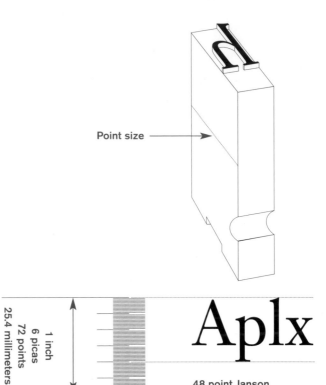

Point size

1 inch
6 picas
72 points
25.4 millimeters

Aplx

48 point Janson

48 pt. type →

3 pt. leading →

48 point Janson with
3 point leading—
48/51 Janson

Set width

All letterforms have set widths: the width of the form itself plus the space required on either side to prevent one letter from bumping into another. Set widths are described in 'units,' an entirely arbitrary measure that changes from one system to another. In the example opposite, the uppercase 'M' (typically the widest letterform) is 20 units wide and the lowercase 'a' is 9 units wide; the measurements might just as easily be 40 units and 18 units.

When type was cast by hand, it was possible for every letter, upper- and lowercase, to have a unique set width. As mechanized typesetting evolved, type designers were forced to restrict the number of set widths in any typeface to accommodate the limitations of the system (metal or photo) that produced the type. An 'a' and an 'e', for instance, might be assigned the same set width in some systems because the technology was unable to express finer distinctions. Current digital technology has gone a long way toward restoring the variety of hand-cast type. Many softwares work at a scale of 200 units to the set width of an 'M'.

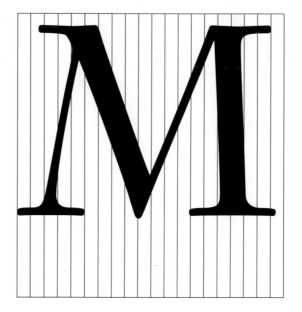

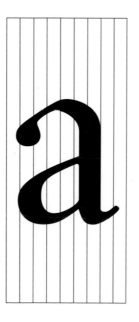

1,234,567.00
450,118.19

1,234,567.00
450,118.19

Uppercase numerals always have identical set widths so that they will align vertically (above). Lowercase numerals, designed with varying set widths, do not align vertically.

12 The ten typefaces displayed opposite represent 500 years of type design. The men and women who rendered them all sought to achieve two goals: easy readability and an appropriate expression of contemporary esthetics. These typefaces (and there are others) have surpassed the latter goal. They have remained in use for decades—in some cases, centuries—after they were first designed, still considered successful expressions of how we think, how we read and write, and how we print.

As a beginning typographer, you should study these ten faces carefully. For any of the exercises in this book—and for almost any early projects—these are all you will need to develop your skills. Once you understand how to use these faces appropriately and effectively, you'll be well prepared to understand and appreciate other typefaces as you encounter them.

Most of the typefaces shown here are fully displayed in the chapter on Development, pages 15–49.

Bembo Radiography

Garamond Radiography

Janson Radiography

Caslon Radiography

Baskerville Radiography

Bodoni Radiography

Serifa Radiography

Futura Radiography

Gill Sans Radiography

Univers Radiography

As you study other designers' work, you'll notice that many people who work seriously with type employ a limited palette of typefaces. Some, in fact, go through their entire careers using only one or two.

For our purposes, what is worth noting is not the similarities among these typefaces, but their differences—the accumulation of choices that renders each unique. Compare, for example, different forms of the lowercase 'a':

a a a a a a a a a a a

Beyond the gross differences in x-height, these forms display a wealth of variety in line weight, relative stroke width and other internal relationships, and in feeling. For any good typographer, each of these feelings connotes specific applications determined by use and expression. In other words, the typefaces suggest applications for which they are appropriate.

R R R R R R R R R R

The uppercase R (above) displays the range of attitude typefaces are capable of conveying. If you examine these forms long enough, you are bound to decide that some of the tails seem more whimsical, some more stately; some will appear more mechanical, some more calligraphic, some harmonious, some awkward. As much as anything, what this examination tells you is how you feel about type and specific typefaces. It tells you what you bring to the discussion of appropriateness in type choices.

Development

16

An alphabet is a series of culturally agreed upon marks—letters—that represent specific sounds. Before the Phœnicians (a seafaring mercantile group living in current-day Lebanon) developed an alphabet around 1500 B.C.E., written language had depicted entire words at a time. The picture of a bull meant a bull, independent of its pronunciation. Being able to write—to document speech—meant knowing the thousands of marks that represented all the things in the known world. By developing a system dependent upon sound ('ah') and not object (bull) or concept (love), the Phœnicians were able to capture language with 20 marks instead of hundreds or thousands. Writing—cuneiforms, hieroglyphs—had been practiced for several millennia before the Phœnicians developed their set of marks, but, for our purpose—the study of letterforms—in the beginning was the alphabet.

The word 'alphabet' is a compression of the first two letters of the Greek alphabet: alpha and beta. By 800 B.C.E., the Greeks had adapted the 20 letters from the Phœnician alphabet, changing the shape and sound of some letters. (The Phœnician alphabet is also the forerunner of modern-day Hebrew and Arabic, but our focus is on its European evolution.)

On the Italian peninsula, first the Etruscans and then the Romans appropriated the Greek alphabet for their own use. The Romans changed the forms of several Greek letters and, on their own, added the letters G, Y, and Z. As Rome's influence spread throughout Europe, Asia Minor, and northern Africa, so too did the Roman alphabet—and Roman letterforms.

Early letterform development: Phœnician to Roman

4th century B.C.E.
Phœnician votive stele
Carthage, Tunisia
The stele bears a four-line inscription to Tanit and Baal Hammon.

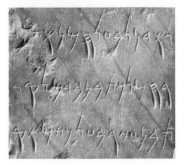

Initially, writing meant scratching into wet clay with a sharpened stick or carving into stone with a chisel. The forms of uppercase letterforms (for nearly 2,000 years the only letterforms) can be seen to have evolved out of these tools and materials. At their core, uppercase forms are a simple combination of straight lines and pieces of circles, as the materials and tools of early writing required. Each form stands on its own. This 'epigraphic' (inscriptional) or 'lapidary' (engraved in stone) quality differentiates upper- from lowercase forms.

The evolution of the letterform 'A':

Phœnician
1000 B.C.E.

Greek
900 B.C.E.

Roman
100 B.C.E.

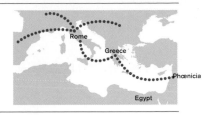

Date unknown
Greek fragment
Stone engraving

Late 1st century B.C.E.
Augustan inscription in the Roman Forum
Rome

The Greeks changed the direction of writing. Phœnicians, like other Semitic peoples, wrote from right to left. The Greeks developed a style of writing called 'boustrophedon' ('how the ox ploughs'), which meant that lines of text read alternately from right to left and left to right.

As they changed the direction of reading, the Greeks also changed the orientation of the letterforms, like this:

ASTHEYCHANGEDTHEDIRECTIO
NOFREADINGTHEYALSOCHANG
EDTHEORIENTATIONOFTHELETTE

(Note: the Greeks, like the Phœnicians, did not use letterspaces or punctuation.) Subsequently, the Greeks moved to a strictly left-to-right direction for writing.

Etruscan (and then Roman) carvers working in marble painted letterforms before inscribing them. Certain qualities of their strokes—a change in weight from vertical to horizontal, a broadening of stroke at start and finish—carried over into the carved forms.

Not all early writing was scratched in clay or carved in stone. Business contracts, correspondence, even love songs required a medium that was less formal and less cumbersome than stone allowed for. From 2400 B.C.E., scribes employed a wedge-shaped brush and papyrus for writing throughout the eastern Mediterranean. Papyrus was made from a bamboo-like plant that grew in the Nile valley. The plant's inner fibers were pulped, then flattened and dried under heavy weights.

Despite its relative ease of use, papyrus had several drawbacks. It could not be written on on both sides, and it was too brittle to be folded. Its main drawback, however, was its single source—Egypt. Availability was limited not only to the size of the papyrus crop from year to year, but also to the Pharaoh's willingness to trade.

Ephemeral communication—notes, calculations, simple transactions—were often scratched out on wax panels framed in wood. When the communication had served its purpose, the wax could be smoothed out for subsequent use. This practice continued into the Middle Ages.

By 400 C.E., the codex (individual parchment sheets stitched together) had replaced the papyrus scroll as the preferred format for books.

Hand script from 3rd to 10th century C.E.

4th or 5th century Square capitals	Late 3rd to mid-4th century Rustic capitals	4th century Roman cursive

Square capitals were the written version of the lapidary capitals that can be found on Roman monuments. Like their epigraphic models, these letterforms have serifs added to the finish of the main strokes. The variety of stroke width was achieved by the use of a reed pen held at an angle of approximately 60° off the perpendicular.

A compressed version of square capitals, rustic capitals allowed for twice as many words on a sheet of parchment and took far less time to write. The pen or brush was held at an angle of approximately 30° off the perpendicular. Although rustic capitals were faster and easier to write than their square counterparts, they were slightly harder to read because of the compressed nature of the forms.

Both square and rustic capitals were typically reserved for documents of some intended permanence. Everyday transactions, however, were typically written with a cursive hand, in which forms were simplified for speed. We can see here the beginning of what we now refer to as lowercase letterforms.

By 150 B.C.E., parchment had replaced papyrus as the writing surface of choice. Most famously manufactured in Pergamum (from which the word is derived), parchment was made from the treated skins of sheeps and goats. Vellum—a particularly fine version of parchment—was made from the skins of newborn calves. Unlike papyrus, parchment could be written on on both sides and folded without cracking. Its harder surface also stood up to a hard-nibbed reed pen, which in turn allowed for smaller writing.

Paper was invented in China in 105 C.E. by Ts'ai Lun, a court eunuch, who made a pulp of various available fibers, which he then spread over a piece of cloth and allowed to dry. His contemporaries (and those who followed) used a brush to 'paint' characters on the resulting, rather rough, sheet. Over time, the drying cloth was replaced by a dense screen of thin strips of bamboo. The technique did not reach Europe for 900 years.

Papermaking spread to Japan in the seventh century, to Samarkand (now Uzbekhistan) in the eighth, and then, via the Moors, to Spain, where papermaking was practiced around 1000 C.E. A paper mill (or factory), using water-powered machines to pulp linen fiber and fine screens to produce smooth, flexible sheets, was operating in Fabriano, Italy, by 1300. The process spread quickly through Europe. By 1600, more than 16,000 paper mills were in operation.

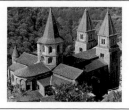

Abbey Church of Sainte-Foy
Conques, France
c. 1050–1120

4th–5th century	c. 500	925
Uncials	Half-uncials	Caroline miniscule

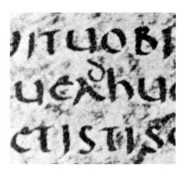

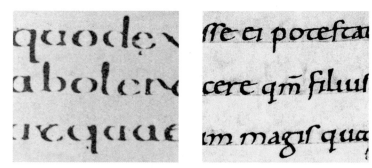

Uncials incorporated some aspects of the Roman cursive hand, especially in the shape of the A, D, E, H, M, U, and Q. 'Uncia' is Latin for a twelfth of anything; as a result, some scholars think that uncials refer to letters that are one inch (one twelfth of a foot) high. It might, however, be more accurate to think of uncials simply as small letters. The point for the scribe, after all, was to save expensive parchment, and the broad forms of uncials are more readable at small sizes than rustic capitals.

A further formalization of the cursive hand, half-uncials mark the formal beginning of lowercase letterforms, replete with ascenders and descenders, 2,000 years after the origin of the Phœnician alphabet. Due to the political and social upheaval on the European continent at the time, the finest examples of half-uncials come from manuscripts produced in Ireland and England.

Charlemagne, the first unifier of Europe since the Romans, issued an edict in 789 to standardize all ecclesiastical texts. He entrusted this task to Alcuin of York, Abbot of St. Martin of Tours from 796 to 804, under whose supervision a large group of monks rewrote virtually all the ecclesiastical and, subsequently, secular texts then in existence. Their 'print'—including both majuscules (upper case) and miniscules (lower case)—set the standard for calligraphy for a century, including capitalization and punctuation.

Roman numerals, used in the first millennium throughout Europe, matched seven Roman letters.

I V X L C D M
1 5 10 50 100 500 1000

With the development of lowercase letterforms, the numerals came to be written in lowercase as well.

i v x l c d m
1 5 10 50 100 500 1000.

What we call Arabic numerals originated in India between 1,500 and 2,000 years ago. Our first evidence of their use in Arabic is from an Indian astronomical table, translated in Baghdad around 800 C.E. Arab scribes referred to them as Hindu figures, and they looked like this (remember, Arabic reads from right to left):

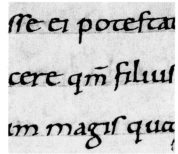

As with papermaking, use of Arabic numerals spread from Moorish Spain to Europe around 1000 C.E. The numerals were quickly adopted by merchants and scientists not only because of their legibility, but also, significantly, because they brought with them the Hindu concept of zero, which allowed for decimals and place value. Compare:

M 1000
 and
viii 8

Blackletter to Gutenberg's type

West façade
Amiens Cathedral, France
1220–1269

c. 1300
Blackletter (Textura)

1455
42-line bible
Johann Gutenberg
Mainz
(below [detail] and opposite)

With the dissolution of Charlemagne's empire came regional variations upon Alcuin's script. In northern Europe, a condensed, strongly vertical letterform known as blackletter or textura (for the woven effect it produced on a page of text) gained popularity. In the south, a rounder, more open hand, called 'rotunda,' prevailed. In northern France, England, and the Low Countries, a hybrid of the two, called *batarde*, was predominant. In the north, the blackletter style remained the standard for almost 500 years.

In the south, particularly in Italy, scholars were rediscovering, analyzing, and popularizing Roman and Greek texts. Their sources were written in Alcuin's Caroline miniscule, which they mistakenly believed to be that of the ancient authors. Scribes adapted the rotunda style to the Caroline as they copied the manuscipts, calling it 'scrittura humanistica'—humanist script.

We know that Johann Gutenberg did not singlehandedly invent type-casting or printing, but what little we know of him—mostly from court documents describing a lifetime of unpaid debts—is a good deal more than what we know of his few contemporaries. We do know that his achievement has endured, and so he is central to the development of type.

Born in Mainz in 1397, Gutenberg moved in 1428 to Strasbourg, where he worked as a goldsmith. Printing at that time—and it was a new idea in Europe—consisted of burnishing a piece of paper against a carved, inked block of wood. By 1436 he had begun experimenting with a new technology—an adjustable mold system for 'casting' movable, reusable type from molten lead. In 1438 he designed his first press, based on the grape press used in winemaking. Along the way he developed an ink that had enough tack to stick to his metal type. By 1448 he had returned to Mainz and borrowed 150 gulden from a relative to set up shop.

By 1455, a subsequent mortgage from merchant Johann Fust had, with interest, reached 2,000 gulden. When Fust foreclosed, Gutenberg had to forfeit all his equipment—including his work in progress, the 42-line bible. Fust and his son-in-law Peter Schöffer finished production on the bible and sold it for a handsome profit.

Fust and Schöffer continued printing and publishing with great success. Fust died in 1466. Gutenberg died penniless two years later. At Schöffer's death in 1502, his son Johann took over the business.

Gutenberg's skills included engineering, metalsmithing, and chemistry. He marshalled them all to build pages that accurately mimicked the work of the scribe's hand. For his letterforms, Gutenberg referred to what was known in his time and place—the blackletter of northern Europe. His type mold required a different brass matrix, or negative impression, for each letterform. Because he wanted his type to resemble handwriting as closely as possible, he eventually worked with 270 different matrices, including variants of individual letterforms and numerous ligatures.

verse sunt. Ibi constituit ei precepta atq;
iuditia: et ibi temptauit eu dicens. Si
audieris vocem dñi dei tui· et qð rectū
est coram eo feceris· et obedieris mãda
tis ei9· custodierisq; oīa precepta illi9:
cunctū langore quē posui i egypto nō
inducā super te. Ego eni sum domin9
deus saluator. Venerūt autē in helim
filij israhel: ubi erant duodecim fontes
aquarum 7 septuagīta palme: et ca
strametati sunt iuxta aquas. XVI
Profectiq; de helim venit omnis
multitudo filiox isrl' in desertum
syn· qð est inter helim 7 sinai· quintade
cima die mensis secundi postq; egressi
sūt de tra egypti. Et murmurauit ois
cōgregatio filiox isrl'· cōtra moysen et
aaron· in solitudine. Dixeruntq; filij
isrl' ad eos. V tinā mortui essem9 per
manū dñi i tra egypti: quādo sedebam9
sup ollas carniū· 7 comedebam9 pane
i saturitate. Cur induxistis nos in de
sertū istud: ut occideretis omnē mltitu
dine fame? Dixit autem dñs ad moy
sen. Ecce ego pluā vobis panes de celo.
Egrediat pls et colligat q sufficiunt
per singulos dies: ut temptē eū· vtrum
ambulet in lege mea· an non. Die au
tem sexto parēt quod inferant: 7 sit du
plum quam colligere solebāt p singu
los dies. Dixeruntq; moyses 7 aaron
ad oīnes filios isrl'. Vespere scietis q̄
domin9 eduxerit vos de tra egypti: et
mane videbitis gloriā domini. Au
diui eni murmur vestrū contra dñm.
Nos vero qð sum9: quia inuisitastis
cōtra nos? Et ait moyses. Dabit vo
bis dñs vespere carnes edere· et mane
panes i saturitate: eo q̄ audierit mur
murationes vestras quibz murmu
rati estis cōtra eū. Nos eni qð sum9?
Nec contra nos est murmur vestrū:

sed contra dominū. Dixit quoq; mo
yses ad aaron. Dic vniūse cōgregati
oni filiox isrl'. Accedite cora domino.
Audiuit eni murmur vestrū. Cūq; lo
queret aaron· ad omnē cetum filiox
isrl': respexerūt ad solitudinem. Et ecce
gloria dñi apparuit in nube. Locutu
est autē domin9 ad moysen dicēs. Au
diui murmurationes filiorū isrl'. Lo
que ad eos. Vespere comedetis carnes:
7 mane saturabimini panibz: scietisq;
q̄ ego sum domin9 deus vester. Factū
est ergo vespere 7 ascendēs coturnix co
operuit castra: mane quoq; ros iacuit
per circuitū castrox. Cūq; operuisset su
perficiem terre: apparuit in solitudine
minutū· et quasi pilo tusum in similitu
dinem pruine super terrā. Quod cū vi
dissent filij israhel: dixerunt ad inuicē.
Manhu? Quod significat. Quid est
hoc? Ignorabant eni qð esset. Quibz
ait moyses. Iste est panis quē dñs de
dit vobis ad vescendū. Hic est sermo
quē precepit vobis dñs. Colligat unus
quisq; ex eo quantū sufficit· ad vescēdū:
gomor p singla capita. Iuxta nume
rum animax vestrax q̄ habitāt in ta
bernaclo: sic colletis. Feceruntq; ita filij
isrl': et collegerūt· alius plus alius mi
nus: 7 mensi sūt ad mensurā gomor:
Nec q plus collegerat· habuit ampli
us: nec q̄ min9 parauerat· reperit min9:
sed singuli iuxta id qð edere poterant
cōgregauerūt. Dixitq; moyses ad eos.
Nullus relinquat ex eo i mane. Qui
non audierūt eū: sed dimiserūt quidā
ex eis usq; mane: et scatere cepit ōmibz:
atq; computruit. Et irat9 ē cōtra eos
moyses. Colligebant autē mane· sin
guli: quantū sufficere poterat ad vescen
dum. Cūq; incaluisset sol: liquefiebat.
In die autem sexta· collegerunt cibos

European cities with printing offices, 1455–1500

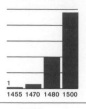

1455 1470 1480 1500

By 1500 there were 1,000 printing offices in 240 cities in Europe. 12,000,000 printed copies of 35,000 books were in distribution, more than all the books that had been hand-copied in the previous one and a half millennia.

c. 1460
Lucius Lactantius
De Divinis Institutionibus
Venice

In 1462, the city of Mainz was ransacked by troops of the Archbishop of Nassau. Printers—many of whom had come from other countries to learn the new technology—spread back out across Europe in search of safer havens for the practice of their craft.

In 1465, two German printers—Conrad Sweynheym, who had clerked for Schöffer in Mainz, and Arnold Pannartz—established a press at the Benedictine monastery in Subiaco, some 31 miles (50 km) east of Rome. After printing just four books, they moved their press to the Palazzo de' Massimi in Rome, where they worked until 1473. Just as Gutenberg cast his type to mimic the prevailing writing style in the north, Sweynheym and Pannartz cast their type to match the Italian calligraphic hand, humanist script.

In 1469, German Johannes da Spira set up the first press in Venice. His type, too, reflected humanist script, but it displayed a regularity of tone that far exceeded the work of Sweynheym and Pannartz. Da Spira died in 1470, and his press was taken over by Nicholas Jenson, a Frenchman who had gone to Mainz in 1458 to learn type-casting and printing and who is believed to have cast da Spira's original type. Whether he did or not, in his own work until his death in 1480, Jenson effectively codified the esthetics of type for those who followed.

These three pages (above and opposite, with details below), produced within around ten years of each other, demonstrate the transition from humanist script to roman type in Italy. Nicholas Jenson's accomplishment—in terms of both craft and form—is all the more vivid when compared to the contemporary work of Sweynheym and Pannartz.

Some early printing offices, by date	1461 Bamberg	1470 Paris	1474 Valencia
	1462 Strasbourg	Toulouse	1475 Bruges
	1465 Subiaco	1473 Lyons	1476 London
	1466 Cologne	Utrecht	1477 Delft
	1468 Augsburg	Ulm	
	1469 Venice		

23

1472
Cardinal Johannes Bessarion
Adversus Calumniatorem Platonis
Conrad Sweynheym and
Arnold Pannartz
Subiaco press, Rome

1471
Quintilian
Institutiones Oratoriae
Nicholas Jenson
Venice

unā traxerit pter aduersariū.Nunc eius argumenta aggredior: et quonia nephandi amoris crimē in primis Platoni obiicit:qbus id rationibus oftedere conetur:post uidebimus. Nunc de amore aliquid disteramus. Equidem non is sum:qui neminē unā incidisse in amoris illicitos.ac per libidinem scelus cōmisisse existimē. Neqt enī negari potest plures ex omni natiōe extitisse:natura puersa & deprauatis moribus:qui non animos sed corpora mariū amāt instar eorū qui ut Plato inquit fructui appetut. Quippe & apo/stolus Paulus i epistola quā ad romaōs scribit:eos nefādi amoris arguit.& Plato non sine causa idipsu & reprehendit & lege uetat. Sed illud animaduertendū est:non omnem amorem uitiosum eē ac turpē:sed queadmodū pleraqt alia cōmuni nomine appellata: diuersam habere rationem : & partim honestum: partim turpem constitui:quod non modo ex his que gentiles auctores scripsere: sed etiā ex sacris nostre religionis litteris oftendi potest.Gentiles enim amorem siue cupidinem: si cui ita uocare magis placet:ānā non apte hoc omnibus locis dici potest: duplicem esse uoluerunt ne eadem uia eodem ue afflatu animos hominum incendere:sed alterum ut nimis pueriliter sentientem:nulla ratione regi ac insi/pietuum solummodo animi insidere:libidinis atqt luxurie comicē: impudentem:scelestum:ad id quod male appetit temere ruērem. Alterum honestum:modestum:uerecundū:constantem:sanctū: beatū:castitatis continentieqt custodem:benigne animi afflantē & amantē obseruantemqt uirtutis:itaqt cum unā amoris sit nomē non easdem ex utro qt prodire actiōes:quemadmodum pudoris quoqt & cōtentionis eodem permanente nomine diuerse actiōes sut. Nempe homini cultus profuit.nocuitqt pudori:ut Hesiodus inquit.Cōtentionis item genus non simplex sed duplex est.ut.n. idem poeta inquit. Hec pueris nimis:digna est laudarier illa. Ad/uersofqt animos longe propellere tendunt. Quid igitur mirum si beniuolētia honesta & sancta idem nomen habet: cum turpi se/doqt affectu ? Honestum hoc genus amoris:quem Plato celestem etiam:ac diuinū appellat.in litteris quoqt sacris celebrari uidemus: quemadmodum Salomon specie quadam elegie sacra cātica mo/dulatus est:que nisi quisqt pro sua & scribētii uirtute iudicet:male de uiro illo diuino sentiat necesse est. pfecto ita natura cōparatu ē.ut qt castitate ac moderatiōe almi pstat:quecuiq huiusmōi uer/ba in meliorē parte accipiat. q uero ppriul sceleribus coignatus

MARCI FABII QVINTILIANI LIBER TERTIVS INCIPIT FOELICITER.
DE Scriptoribus artis rhetoricae.

VONIAM IN LIBRO SECVNDO QVAESITu est quid est& rhetorice:& quis finis eius:artē quoque esse eā & utilem & uirtuté:ut uires nostra tuleś osté/dimus:materiaqt ei res oēs de qbus dicere oportet& subiecimus. Iam hinc unde cœpent:quibus constet: quo quæqt in ea modo inuenienda atqt tractāda sint exequar. Intra quem modum pleriqt scriptores artiū cōstitereē: adeo ut Appollodorus cōtentus solis iudicialibus fuerit.Nec sum ignarus hoc a me præcipue:quod hic liber incohat:opus studiosis eius desiderasse: ut iquisitione opinionū:quæ diuersissima fuerunt:longe difficillimū ita nescio:an minime legentibus futurū uoluptati:quippe quod prope nudam præceptorum traditionem desiderat . In cæteris enī admiscere temptauimus aliquid nitoris : non iactandi ingenii grāta:nanqt in id eligi materia poterat uberior.Sed ut hoc ipso alliceremus magis iuue tutem ad cognitionem eorū quæ necessaria studiis arbitrabamur: si du/cti iucunditate aliqua lectionis libentius discerent ea quorū ne ieiuna atqt arida traditio auertet& animos & aures ; præsertim tam delicatas rader&uerebamur. Qua rōne se Lucretius dicit præcepta philosophiæ carmine ferre coactus esse cōplexum.Naqt hac ut est notum similitudine utitur :Ac ueluti pueris absinthia tetra medentes : Cum dare conantur:prius oras pocula circum:Aspirant mellis dulci flauoqt liquore.Et quæ sequunt. Sed nos nunc ueremur:ne parum hic liber mellis:& absinthii multum habere uideatur:sitqt salubrior studiis q dulcior:quinetiam hoc timeo ne ex eo minorem gratiam ineat:quod pleraqt non inuēta per me:sed ab aliis tradita continebit.habeat etiam quosdam qui contra sentiant & aduersent:propterea q plurimi auctores:quis eodē tēderet:diuersas tamen uias inuenerunt:atqt in suam quisqt induxit sequentes.Illi aūt probant qualecuqt ingressi sunt iter.nec facile inculcatis pueris psua/siones mutaueris:quia nemo nō didicisse mauult q discere. Est autem ut procedente libro patebit infinita dissensio auctorum.Primo ad ea q rudia atqt imperfecta adhuc erant adicientibus:quod inuenisse . scri/ptoribus mox:ut aliquid sui uiderent afferre:etiam recta mutantibus. Nā primus post eos quos poeta tradidet:mouisse aliqua circa rhetori/cen Empedocles dicitur.Artium autem scriptores ātiquissimi Corax & Thysias siculi:quos insecutus est uir eiusdē insulæ Gorgias Leontinus

The spread of printing in the sixteenth century	1503 Turkey	1556 India
	1508 Romania	1563 Palestine
	1515 Greece	1584 Peru
	1534 Mexico	1590 Japan
	1550 Ireland	
	1553 Russia	

Venetian type from 1500

24

1499
Colona
Hypnerotomachia Poliphili
type by Francesco Griffo

1515
Lucretius
De Rerum Natura
type by Francesco Griffo

tamente,quella alquáto temperai.Et reflexi gli risonáti sospiri, & cú adu-
latrice sperácia(O cibo amoroso degli amanti, & souente fiate cú lachry-
moso poto cóiuncto)per altro morsicante freno gyrai gli cócitati pésieri
cú tanto pensiculato & fabricato piacere,mirando cú extremo dilecto in
quel corpo gratissimo & geniale,in quelle rosee gene,in qlli mébri nitidi
& luculei solacianti. Per leqle singulare cose,gli mei fremédi desii cófor-
tantime benignaméte mitigai,dalle rabiose ire da tropo ardore redempti,
& dal foco amoroso cusi ppinquo che dispositaméte se accendeuano.

LA NYMPHA PER ALTRI BELLI LOCHI,LO AMO-
ROSO POLIPHILO CONDVCE,OVE VIDE INNVME-
RE NYMPHE SOLENNIGIANTE ET CVM IL TRIVM-
PHO DI VERTVNO ET DI POMONA DINTORNO
VNA SACRA ARA ALACREMENTE FESTIGIANTI.
DA POSCIA PERVENERON AD VNO MIRAVEGLIO
SO TEMPLO. ILQVALE ELLO IN PARTE DESCRI-
VE,ET LARTE AEDIFICATORIA. ET COME NEL DI-
CTO TEMPLO,PER ADMONITO DELLA ANTISTITE,
LA NYMPHA CVM MOLTA CERIMONIA LA SVA
FACOLA EXTINSE, MANIFESTANTISE ESSERE LA
SVA POLIA A POLIPHILO. ET POSCIA CVM LA SA-
CRIFICABONDA ANTISTETE,NEL SANCTO SACEL
LO INTRATA,DINANTI LA DIVINA ARA INVOCO
LE TRE GRATIE.

ONTRASTARE GIA NON VALEVA IO
alle cæleste & uiolente armature,& dicio hauendo la ele-
gantissima Nympha amorosaméte adepto,de me misel
lo amante irreuocabile dominio,Seco piu oltra(imitan
te io gli moderati uestigii)abactrice pare allei uerso ad
uno spatioso littore me códuceua,Ilquale era cótermine
della florigera & collinea cóualle,Oue terminauano a questo littore le or
nate montagniole,& uitiferi colli,cum præclusi aditi,questa aurea patria,
piena di incredibile oblectamento circumclaustrando.Leqnale erano di
siluosi nemori di cóspicua densitate,quanto si fusseron stati gli arbusculi
ordinataméte locati amœne,Quale il Taxo cyrneo,& lo Arcado,Il pina
stro infructuoso & resinaceo,alti Pini,driti Abieti,negligenti al pandare,
& contumaci al pondo,Arsibile Picee,il fungoso Larice,Tedee are,& gli
colli amanti,Celebrati & cultiuati da festigiante oreade , Quiui ambidui

m iii

LVCR.

O bruerent terras:nisi inædificatta superne
M ulta forent multis exempto nubila sole.
N ec tanto possent terras opprimere imbri:
F lumina abundare ut facerent:campos'q; natare:
S i non extructis foret alte nubibus æther.
H is igitur uentis,atq; ignibus omnia plena
S unt:ideo passim fremitus,& fulgura fiunt.
Q uippe etenim supra docui permulta uaporis
S emina habere etus nubes:& multa necesse est
C ondpere ex solis radijs,ardore'q; eorum.
H oc,ubi uentus eas idem qui cogit in unum
F orte locum quemuis,expressit multa uaporis
S emina:seq; simul cum eo commiscuit igni:
I nsinuatus ibi uortex uersatur in alto:
E t calidis acuit fulmen fornacibus intus.
N am dupliciratione accenditur:ipse sua cum
M obilitate calescit:& è contagibus ignis.
I nde ubi percaluit uis uenti:uel grauis ignis
I mpetus incessit:maturum tum quasi fulmen
P erscindit subito nubem:fertur'q; coruscis
O mnia luminibus lustrans loca percitus ardor.
Q uem grauis insequitur sonius:displosa repente
O pprimere ut cœli uideantur templa superne.
I nde tremor terras grauiter pertentat:& altum
M urmura percurrunt cœlum:nam tota ferè tum
T empestas concussa tremit:fremitus'q; mouentur.
Q uo de concussu sequitur grauis imber,& uber:
O mnis uti uideatur in imbrem uertier æther:
A tq; ita præcipitans ad diluuiem reuocare:
T antus dissidio nubis,uentiq; procella,

Venetian publisher Aldus Manutius
(1450–1515), was the first of the
great European printer-scholars, his
books valued for their accuracy and
scholarship. Their beauty owed much
to Francesco Griffo da Bologna, a
type-caster working for Manutius. By
making the uppercase letters shorter
than the ascenders in the lower
case, Griffo was able to create a
more even texture on the page than
Jenson had achieved.

Manutius's achievements include the
first pocket-sized books, whose low
cost and easy portability helped
foster the spread of knowledge
among Renaissance scholars. In
1501, editions of Virgil and Juvenal
featured Griffo's first *italic* typeface,
based on the chancery script favored
by papal scribes. The immediate
value of the italic was its narrower
letterforms, which allowed for more
words on a page, thereby reducing
paper costs. Griffo's italics were
produced only in the lower case.

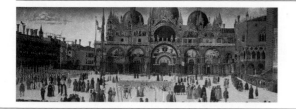

ABCDEFGHIJKLMN
OPQRSTUVWXYZ
1234567890

ABCDEFGHIJKLMN
OPQRSTUVWXYZ

abcdefghijklmn
opqrstuvwxyz
1234567890

ABCDEFGHIJKLM
NOPQRSTUVWXYZ
1234567890

abcdefghijklmn
opqrstuvwxyz
1234567890

Bembo (shown here) is based on
type cut by Francesco Griffo in
1495 for an edition of *De Aetna*
by Pietro Bembo. This revival of
Griffo's typeface was first
produced by the Monotype
Corporation in 1929, under the
direction of Stanley Morison.
The italic is based not on Griffo's
type, but on the calligraphy of
early sixteenth-century scribes
Ludovico degli Arrighi and
Giovantonio Tagliente.

The Golden Age of French printing

1531
Illustrissimae Galliaru reginae Helianorae (opening page)
Printed by Robert Estienne
Paris
Type-cast by Claude Garamond

The earliest printers in France brought with them the blackletter they had learned to cast in Mainz. By 1525, however, a group of French printers—among them Henri and Robert Estienne, Simon de Colines, Geofroy Tory, and Jean de Tournes—had made the Venetian model their own, mirroring contemporary French interest in Italian Renaissance culture.

Of particular importance to the history of type is Parisian Claude Garamond (1480–1561), the first independent type founder. Beyond establishing type-casting as a profession distinct from printing, Garamond created letterforms more expressive of the steel in which he worked than of the strokes made by a calligrapher's pen. A comparison of a Venetian 'a' (Monotype Dante, below left) with Garamond's (Adobe Garamond, below right) clearly demonstrates the difference:

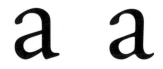

Around 1540, Garamond and his collaborator Robert Granjon developed the first italic forms that were intended for use with roman forms, including an italic upper case. Granjon's work in italic continued until 1577, when he designed a typeface called Civilité that reverted back to the elaborate French *batarde* handwriting of the day. Although it did not supplant italic, it did spur a line of script typefaces that continues to the present.

ILLVSTRISSI-
mæ Galliarũ reginæ
Helianoræ

Iacobus Syluius Ambianus Philiatros.
S. D. P.

DIci non po
test, neque cogitari, re-
gina optima, maxima,
quàm optatus, quàm iu
cundus, quàm verendus
Gallis omnibus fuerit
tuus iste in Gallias ad-
uétus, augustissimúsque
tui cóspectus, non hic sine numine diuûm cócessus. Quandoquidem si nihil cómodius, nihil fœlicius, nihil denique diuinius pace ipsa hominibus à diis immortalibus dari potest, ô quá te memorem regina, pacis toties ac tandiu optatæ, secúdum deú author, pacis alumna, pacis vinculum, faxit deus, adamátinum . Quos tibi triumphos vniuersa de-
a.ii.

ABCDEFGHIJKLMN
OPQRSTUVWXYZ
1234567890

ABCDEFGHIJKLMN

OPQRSTUVWXYZ

abcdefghijklmn

opqrstuvwxyz

1234567890

ABCDEFGHIJKLMN
OPQRSTUVWXYZ
1234567890
abcdefghijklmn
opqrstuvwxyz
1234567890

For years, most typefaces called Garamond were derived from cuttings produced in 1615 by Jean Jannon based on Garamond's work. Robert Slimbach produced Adobe Garamond (shown here) in 1989, working directly from specimens of Garamond's roman and Granjon's italic.

The spread of	1602	Philippines	1642	Finland
printing in the	1610	Lebanon	1643	Norway
seventeenth		Bolivia	1644	China
century	1639	America		
	1640	Iran		

Dutch printing, c. 1600

1572
Polyglot Bible (Preface)
Printed by Christophe Plantin
Antwerp

By the end of the sixteenth century, Dutch publishing houses, particularly the Plantin-Moretus and Elzevir family enterprises, were among the most successful in Europe. At first, these publishers and printers bought much of their type from French foundries. By the seventeenth century, however, they were buying from type founders closer at hand.

Dutch type was widely recognized not so much for its intrinsic beauty as for its clarity and sturdiness. Compare, for example, (French) Adobe Garamond (left) and (Dutch) Linotype Janson (right):

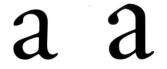

Virtually all English type of the period was purchased in Holland. The Oxford University Press, founded in 1667, purchased its first type from Christoffel van Dijck of Amsterdam. In 1672, Bishop John Fell brought over punches and matrices for the Press cut by Dirk and Bartholomew Voskens.

REGNI NEAPOLITANI
PRIVILEGIVM.

PHILIPPVS DEI GRATIA REX
CASTELLÆ, ARAGONVM, VTRIVSQVE
SICILIÆ, HIERVSALEM, VNGARIÆ, DALMATIÆ, ET CROATIÆ, &c.

NTONIVS Perrenotus, S.R.C. tit. Sancti Petri ad Vincula Presby-ter, Cardinalis de Granuela, prefatæ Regiæ & Catholicæ Maiestatis à consiliis status, & in hoc Regno locum tenens, & Capitaneus ge-neralis, &c. Mag.co viro Christophoro Plantino, ciui Antuerpien-si, & præfatæ Catholicæ Maiestatis Prototypographo fideli Re-gio, dilecto, gratiam Regiam & bonam voluntatem. Cùm ex præ-clarorum virorum literis certiores facti simus, opus Bibliorum quinque linguarum, cum tribus Apparatuum tomis, celeberrimum, reique publicæ Christianæ vtilissimũ, eiusdem serenissimæ Maiestatis iussu, ope atque auspiciis, ad publicam totius Chri-stiani orbis commoditatem & ornamentum, typis longè elegantissimis, & præstan-tissimi viri Benedicti Ariæ Montani præcipua cura & studio . quàm emendatissimè à te excusum esse, eiusdemq́; exemplar sanctissimo Domino nostro P.P. Gregorio XIII. oblatum, ita placuisse, vt præfatæ Maiestatis sanctos conatus, & Regi Catholico in primis conuenientes, summopere laudarit, & amplissima tibi priuilegia ad hoc opus tuendum Motu proprio concesserit, Nos quoque cum naturali genio impellimur ad fouendum præclara quæque ingenia, quæ insigni quopiam conatu ad publica com-moda promouenda atque augenda aspirant, primùm quidem longè præclarissimum hoc suæ Maiestatis studium, vt verè Heroicum & Ptolomęi, Eumenis, aliorumq́ue olim conatibus in Bibliothecis instruendis eò præstantius, quòd non vanæ stimulo gloriæ, vt illi, sed rectæ Religionis conseruandæ & propagandæ zelo susceptum, meri-tò suspicientes, deinde eximiam operam doctissimi B. Ariæ Montani, ac immortali laude dignam admirantes, rebusque tuis, quemadmodũ tuo nomine expetitur, pro-spicere cupientes, ne meritis frauderis fructibus tantæ operæ, & impensæ, quæ summa solicitudine & industria in opus ad finem feliciter perducendum à te etiam insumpta esse accepimus, cumq́ue certò constet, opus hoc nunquam hactenus hoc in Regno ex-cusum esse, dignumq́ue ipso S. sedis Apostolicæ suffragio sit iudicatum vt diuulgetur ac priuilegiis ornetur. Tuis igitur iustissimis votis, vt deliberato consilio, ita alacri & exporrecta fronte lubenter annuentes, tenore præsentium ex gratia speciali, præfatæ Maiestatis nomine, cum deliberatione & assistentia Regij collateralis consilij, statui-mus & decreuimus, ne quis intra viginti annos proximos, a die dat. præsentium dein-ceps numerandos, in hoc Regno dictum Bibliorum opus, cum Apparatuum tomis coniunctis, vel Apparatus ipsos, aut eorũ partem aliquam seorsum, citra ipsius Chri-stophori, aut causam & ius ab ipso habentis, licentiam imprimere, aut ab aliis impres-sa vendere, aut in suis officinis vel aliàs tenere possit. Volentes & decernentes expressè, quòd

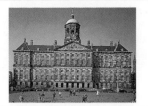

Jacob van Campen
Royal Palace
(formerly Amsterdam Town Hall)
Dam Square
1647–1655

ABCDEFGHIJKLM
NOPQRSTUVWXYZ
1234567890

ABCDEFGHIJKLMN
OPQRSTUVWXYZ

abcdefghijklmn
opqrstuvwxyz
1234567890

ABCDEFGHIJKLM
NOPQRSTUVWXYZ
1234567890

abcdefghijklmn
opqrstuvwxyz
1234567890

Although Janson was named for Dutch punch-cutter Anton Janson, we now know that it was cut by Hungarian Nicholas Kis in 1690. This version from Linotype is based on Stempel Foundry castings made in 1919 from Kis's original matrices.

English type from the eighteenth century

In the eighteenth century, a formal distinction in English spelling was accepted between 'i' and 'j', 'u' and 'v'. At the same time, 'w', as opposed to 'vv', became a distinct character.

1734
William Caslon
Type specimen sheet
London

A SPECIMEN

By W. CASLON, Letter-Founder, in Ironmonger-Row, Old-Street, LONDON.

ABCD
ABCDE
ABCDEFG
ABCDEFGHI
ABCDEFGHIJK
ABCDEFGHIJKL
ABCDEFGHIKLMN

French Cannon.

Quouſque tan-
dem abutere,
Catilina, pati-
Quouſque tandem

DOUBLE PICA ROMAN.
Quouſque tandem abutere, Catilina, patientia noſtra ? quamdiu nos etiam furor iſte tuus eludet? quem ad finem ſeſe effrenata jac-
ABCDEFGHJIKLMNOP

GREAT PRIMER ROMAN.
Quouſque tandem abutere, Catilina, patientia noſtra ? quamdiu nos etiam furor iſte tuus ӕludet? quem ad finem ſe-ſe effrenata jaȼtabit audacia ? nihilne te noȼturnum præſidium palatii, nihil ur-bis vigiliæ, nihil timor populi, nihil con-
ABCDEFGHIJKLMNOPQRS

ENGLISH ROMAN.
Quouſque tandem abutere, Catilina, patientia noſtra? quamdiu nos etiam furor iſte tuus eludet? quem ad finem ſeſe effrenata jaȼtabit audacia ? nihilne te noȼturnum præſidium palatii, nihil urbis vigiliæ, nihil timor populi, nihil conſenfus bonorum omnium, nihil hic munitiſſimus
ABCDEFGHIJKLMNOPQRSTVUW

PICA ROMAN.
Melium, novis rebus ſtudentem, manu ſua occidit. Fuit, fuit iſta quondam in hac repub. virtus, ut viri fortes acrioribus ſuppliciis civem perniciofum, quam acerbiſſimum hoſtem coërcerent. Habemus enim ſe-natuſconſultum in te, Catilina, vehemens, & grave: non deeſt reip. conſilium, neque autoritas hujus or-dinis : nos, nos, dico aperte, conſules defumus. De-
ABCDEFGHIJKLMNOPQRSTVUWX

Double Pica Italick.
Quouſque tandem abutere, Catili-na, patientia noſtra ? quamdiu nos etiam furor iſte tuus eludet ? quem ad finem ſeſe effrenata jac-
ABCDEFGHJIKLMNO

Great Primer Italick.
Quouſque tandem abutére, Catili-na, patientia noſtra ? quamdiu nos etiam furor iſte tuus eludet ? quem ad finem ſeſe effrenata jaȼtabit audacia ? nihilne te noȼturnum præſidium palatii, nihil ur-bis vigiliæ, nihil timor populi, nibil con-
ABCDEFGHIJKLMNOPQR

Engliſh Italick.
Quouſque tandem abutere, Catilina, patientia noſ-traꝰ quamdiu nos etiam furor iſte tuus eludet? quem ad finem ſeſe effrenata jaȼtabit audacia ? nihilne te noȼturnum præſidium palatii, nihil ur-bis vigiliæ, nihil timor populi, nihil conſenſus bo-norum omnium, nihil hic munitiſſimus habendi ſe-
ABCDEFGHIJKLMNOPQRSTVU

Pica Italick.
Melium, novis rebus ſtudentem, manu ſua· occidit. Fuit, fuit iſta quondam in hac repub. virtus, ut viri fortes acrioribus ſuppliciis civem perniciofum, quam a-cerbiſſimum hoſtem coërcerent. Habemus enim ſenatuſ-conſultum in te, Catilina, vehemens, & grave : non deeſt reip. conſilium, neque autoritas hujus ordinis : nos, nos, dico aperte, conſules defumus. Decrevit quondam ſenatus
ABCDEFGHIJKLMNOPQRSTVUWXYZ

Pica Black.
And be it further enaȼted by the Authority aforeſaid, That all and every of the ſaid Ex-chequer Bills to be made ſorth by virtue of this Act, oꝛ ſo many of them as ſhall from
ABCDEFGHIJKLMNOPQRST

Brevier Black.
And be it further enaȼted bye the Authoꝛity aforeſaid, That all and every of the ſaid Exchequer Bills to be made ſoꝛth by virtue of this Act, oꝛ ſo many of them as ſhall from time to time remain unbiſchargeſd and uncan-cell'd, until the ſubſigning and cancelling the fame purſuant to this Act,

Pica Gothick.
ATTA ꝰNSAK ꝰN ꝰN hiMiNAM VEihiNAi NAMꝶ VEiN uiMAi ViNAiNASSiS VEiNS VAiKVAi ViAꝶA VEiNS SVE ꝰN hiMiNA

Pica Coptick.
ϧⲉⲛ ⲟⲩⲁⲣⲭⲏ ⲁϥⲧ̄ ⲟⲗⲗⲟ ⲁ̄ⲧϥⲉ ⲛⲉⲙ ⲡⲕⲁ-ϩⲓ· ⲡⲕⲁϩⲓ ⲇⲉ ⲛⲉ ⲟⲩⲁⲑⲏⲩⲧ ⲉⲣⲟϥ ⲛⲉ ⲟⲩⲟϩ, ⲛⲁⲧⲥⲟⲃⲧ̄ ⲟⲩⲭⲁⲕⲓ ⲛⲁϥⲭⲏ ⲉⲭⲉⲛ ϥⲛⲟⲩⲛ ⲟⲩⲟϩ, ⲟⲩⲡⲛ̄ⲁ̄ ⲛ̄ⲧⲉϥⲧ ⲛⲁϥⲙⲟⲩ ⲫ̄ⲓⲝⲉⲛ ⲛⲓⲙⲱⲟⲩ ⸱- ⲟ-

Pica Armenian.
Ուրաչ Ֆրագսորէ եղբէ և ճայնա, որոյ աճէէ և ալասախէր որայ և ե ճայ ժոֆ Ստամխոֆ ել լաֆալ և աւաաքնե ֆ ֆեր գաֆ լատ Ֆրագ...որ. և ճիացդ րափն կեֆ, աբ։ող եֆֆ

English Syriack.
ܘܨܠܝ ܡܢ ܐܣܬ ܐܠܟܝ ܟܝܚܨܐ ܐܣܬ
ܐܚܬ ܡܢ ܣܡܥܠ ܠܐܠܠ ܠܐ ܘܠ ܨܥ ܟ ܨܚܢܣܟ
ܟܐ ܠ ܐܬܨ ܐܠ ܐܠܠ ܥ ܚ ܚ ܨ ܟ ܨܚܢܥ

Pica Samaritan.
ꟽꟼꓔꟙꓶꟿ ꓷꓔꟙꟺ ꟿꓔꟿꟺ ꟹꟘꓔ ꟿ ꓷꟹꟿꟺꟿꟹꟺ ꟽ ꟹꟽꟿ
ꟺꟼꟿ ꟿꟹꟺꟺ ꟼꟺꟙ ꟽ ꓶꟾꟺꟺꟙꟿꟹ ꟽ ꟿ ꓶꟾꟙ ꟼꟾꟿꟿ
ꟺꟺ ꟼꟼ ꟼꟺꟙꟿꟿꟺ ꟿꟺ ꟺꟿꟿ

English Arabick.

William Caslon (1692–1766) was the first notable English type designer. He introduced his sturdy, albeit idio-syncratic, typeface in 1734. It gained widespread acceptance almost immediately and, except between 1800 and 1850, has been a standard ever since. The influence of Dutch models is clear if you compare Janson (left) with Caslon (right):

Caslon's type was distributed throughout England's American colonies, and was the typeface used in the first printed copies of the U.S. Declaration of Independence and Constitution. Through Caslon's sons, the foundry was to continue well into the second half of the nine-teenth century.

a a

Thomas Chippendale
Chair back (detail)
from *The Gentleman and Cabinet-Maker's Director*
London
1754

31

ABCDEFGHIJKLM
NOPQRSTUVWXYZ
1234567890

ABCDEFGHIJKLMN

OPQRSTUVWXYZ

abcdefghijklmn

opqrstuvwxyz

1234567890

ABCDEFGHIJKLMN
OPQRSTUVWXYZ
1234567890

abcdefghijklmn

opqrstuvwxyz

1234567890

Adobe Caslon, introduced in
1990, was designed by Carol
Twombly from Caslon specimen
sheets of 1738 and 1786.

1761
William Congreve
The Works of William Congreve
Typeset and printed by John Baskerville
Birmingham

At the turn of the eighteenth century, Philippe Grandjean was almost a decade into production of a *romain du roi* for Louis XIV's royal press—a project that would carry on 30 years past his death in 1714. Characterized by thin, unbracketed serifs, extreme contrast between thick and thin strokes, and a perpendicular stress, the typeface marked a clear departure from the types of Griffo and Garamond and met with immediate acclaim. However, as the personal property of the King, it could not be used by commercial printers.

Enterprising type founders in France began copying Grandjean's work almost immediately, but the most successful application of his ideas came from John Baskerville (1706–1775), a self-taught type founder, papermaker, and printer in Birmingham. Baskerville's type featured pronounced contrast between thick and thin strokes and a clear vertical stress. Compare Bembo (left) and Baskerville (right):

To maintain the delicacy of his type on the page, Baskerville had to develop several ancillary technologies. To prevent his shiny ink from spreading beyond the actual imprint of the page, he crafted his own very smooth paper (now called a 'wove' finish; earlier, ribbed sheets are called 'laid'). He also pressed his sheets between heated copper plates after printing to hasten drying.

The LIFE *of* CONGREVE. xix

natural, that, if we were not apprifed of it, we fhould never have fufpected they were Tranflations. But there is one Piece of his which ought to be particularly diftin-guifhed, as being fo truly an Original, that though it feems to be written with the ut-moft Facility, yet we may defpair of ever feeing it copied: This is his *Doris,* fo high-ly and fo juftly commended by Sir *Richard Steele,* as the fharpeft and moft delicate Sa-tire he had ever met with.

His two Pieces of the Dramatic Kind, do him equal Honor as a Poet and as a Lover of Mufic, *viz. The Judgment of Paris,* a Mafque, and *The Opera of Semele.* Of thefe, the for-mer was acted with great Applaufe, and the latter finely fet to Mufic by Mr. *Eccles.* In Refpect to both, it is but Juftice to fay, that they have the fame Stamp of Excel-lency with the Reft of his Writings, were confidered as Mafter-pieces when publifh-ed, and may ferve as Models to Pofterity.

His *Effay upon Humor in* Englifh *Comedy,* is, without Doubt, as inftructive, as enter-taining,

George Hepplewhite
Window stool
from *The Cabinet-Maker and Upholsterer's Guide*
London
1790

ABCDEFGHIJKLMN
OPQRSTUVWXYZ
1234567890

ABCDEFGHIJKLMN
OPQRSTUVWXYZ
abcdefghijklmn
opqrstuvwxyz
1234567890

ABCDEFGHIJKLMN
OPQRSTUVWXYZ
1234567890

abcdefghijklmn
opqrstuvwxyz
1234567890

Monotype Baskerville was
produced in 1929 under
Stanley Morison's direction.

34

1818
Giambattista Bodoni
Manuale Tipografico
Parma (published posthumously)

Baskerville's innovations exerted a notable influence on European type founders, particularly the Didot and Fournier families in France and Giambattista Bodoni (1740–1813) in Italy.

Serving as the subsidized private printer to the Duke of Parma, Bodoni produced over 100 typefaces. His early typefaces retain some elements we associate with Baskerville, primarily in the gentle slope of the upper serifs of the 'i', 'j', and 'l'. Firmin Didot, by contrast, produced type with unbracketed, purely horizontal serifs. Compare Bauer Bodoni (left) and Linotype Didot (right):

i i

Bodoni carried forward the technological advances begun by Baskerville, improving both ink and paper surface to show off his delicate type to best advantage.

I

GIAMBATTISTA BODONI

A CHI LEGGE.

Eccovi i saggi dell'industria e delle fatiche mie di molti anni consecrati con veramente geniale impegno ad un'arte, che è compimento della più bella, ingegnosa, e giovevole invenzione degli uomini, voglio dire dello scrivere, di cui è la stampa la miglior maniera, ogni qual volta sia pregio dell'opera far a molti copia delle stesse parole, e maggiormente quando importi aver certezza che

Alexandre-Pierre Vignon
Church of Mary Magdalene
('La Madeleine')
Paris
1807–1842

ABCDEFGHIJKLMN
OPQRSTUVWXYZ
1234567890

ABCDEFGHIJKLMN
OPQRSTUVWXYZ

abcdefghijklmn
opqrstuvwxyz
1234567890

ABCDEFGHIJKLMN
OPQRSTUVWXYZ
1234567890
abcdefghijklmn
opqrstuvwxyz
1234567890

Bauer Bodoni, produced by Louis Höll of the Bauer type foundry in 1926, is based on Bodoni's cuts of 1789. It shows clearly the differences between what Bodoni actually produced and what people often think of as 'Bodoni.'

W CASLON JUNR

Boldface

The Industrial Revolution of the early nineteenth century, triggered by the invention of the steam engine, changed printing, typesetting, and type-casting from the product of the human hand to the product of power-driven machinery. The sheer speed of mechanized presses meant that thousands of copies could be printed in the time it formerly took to print dozens. The sudden, wide dissemination of printed matter contributed to the rise of literacy as dramatically as the invention of printing itself had three and a half centuries earlier. It also created a new market of consumers for manufacturers. Products (and services, for that matter) could be advertised to broad masses at relatively low cost. Printers began to distinguish between book printing and jobbing, or commercial printing. This new printing required a new esthetic.

Typefaces from the previous centuries, designed for text settings, seemed inadequate for the new medium of advertising. Bigger, bolder, louder type was required to make messages stand out in the otherwise gray printed environment. One of the first type founders to experiment with a 'fat face' was Robert Thorne, who in 1803 cast the face that bears his name (above, left). Hundreds of boldfaces followed.

For several decades, boldfaces existed in a class distinct from text type. However, by the time typefaces from the sixteenth, seventeenth, and eighteenth centuries were revived in the early twentieth, type founders (notably Morris Benton of American Type Founders) were so accustomed to working with boldface that they chose to retrofit bold forms into each typeface 'family,' along with existing italics, small caps, etc.

Sans serif

One variation of the boldface idea involved losing serifs altogether. First introduced by William Caslon IV in 1816 (above, right), sans serif type, featuring no change in stroke weight, was reserved almost exclusively for headlines, although there are occasional examples of sans serif captions.

Caslon named his type 'Egyptian,' probably because the art and architecture of ancient Egypt had colored European imagination since Napoleon's campaign and the discovery of the Rosetta stone in 1799. But the label didn't stick. Opponents of the form quickly called it 'grotesque'; others termed it 'gothic' (a style that was also enjoying a revival in the early nineteenth century). English type founder Vincent Figgins was the first to call it 'sans syrruph,' in 1832.

Charles Barry and A.W.N. Pugin
Houses of Parliament
London
1840–1860

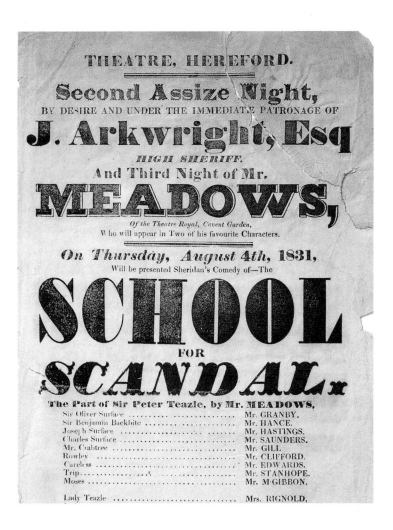

1831
Poster

Display faces

Since medieval copyists had illumi-nated initial letters in manuscripts, typographers had often produced oversized, intricately detailed letter-forms to provide color and contrast on the text page. In the nineteenth century, at the same time as the development of boldface and for much the same reason, type founders began casting entire typefaces—upper and lower case—decorated (illuminated) to suggest various architectural and natural motifs. Typically, these typefaces were intended for use as headlines or display material; hence, the term 'display face.' In most cases the vogue for any particular display face lasted only as long as the trend in fashion it mimicked.

The subsequent evolution of type technology (first photo typesetting, then digital rendering), combined with the desire of some designers to introduce novelty for its own sake, has given rise to the use of these display faces (and their twentieth-century offspring) in all kinds of settings, from 100 pt. display material in advertising to 7 pt. phone numbers on business cards. As it happens, we all know our alphabet well enough that we can usually read the letters and numbers in display faces despite the tortuous machinations they have endured.

38

1817
Vincent Figgins
Specimens of Printing Types
London

TWO LINES GREAT PRIMER, IN SHADE.

ABCDEFGHIJKLMNO
PQRSTUVWXYZ&,.:.'

TWO LINES BREVIER, IN SHADE.

ABCDEFGHIJKLMNOPQRSTUVWXYZ&,.:'.

TWO LINES NONPAREIL, IN SHADE.

ABCDEFGHIJKLMNOPQRSTUVWXYZÆŒ&,.:-'

FOUR LINES PICA, ANTIQUE.

MANKIND

TWO LINES SMALL PICA, ANTIQUE.

ABCDEFGHIJKLMNOPQRSTUVW

V. FIGGINS.

A fourth nineteenth-century development in typography—the square serif—first appeared in England in 1817. Just as William Caslon IV was eliminating serifs altogether, other type founders were fattening them up to have the same weight as the strokes of the letterform itself. First called 'Antique' by Vincent Figgins (above), the type eventually became known as 'Egyptian,' perhaps because its strong serifs mirrored the base and capital of an Egyptian column.

Although some nineteenth-century square serifs (such as Clarendon) drew upon traditional letterforms (and, like Clarendon, had bracketed serifs), many twentieth-century typefaces referred to geometric models.

The mechanization of printing, and the allied rise of advertising, contributed to a general degradation of both the printer's and the typographer's craft. By the end of the nineteenth century, movements in both the U.S. and the U.K. were afoot to revive the handicraft and the care of previous centuries' printing, led by William Morris's Kelmscott Press in 1891.

ABCDEFGHIJKLM
NOPQRSTUVWXYZ
1234567890

abcdefghijklmn
opqrstuvwxyz

ABCDEFGHIJKLMN
OPQRSTUVWXYZ
1234567890

abcdefghijklmn
opqrstuvwxyz

Adrian Frutiger designed Serifa
for the Bauer foundry in 1967.
Compare Frutiger's forms with
earlier, more geometric slab
serifs like Memphis (below),
designed by Rudolf Wolf in 1929
for the Stempel foundry.

ABCDEFGHIJ
KLMNOPQRST
UVWXYZ
1234567890
abcdefghijkl
mnopqrstuvw
xyz

1923
(top)
Prospectus for the Bauhaus
László Moholy-Nagy

1959
(bottom)
New Graphic Design
Josef Müller-Brockmann, Richard
Lohse, Hans Neuberg, and Carlo
Vivarelli, eds.

The movement to revive older type models flourished in the early twentieth century, led by T. J. Cobden-Sanderson, Stanley Morison, and Beatrice Warde in the U.K. and Daniel Berkeley Updike, Frederick W. Goudy, W. A. Dwiggins, and Bruce Rogers in the U.S. Their scholarly work showed typography, for the first time, to be a subject worthy of study, even as they demonstrated the value of earlier forms.

At the same time, the astonishing and often bewildering technological developments of the new century, combined with widespread social upheaval in Europe and America, caused many to seek new forms of graphic expression. Sans serif type—until then reserved for headlines and captions—was seen by many as most appropriate for asymmetric page composition that broke with traditional models. It is worth noting that the idea of graphic design as a profession distinct from printing, type-casting, or 'fine' art, began at the same time.

ABCDEFGHIJKLMN OPQRSTUVWXYZ 1234567890

abcdefghijklmn opqrstuvwxyz 1234567890

ABCDEFGHIJKLM NOPQRSTUVWXYZ 1234567890 abcdefghijklmn opqrstuvwxyz

The first widely used sans serif typeface, Akzidenz Grotesk was developed by the Berthold type foundry in 1896. ('Akzidenz' is the German term for the 'schrift' or type used by commercial—as opposed to book—printers, and 'Grotesk' is the nineteenth-century German word for sans serif. In the United States, the typeface was known simply as 'Standard.') The light weight includes a set of lowercase numerals (shown in red) designed by Erik Spiekermann in 1990.

42

ABCDEFGHIJKLMN
OPQRSTUVWXYZ
1234567890

abcdefghijklmn
opqrstuvwxyz

ABCDEFGHIJKLMN
OPQRSTUVWXYZ
1234567890

abcdefghijklmn
opqrstuvwxyz

Designed by Eric Gill in 1928, Gill Sans is based on the typeface his teacher Edward Johnston created in 1916 for the signage of the London Underground. Gill also designed several serif typefaces (Perpetua, Joanna, Arial), which share many of the proportions and characteristic counters of Gill Sans. Although strictly contemporary in effect, Gill's type, like Johnston's before him, owes much to the proportions and forms of the Renaissance letter.

Pierre
Jenneret
(Le Corbusier)
Villa Savoie
Poissy, France
1928–1929

43

ABCDEFGHIJKLMN OPQRSTUVWXYZ 1234567890

abcdefghijklmn opqrstuvwxyz

ɑλɑɑℯℊℊⲙⲛⲅ 1234567890

ABCDEFGHIJKLMN
OPQRSTUVWXYZ
1234567890
abcdefghijklmn
opqrstuvwxyz

Designed by Paul Renner in 1927, Futura is the first geometric sans serif typeface designed for text applications. Although Futura seems to use basic geometric proportions, it is in fact a complex combination of stressed strokes and complex curves, with stronger connections to preceding serif forms than its spare effect would at first suggest.

Renner designed a number of lowercase forms and numerals for Futura (shown in red), which the Bauer foundry abandoned but which were revived by The Foundry (London) as Architype Renner in 1994.

	Univers 53	Univers 63	Univers 73	Univers 83
	Univers 54	*Univers 64*	*Univers 74*	*Univers 84*
Univers 45	Univers 55	**Univers 65**	**Univers 75**	**Univers 85**
Univers 46	*Univers 56*	*Univers 66*	*Univers 76*	***Univers 86***
Univers 47	Univers 57	**Univers 67**		
Univers 48	*Univers 58*	***Univers 68***		
Univers 39	Univers 49	**Univers 59**		

By mid-century, photo typesetting had replaced metal type for most commercial work, further freeing both typesetting and layouts from the technical restrictions of older traditions. Photo typesetting had its own drawbacks, however, which were finally resolved with the introduction of desktop publishing in the 1980s.

Although Adrian Frutiger is well respected for a number of widely used typefaces, his masterwork is Univers, released in 1957 by the Deberny & Peignot foundry in Paris for both metal and photo type. In an effort to eliminate the growing confusion in typeface terminology (thin/light, regular/medium, bold/black), Frutiger used numbers rather than names to describe the palette of weights and widths in Univers. (Opposite: Univers 55.)

In any 2-digit descriptor, the first number designates line weight (3- is the thinnest, 8- the heaviest) and the second designates character width (-3 is the most extended, -9 the most condensed). Even numbers indicate italic, odd numbers roman. Frutiger has subsequently used this system on other typefaces he has designed (Serifa, Glypha, Frutiger, Avenir, etc.), and other type manufacturers have adapted his system for some of their typefaces (Helvetica Neue, etc.).

The 'Caravelle'
French jet transport plane
1956

ABCDEFGHIJKLMN
OPQRSTUVWXYZ
1234567890

abcdefghijklmn
opqrstuvwxyz

ABCDEFGHIJKLMN
OPQRSTUVWXYZ
1234567890

abcdefghijklmn
opqrstuvwxyz

An expanded type 'family'

46 In the last 15 years, some typographers, notably Otl Aicher, Martin Majoor, and Sumner Stone, have developed families of typefaces that not only include a range of color (light/regular/bold/black), but also incorporate serif and sans serif fonts. Shown here are samples from Aicher's Rotis family, drawn in 1989.

Rotis
Serif

Regular

Rotis
SemiSerif

Regular

Rotis
SemiSans

Regular

Rotis
Sans Serif

Regular

		Rotis Serif Regular	Rotis Serif Italic	Rotis Serif Bold	
		Rotis SemiSerif Regular		Rotis SemiSerif Bold	
Rotis SemiSans Light	Rotis SemiSans Light Italic	Rotis SemiSans Regular	Rotis SemiSans Italic	Rotis SemiSans Bold	Rotis SemiSans Extra Bold
Rotis Sans Serif Light	Rotis Sans Serif Light Italic	Rotis Sans Serif Regular	Rotis Sans Serif Italic	Rotis Sans Serif Bold	Rotis Sans Serif Extra Bold

Text type classification
Dates of origin approximated to
the nearest quarter century.

As you have seen, type forms have developed in response to prevailing technology, commercial needs, and esthetic trends. Certain models have endured well past the cultures that spawned them. Recognizing the need to identify the stages of type form development, typographers have come up with a number of systems to classify typefaces, some of them dizzying in their specificity.

The classification here, based on one devised by Alexander Lawson, covers only the main forms of text type. Decorative styles have been omitted, and sans serif forms have been grouped together without differentiation between humanist and geometric forms.

This system offers a useful, if simplified, description of the kinds of type you will most often encounter when working with text. As your experience with type develops, you should definitely familiarize yourself with other, more specific, systems. Keep in mind that the best system is the one that most helps you recognize kinds of typefaces and their historical origins.

1450 Blackletter

The earliest printing type, its forms were based upon the hand-copying styles then used for books in northern Europe.

Examples:
Cloister Black
Goudy Text

1475 Oldstyle

Based upon the lowercase forms used by Italian humanist scholars for book copying (themselves based upon the ninth-century Caroline miniscule) and the uppercase letterforms found inscribed on Roman ruins, the forms evolved away from their calligraphic origins over 200 years, as they migrated across Europe, from Italy to England.

Examples:
Bembo
Caslon
Dante
Garamond
Janson
Jenson
Palatino

1500 Italic

Echoing contemporary Italian handwriting, the first italics were condensed and close-set, allowing more words per page. Although originally considered their own class of type, italics were soon cast to complement roman forms. Since the sixteenth century, virtually all text typefaces have been designed with accompanying italic forms.

1550 Script

Originally an attempt to replicate engraved calligraphic forms, this class of type is not entirely appropriate in lengthy text settings. In shorter applications, however, it has always enjoyed wide acceptance. Forms now range from the formal and traditional to the casual and contemporary.

Examples:
Kuenstler Script
Mistral
Snell Roundhand

1750 Transitional

A refinement of Oldstyle forms, this style was achieved in part because of advances in casting and printing. Thick-to-thin relationships were exaggerated, and brackets were lightened.

Examples:
Baskerville
Bulmer
Century
Times Roman

1775 Modern

This style represents a further rationalization of Oldstyle letterforms. Serifs were unbracketed, and the contrast between thick and thin strokes was extreme. English versions (like Bell) are also known as Scotch Romans and more closely resemble transitional forms.

Examples:
Bell
Bodoni
Caledonia
Didot
Walbaum

1825 Square serif

Originally heavily bracketed serifs, with little variation between thick and thin strokes, these faces responded to the newly developed needs of advertising for heavy type in commercial printing. As they evolved, the brackets were dropped. This class is also known as slab serif.

Examples:
Clarendon
Memphis
Rockwell
Serifa

See **Appendix B** for displays of
some of the typefaces mentioned in
this chart.

1900

Sans serif

As their name implies, these type-
faces eliminated serifs altogether.
Although the form was first intro-
duced by William Caslon IV in 1816, its
use did not become widespread until
the beginning of the twentieth
century. Variations tended toward
either humanist forms (Gill Sans) or
the rigidly geometric (Futura).
Occasionally, strokes were flared to
suggest the calligraphic origins of
the form (Optima). Sans serif is also
referred to as grotesque (from the
German 'grotesk') and gothic.

Examples:
Akzidenz Grotesk
Grotesque
Gill Sans
Franklin Gothic
Frutiger
Futura
Helvetica
Meta
News Gothic
Optima
Syntax
Trade Gothic
Univers

1990

Serif/sans serif

A recent development, this style
enlarges the notion of a family of
typefaces to include both serif and
sans serif alphabets (and, often,
stages between the two).

Examples:
Rotis
Scala
Stone

Letters

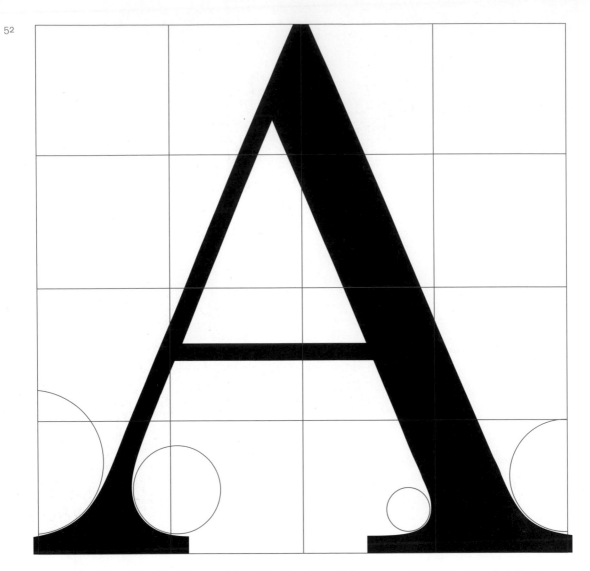

Here are two forms of a relatively simple letter—the uppercase 'a'. Both suggest the symmetry of the form as someone might print it, but neither is in fact symmetrical at all. It's easy to see the two different stroke weights of the Baskerville form (above); more noteworthy is the fact that each of the brackets connecting serif to stem expresses a unique arc.

The Univers form (opposite) may appear symmetrical, but a close examination shows that the width of the left slope is thinner than that of the right stroke. Both demonstrate the meticulous care a type designer takes to create letterforms that are both internally harmonious and individually expressive.

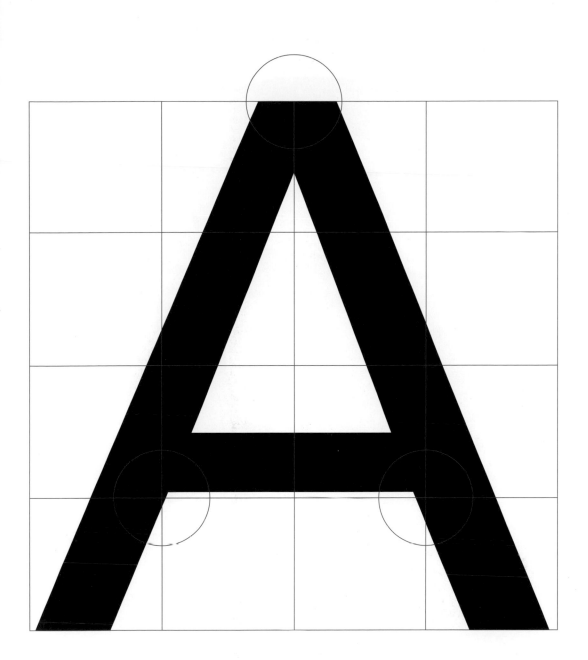

■ Pick your own initials from any
of the typefaces on pages 47–49
and redraw them at least 12"
(300 mm) high.

Draw them as often as it
takes for you to *feel* the
typeface, its nuances, and
unique characteristics.

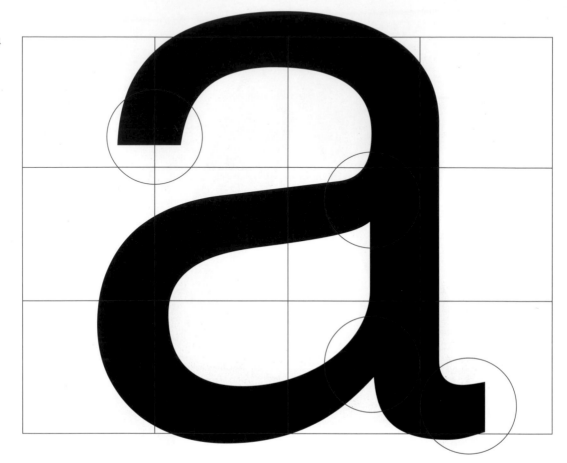

The complexity of each individual
letterform is neatly demonstrated by
examining the lowercase 'a' of two
seemingly similar sans serif type-
faces—Helvetica and Univers. A
comparison of how the stems of the
letterforms finish and how the bowls
meet the stems quickly reveals the
palpable difference in character
between the two.

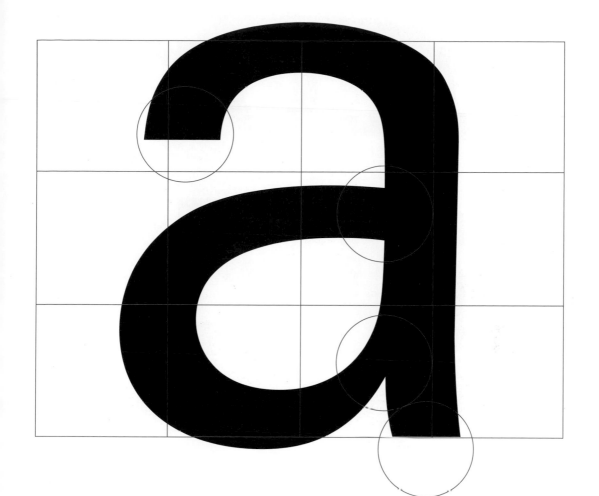

Overlay a lowercase letter from
two typefaces and compare the
similarities and differences. Use
tracing paper. Two methods of
comparison are shown at right.

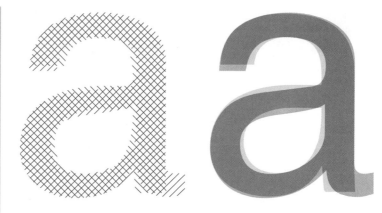

56

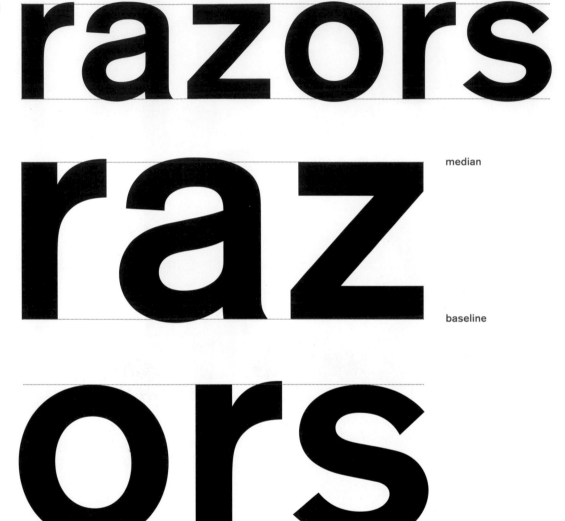

median

baseline

As you already know, the x-height generally describes the size of lowercase letterforms. However, you should keep in mind that curved strokes, such as in 's', must rise above the median (or sink below the baseline) in order to appear to be the same size as the vertical and horizontal strokes they adjoin.

Compare the 'a' in the large examples above with the 'o' and 's'. The latter two characters clearly seem too small, and bounce around within the perceived x-height of the typeface, because they do not extend beyond the median or baseline.

Just as important as recognizing specific letterforms is developing a sensitivity to the counterform (or counter)—the space described, and often contained, by the strokes of the form. When letters are joined to form words, the counterform includes the spaces between them. The latter is a particularly important concept when working with letter-forms like the lowercase 'r' that have no counters per se. How well you handle the counters when you set type determines how well words hang together—in other words, how easily we can read what's been set.

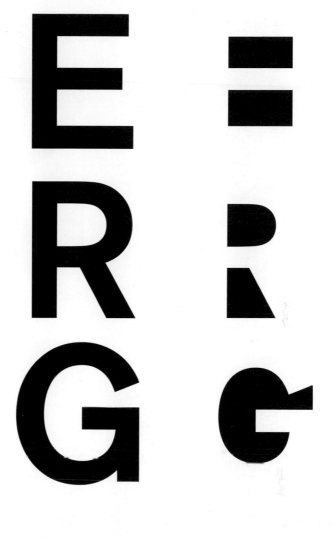

Helvetica Black

One of the most rewarding ways to understand the form and counter of a letter is to examine them in close detail. Beyond giving you an appreciation of the meticulous care that goes into each compound curve, these examinations also provide a

good feel for how the balance between form and counter is achieved and a palpable sense of a letterform's unique characteristics. It also gives you a glimpse into the process of letter-making.

It's worth noting here that the sense of the 'S' holds at each stage of enlargement, while the 'g' tends to lose its identity, as individual elements are examined without the context of the entire letterform.

g

Baskerville

On four 6" (152 mm) squares, present sections of a letterform that highlight its unique characteristics, keeping in mind the contrast between form and counterform. Note the point at which the letterform is no longer recognizable. This project is most beneficial when hand-rendered. However, you can use a good copying machine with enlargement capabilities as long as you clean up your edges with each enlargement.

Remember, one of the discoveries of this exercise is to find that moment when the letterform no longer reads.

60

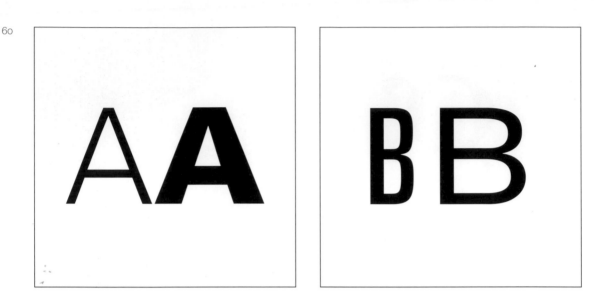

Light/bold Condensed/extended

Organic/machined Roman/italic

The basic principles of graphic
design apply directly to typography.
Above are some examples of
contrast—the most powerful dynamic
in design—as applied to type, based
on a format devised by Rudi Ruegg.

Combining these simple contrasts
produces numerous variations:
small+organic/large+machined;
few+bold/many+light; etc. Adding
color increases the possibilities even
more (e.g. black/red).

Small/large

Positive/negative

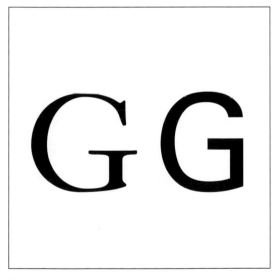

Serif/sans serif

Ornate/simple

■ On 6" (152 mm) squares, create six panels showing contrast in type. Combine as many features as you wish (e.g. small+dark/large+light). Restrict your solutions to black-and-white.

Words and phrases

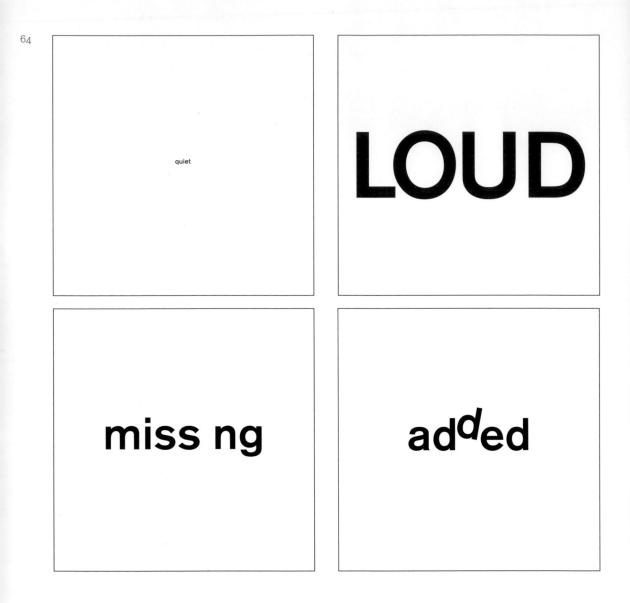

It's possible to find typographic equivalents for words. Simple choices in typeface, size, weight, and position on the page can strengthen representation of the concepts, objects, and actions that words describe. Here, we've stuck to one weight of one typeface, Akzidenz Grotesk Medium, but played with size and placement.

The examples above express some quality of the adjectives on display. 'Quiet' is small and lowercase, 'loud' large and uppercase. The second 'i' in 'missing' is, in fact, missing, and the second 'd' in 'added' is in the process of being added.

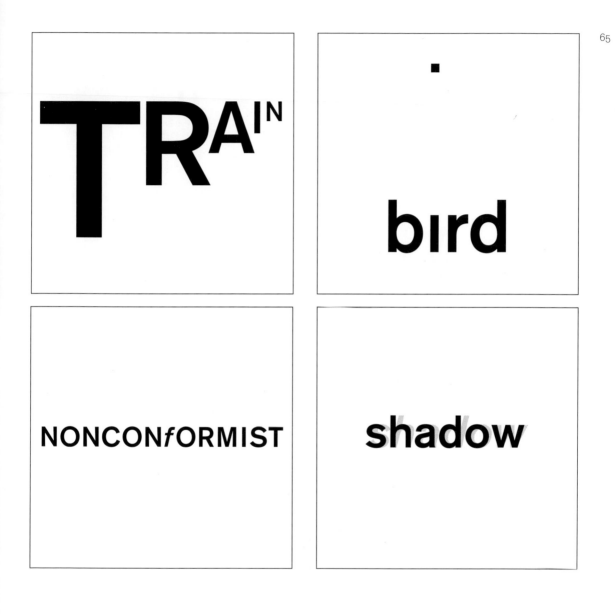

The examples above all carry some quality of the nouns expressed. In 'train,' for example, a Fibonacci sequence of type sizes (page 118), aligned at the cap height, creates the illusion of perspective—we can easily imagine a long train receding into the distance—or, for that matter, pulling into a station.

The dot on the 'i' in 'bird' flies above the rest of the letters; the 'f' in 'nonconformist' does not conform with the other letters; 'shadow' casts a shadow. The examples of contrast in type on pages 60–61 offer a number of possibilities for building on these simple changes.

The meaning of the verbs on this page is reinforced through place-ment within the frame. Direction is implied by how we read (left-to-right = forward; top-to-bottom = down, and so forth).

In the second row on this page, meaning is further enhanced by covering up some portion of the word (and, in the case of 'sink,' by tilting the type slightly downward). Imagine taking a bite out of 'cat.'

■ On 6" (152 mm) squares, create ten panels showing reinforcement of meaning. Keep in mind that your solutions should feel typographic; the letterforms should not be altered to the point where they become drawings or representations of the word.

Here, simple placement of the word 'dance' in the square suggests the activity in a place, possibly a stage. Breaking the letters apart suggests a dancer moving.

Repetition of the word (this page and opposite) suggests different kinds of rhythm and, in fact, different kinds of dancing.

dancedancedance
dancedancedance
dancedancedance
dancedancedance
dancedancedance
dancedancedance
dancedancedance
dancedancedance
dancedancedance

	dance
	dance
	dance
dance	dance
	dance
	dance
	dance
	dance
	dance

dancedancedance
ancedancedanced
ncedancedanceda
cedancedancedan
edancedancedanc
dancedancedance
ancedancedanced
ncedancedanceda
cedancedancedan

dance
 dance
 dancedance
 dance
 dance
dancedance
 dance
ncedancedanceda
 dance

It is better to fail in originality than to succeed in imitation.

It is better to fail
in originality

than to succeed

in imitation.

It is better to fail
in originality

than to
succeed in

imitation.

One way to make sentences (or sentence fragments) more expressive is to reinforce the sense of the words through type play. The three examples shown here (pages 70–72) attempt to make the speaker's voice visible to the reader by manipulating size and position of the words.

The example here starts by organizing the sentence under the word 'fail.' Scale is then introduced to reinforce the author's meaning.

You have to be an intellectual to believe such nonsense. No ordinary man could be such a fool.

You have to be an intellectual to believe such nonsense. No ordinary man could be such a fool.

The example on this page begins by enlarging key words, then lining them up on the page.

You have to be an intellectual to believe such nonsense. No ordinary man could be such

a
fool.

If you can't make it good,
make it **Big.**
If you can't make it big,
make it
red.

Here, simple contrasts of scale and color
are used to dramatic effect. (For other
examples of contrast see pages 60–61.)

A characteristic of type design is that the letterforms themselves have evolved as a response to handwriting—the marks we make as we scrawl across a page. One of the identifiable features of those marks is that we make them as part of a horizontal flow, from left to right. This is something we all take for granted, as natural a part of written language as the use of upper and lower case.

Not all languages are written this way. Hebrew and Arabic, for instance, read right to left, and books in those languages begin at what we would consider the back. Look how illegible English would be if we encountered it set from right to left:

eb dluow hsilgnE elbigelli woh kooL
thgir morf tes ti deretnuocne ew fi
:tfel ot

Letterforms in typefaces have any number of attributes intended to reinforce the left-to-right flow of the written language: ascenders, descenders, consistent x-height, counters in lowercase forms typically appearing to the right. All these contribute to the sense of a line of text. And from the moment when we first learn to read, our brain assimilates these characteristics as essential for readable type.

Now to the point: written Chinese is not based on an alphabet like English; rather it is written in a series of characters called pictographs—forms that express an entire word or idea without necessarily indicating how to pronounce it.

Until recently, Chinese characters were typically read top to bottom, right to left, like this:

趙大年每作佳山水卷
人輙謂是上陵田耶
宋時宗室有遠孫て
紫故也余此茴在上
陵田日日識之
甲子重九後三日
玄宰

The simple fact that all Chinese characters are drawn to the same width makes this reading very simple. You can see in the example above that the characters descending the page make natural and obvious columns.

Occasionally, you will come across English type that has been set like Chinese characters:

As you can see, English letterforms are not all drawn to the same width. In left-to-right reading, the difference in widths presents no problem to readability; in fact, it adds to variety and color on the page. In vertical reading all the type can do is create a shape. (Look at the profiles created by the difference between the wide W and the less-wide O, or between the N and the I.) When you consider that the primary purpose of type is to convey information with as little intrusion as possible, and that letterforms exist as a response to the lateral gestures of handwriting, then it should be clear that setting type vertically is inherently anti-typographic.

When the composition calls for vertical type, be mindful of the properties of the letterforms themselves, and set the type accordingly.

WORSENING

worsening

Improving

While you're at it, keep in mind how the baseline of the vertical type can, or cannot, relate to the vertical axes suggested by the rest of your type (in this instance, the left margin of the text).

Text

76 Originally, the term 'kern' described the portion of a letterform that extended beyond the body of the type slug. As the example opposite shows, this adaptation was required in letterforms with angled slopes, so that spacing between letters within a word would remain optically consistent. Today the term 'kerning' describes the automatic adjustment of space between letters as prescribed by a table embedded within the digital font.

Because kerning removes space between letters, it is often mistakenly referred to as 'letterspacing.' In fact, letterspacing means adding space between letters, not removing it. For our purposes, the term 'tracking,' used in most computer programs that incorporate typesetting, best describes the addition or removal of space between letters. Keep in mind that even the best tracking table sometimes requires minor adjustments, especially at larger point sizes.

Without kerning

With kerning

Without kerning

With kerning

Yellow rifts

Normal tracking

Yellow rifts

Loose tracking (letterspacing)

Yellow rifts

Tight tracking (kerning)

Univers 55

Normal tracking

Tight tracking

Loose tracking

 As in the example above (top left), place a four-letter lowercase word on a 6" (152 mm) square. Adjust the tracking for each letter until the space between the letters feels 'normal'—neither too tight nor too open.

Note that normal tracking for small type feels much too open as the type gets larger. A good way to demonstrate this phenom-enon is to start by letterspacing small type and then to enlarge your result.

This exercise is most effective if you use xeroxes of type that you can cut apart and move by hand. This action most closely approxi-mates working with metal type.

Designers often letterspace upper-case letters, but there has long been strong resistance within the type community to letterspacing lower-case letters within text. The reason for this resistance is quite clear if you look at the examples opposite. Uppercase forms are drawn to be able to stand on their own (consider their epigraphic origins). Lowercase forms require the counterform created between letters to maintain the line of reading (consider their origins in calligraphy).

Normal tracking

Miss Brooke had that kind of beauty which seems to be thrown into relief by poor dress. Her hand and wrist were so finely formed that she could wear sleeves not less bare of style than those in which the Blessed Virgin appeared to Italian painters; and her profile as well as her stature and bearing seemed to gain the more dignity from her plain garments, which by the side of provincial fashion gave her the impressiveness of a fine quotation from the Bible—or from one of

Loose tracking

Miss Brooke had that kind of beauty which seems to be thrown into relief by poor dress. Her hand and wrist were so finely formed that she could wear sleeves not less bare of style than those in which the Blessed Virgin appeared to Italian painters; and her profile as well as her stature and bearing seemed to gain the more dignity from her plain garments, which by the side of provincial fashion gave her the impressiveness of a fine

Tight tracking

Miss Brooke had that kind of beauty which seems to be thrown into relief by poor dress. Her hand and wrist were so finely formed that she could wear sleeves not less bare of style than those in which the Blessed Virgin appeared to Italian painters; and her profile as well as her stature and bearing seemed to gain the more dignity from her plain garments, which by the side of provincial fashion gave her the impressiveness of a fine quotation from the Bible—or from one of the elder poets—in a paragraph of today's newspaper.

Note that lowercase words, when displayed alone and not as text, allow for more play in tracking. Even in these cases, however, a moment occurs when readability is sacrificed for effect and meaning is lost.

IN MEMORIAM

In Memoriam

AFFLUENCE

affluence

EPISTEMOLOGY

epistemology

Flush left

This format most closely mirrors the asymmetrical experience of hand-writing. Each line starts at the same point but ends wherever the last word on the line ends. Spaces between words are consistent throughout the text, allowing the type to create an even gray value.

Flush left, ragged right (fl, rr)

If you know Starkfield, Massachusetts, you know the post-office. If you know the post-office you must have seen Ethan Frome drive up to it, drop the reins on his hollow-backed bay and drag himself across the brick pavement to the white colonnade; and you must have asked who he was.

Centered

This format imposes symmetry upon the text, assigning equal value and weight to both ends of any line. It transforms fields of text into shapes, thereby adding a pictorial quality to material that is non-pictorial by nature. Because centered type creates such a strong shape on the page, it's important to amend line breaks so that the text does not appear too jagged.

Centered (cent.)

If you know Starkfield, Massachusetts, you know the post-office. If you know the post-office you must have seen Ethan Frome drive up to it, drop the reins on his hollow-backed bay and drag himself across the brick pavement to the white colonnade; and you must have asked who he was.

Flush right

This format places emphasis on the end of a line as opposed to its start. It can be useful in situations (like captions) where the relationship between text and image might be ambiguous without a strong orientation to the right.

Flush right, ragged left (fr, rl)

If you know Starkfield, Massachusetts, you know the post-office. If you know the post-office you must have seen Ethan Frome drive up to it, drop the reins on his hollow-backed bay and drag himself across the brick pavement to the white colonnade; and you must have asked who he was.

Justified

Like centering, this format imposes a symmetrical shape on the text. It is achieved by expanding or reducing spaces between words and, some-times, between letters. The resulting openness of lines can occasionally produce 'rivers' of white space running vertically through the text. Careful attention to line breaks and hyphenation is required to amend this problem whenever possible.

Justified (just.)

If you know Starkfield, Massachusetts, you know the post-office. If you know the post-office you must have seen Ethan Frome drive up to it, drop the reins on his hollow-backed bay and drag himself across the brick pavement to the white colonnade; and you must have asked who he was.

All text, 10/13.5 Janson

Designers tend to set type one way or another depending upon several factors, not least of which are tradition and personal preference. Prevailing culture and the need to express play important, inevitable roles in any piece of communication. However, when setting a field of type, keep in mind the typographer's first job—clear, appropriate presentation of the author's message. Type that calls attention to itself before the reader can get to the actual words is simply interference, and should be avoided. Quite simply, if you see the type before you see the words, change the type.

*Anna Klein, Mitchell King
and their families
invite you to join them
in the celebration of
their wedding.*

*23 June 2001
Village Hall
Framingham Center
1.30 p.m.
Reception to follow.*

R.S.V.P.

Preconceptions about how something should look often interfere with effective, appropriate design of the message at hand. The formality of a wedding invitation, for example, is not necessarily tied to centered type—nor to script, for that matter.

Anna Klein, Mitchell King
and their families
invite you to join them
in the celebration of
their wedding.

23 June 2001
Village Hall
Framingham Center
1:30 P.M.
Reception to follow.

R.S.V.P.

82 Beyond learning about the unique characteristics of each typeface—and understanding its place in history—it's very important to understand how different typefaces feel as text. Different typefaces suit different messages. A good typographer has to know which typeface best suits the message at hand. On the next three pages, you can see how the ten typefaces we've just discussed compare with each other in identical text settings.

On pages 12-13 we discussed how typefaces 'felt' different from each other. Here you can see that the difference between typefaces is expressed not only in individual letterforms but also—and most importantly—in lines of type massed together to form blocks of text.

Consider, too, the different textures of these typefaces. Type with a relatively generous x-height or relatively heavy stroke width produces a darker mass on the page than type with a relatively smaller x-height or lighter stroke. Sensitivity to these differences in color is fundamental for creating successful layouts.

Call me Ishmael. Some years ago—never mind how long precisely—having little or no money in my purse, and nothing particular to interest me on shore, I thought I would sail about a little and see the watery part of the world. It is a way I have of driving off the spleen, and regulating the circulation. Whenever I find myself growing grim about the mouth; whenever it is a damp, drizzly November in my soul; whenever I find myself pausing before coffin warehouses, and bringing up the rear of every funeral I meet; and especially whenever my hypos get such an upper hand of me, that it requires a strong moral principle to prevent me from deliberately stepping

10/13.5 Bembo

Call me Ishmael. Some years ago—never mind how long precisely—having little or no money in my purse, and nothing particular to interest me on shore, I thought I would sail about a little and see the watery part of the world. It is a way I have of driving off the spleen, and regulating the circulation. Whenever I find myself growing grim about the mouth; whenever it is a damp, drizzly November in my soul; whenever I find myself pausing before coffin warehouses, and bringing up the rear of every funeral I meet; and especially whenever my hypos get such an upper hand of me, that it requires a strong moral principle to prevent me from

10/13.5 Adobe Caslon

Call me Ishmael. Some years ago—never mind how long precisely—having little or no money in my purse, and nothing particular to interest me on shore, I thought I would sail about a little and see the watery part of the world. It is a way I have of driving off the spleen, and regulating the circulation. Whenever I find myself growing grim about the mouth; whenever it is a damp, drizzly November in my soul; whenever I find myself pausing before coffin warehouses, and bringing up the rear of every funeral I meet; and especially whenever my hypos get such an upper hand of me, that it requires a strong moral principle to prevent me from deliberately stepping into the

10/13.5 Adobe Garamond

Call me Ishmael. Some years ago—never mind how long precisely—having little or no money in my purse, and nothing particular to interest me on shore, I thought I would sail about a little and see the watery part of the world. It is a way I have of driving off the spleen, and regulating the circulation. Whenever I find myself growing grim about the mouth; whenever it is a damp, drizzly November in my soul; whenever I find myself pausing before coffin warehouses, and bringing up the rear of every funeral I meet; and especially whenever my hypos get such an upper hand of me, that it requires a strong

10/13.5 Janson

Call me Ishmael. Some years ago—never mind how long precisely—having little or no money in my purse, and nothing particular to interest me on shore, I thought I would sail about a little and see the watery part of the world. It is a way I have of driving off the spleen, and regulating the circulation. Whenever I find myself growing grim about the mouth; whenever it is a damp, drizzly November in my soul; whenever I find myself pausing before coffin warehouses, and bringing up the rear of every funeral I meet; and especially whenever my hypos get such an upper hand of me, that it requires a strong moral principle to prevent me from deliberately

10/13.5 Monotype Baskerville

Call me Ishmael. Some years ago—never mind how long precisely—having little or no money in my purse, and nothing particular to interest me on shore, I thought I would sail about a little and see the watery part of the world. It is a way I have of driving off the spleen, and regulating the circulation. Whenever I find myself growing grim about the mouth; whenever it is a damp, drizzly November in my soul; whenever I find myself pausing before coffin warehouses, and bringing up the rear of every funeral I meet; and especially whenever my hypos get such an upper hand of me, that it requires a strong

10/13.5 Bauer Bodoni

Call me Ishmael. Some years ago—never mind how long precisely—having little or no money in my purse, and nothing particular to interest me on shore, I thought I would sail about a little and see the watery part of the world. It is a way I have of driving off the spleen, and regulating the circulation. Whenever I find myself growing grim about the mouth; whenever it is a damp, drizzly November in my soul; whenever I find myself pausing before coffin warehouses, and bringing up the rear of every funeral I meet; and especially

10/13.5 Serifa

Call me Ishmael. Some years ago—never mind how long precisely—having little or no money in my purse, and nothing particular to interest me on shore, I thought I would sail about a little and see the watery part of the world. It is a way I have of driving off the spleen, and regulating the circulation. Whenever I find myself growing grim about the mouth; whenever it is a damp, drizzly November in my soul; whenever I find myself pausing before coffin warehouses, and bringing up the rear of every funeral I meet; and especially whenever my hypos get such an upper hand of me, that it

10/13.5 Futura Book

Call me Ishmael. Some years ago — never mind how long precisely — having little or no money in my purse, and nothing particular to interest me on shore, I thought I would sail about a little and see the watery part of the world. It is a way I have of driving off the spleen, and regulating the circulation. Whenever I find myself growing grim about the mouth; whenever it is a damp, drizzly November in my soul; whenever I find myself pausing before coffin warehouses, and bringing up the rear of every funeral I meet; and especially

10/13.5 Univers 55

Call me Ishmael. Some years ago — never mind how long precisely — having little or no money in my purse, and nothing particular to interest me on shore, I thought I would sail about a little and see the watery part of the world. It is a way I have of driving off the spleen, and regulating the circulation. Whenever I find myself growing grim about the mouth; whenever it is a damp, drizzly November in my soul; whenever I find myself pausing before coffin warehouses, and bringing up the rear of every funeral I meet; and especially whenever my hypos get such an upper hand of me, that it requires a strong

10/13.5 Meta Plus Normal

For the better part of the twentieth century, the distinctive forms of typewriter type (notably its single character width and unstressed stroke) characterized the immediacy of thought: getting the idea down without dressing it up. Now that computers have replaced typewriters, most word processing programs default to Helvetica or Times Roman (or their derivatives) as the typographic expression of simple typing (see below). E-mail—currently the most immediate form of typed communication—appears on our screens as an electronically neutered sans serif, any individuality scraped off in deference to the requirements of the pixel.

As a typographer, you should recognize the difference between typing and typesetting. Time and usage may ultimately make Inkjet Sans the expected typeface for letters. For now, however, on paper, typewriter type (like Courier, shown below) is still the best expression of the intimate, informal voice—direct address. Imitating the formalities of typesetting in a letter is always inappropriate because it suggests an undeserved permanence—the end of a discussion, not its continuation.

```
I have great trouble, and some
comfort, to acquaint you with.
The trouble is, that my good
lady died of the illness I
mentioned to you, and left us
all much grieved for the loss of
her; for she was a dear good
lady, and kind to all us her
servants. Much I feared, as I was
taken by her ladyship to wait
upon her person, I should be
quite destitute again, and forced
to return to you and my poor
mother, who have enough to do to
maintain yourselves; and, as my
lady's goodness had put me to
```

10/12 Courier

I have great trouble, and some comfort, to acquaint you with. The trouble is, that my good lady died of the illness I mentioned to you, and left us all much grieved for the loss of her; for she was a dear good lady, and kind to all us her

10/12 Helvetica

I have great trouble, and some comfort, to acquaint you with. The trouble is, that my good lady died of the illness I mentioned to you, and left us all much grieved for the loss of her; for she was a dear good lady, and kind to all us her servants. Much I feared, as

10/12 Times Roman

86

I had taken Mrs. Prest into my confidence; in truth without her I should have made but little advance, for the fruitful idea in the whole business dropped from her friendly lips. It was she who invented the short cut, who severed the Gordian knot. It is not supposed to be the nature of women to rise as a general thing to the largest and most liberal view—I mean of a practical scheme; but it has struck me that they sometimes throw off a bold conception—such as a man would not

10/10 Janson
10 pt. type
10 pt. line

I had taken Mrs. Prest into my confidence; in truth without her I should have made but little advance, for the fruitful idea in the whole business dropped from her friendly lips. It was she who invented the short cut, who severed the Gordian knot. It is not supposed to be the nature of women to rise as a general thing to the largest and most liberal view—I mean of a practical scheme; but it has struck me that they sometimes throw off

10/11 Janson
10 pt. type
11 pt. line

I had taken Mrs. Prest into my confidence; in truth without her I should have made but little advance, for the fruitful idea in the whole business dropped from her friendly lips. It was she who invented the short cut, who severed the Gordian knot. It is not supposed to be the nature of women to rise as a general thing to the largest and most liberal view—I mean of a practical scheme; but it has struck me that they sometimes throw off

10/10.5 Janson
10 pt. type
10.5 pt. line

I had taken Mrs. Prest into my confidence; in truth without her I should have made but little advance, for the fruitful idea in the whole business dropped from her friendly lips. It was she who invented the short cut, who severed the Gordian knot. It is not supposed to be the nature of women to rise as a general thing to the largest and most liberal view—I mean of a practical scheme; but it

10/11.5 Janson
10 pt. type
11.5 pt. line

The goal in setting text type is to allow for easy, prolonged reading. At the same time, a field of type should occupy the page much as a photograph does.

Type size
Text type should be large enough to be read easily at arm's length—imagine yourself holding a book in your lap.

Leading
Text that is set too tightly encourages vertical eye movement; a reader can easily lose his or her place. Type that is set too loosely creates striped patterns that distract the reader from the material at hand.

Virtually every computer program assumes a default leading of 120% of type size (10 pt. type is set to a 12 pt. line, 12 pt. type is set to a 14.4 pt. line, and so on.). If your program says your type is leaded to 'default', fix it.

I had taken Mrs. Prest into my confidence; in truth without her I should have made but little advance, for the fruitful idea in the whole business dropped from her friendly lips. It was she who invented the short cut, who severed the Gordian knot. It is not supposed to be the nature of women to rise as a general thing to the largest and most liberal view—I mean of a practical scheme; but it

10/12 Janson
10 pt. type
12 pt. line

I had taken Mrs. Prest into my confidence; in truth without her I should have made but little advance, for the fruitful idea in the whole business dropped from her friendly lips. It was she who invented the short cut, who severed the Gordian knot. It is not supposed to be the nature of women to rise as a general thing to the largest and most liberal

10/13 Janson
10 pt. type
13 pt. line

I had taken Mrs. Prest into my confidence; in truth without her I should have made but little advance, for the fruitful idea in the whole business dropped from her friendly lips. It was she who invented the short cut, who severed the Gordian knot. It is not supposed to be the nature of women to rise as a general thing to the largest and most liberal view—I mean of a practical scheme; but it

10/12.5 Janson
10 pt. type
12.5 pt. line

I had taken Mrs. Prest into my confidence; in truth without her I should have made but little advance, for the fruitful idea in the whole business dropped from her friendly lips. It was she who invented the short cut, who severed the Gordian knot. It is not supposed to be the nature of women to rise as a general thing to the largest and most liberal

10/13.5 Janson
10 pt. type
13.5 pt. line

Line length

Appropriate leading for text is as much a function of line length as it is a question of type size and leading. Shorter lines require less leading; longer lines, more.

In general text settings—specifically not including captions and head-lines—a good rule of thumb is to keep line length somewhere between 35 and 65 characters. In practice, limitations of space or the dictates of special use may require longer or shorter lengths. In any event, be sensitive to that moment when extremely long or short line lengths impair easy reading.

■ **Using three of the ten typefaces we've discussed, typeset a selection of text (any text you like—no more than 200 words). In each case, pay close attention to type size, leading, and line length. Then determine which typeface best communicates the message in the text.**

I had taken Mrs. Prest into my confidence; in truth without her I should have made but little advance, for the fruitful idea in the whole business dropped from her friendly lips. It was she who invented the short cut, who severed the Gordian knot. It is not supposed to be the nature of women to rise as a general thing to the largest and most liberal view—I mean of a practical scheme; but it has struck me that they sometimes throw off a bold conception—such as a man would not have risen to—with singular serenity. "Simply ask them to take you in on the footing of a lodger"—I don't think that unaided I should have risen to that. I was beating about the bush, trying to be ingenious, wondering by what combination of arts I might have become an acquaintance, when she offered this happy suggestion that the way to become an acquaintance was first to become an inmate. Her actual knowledge of the Misses Bordereau was scarcely larger than mine, and indeed I had

10/12 Janson x 22p3

I had taken Mrs. Prest into my confidence; in truth without her I should have made but little advance, for the fruitful idea in the whole business dropped from her friendly lips. It was she who invented the short cut, who severed the Gordian knot. It is not supposed to be the nature of women to rise as a general thing to the largest and most liberal view—I mean of a practical scheme; but it has struck me that they sometimes throw off a bold conception—such as a man would not have risen to—with singular serenity. "Simply ask them to take you in on the footing of a lodger"—I don't think that unaided I should have risen to that. I was beating about the bush, trying to be ingenious, wondering by what combination of arts I might have become an acquaintance, when she offered this happy suggestion that the way to become an acquaintance was first to become an inmate. Her actual knowledge of the Misses

10/13 Janson x 22p3

I had taken Mrs. Prest into my confidence; in truth without her I should have made but little advance, for the fruitful idea in the whole business dropped from her friendly lips. It was she who invented the short cut, who severed the Gordian knot. It is not supposed to be the nature of women to rise as a general thing to the largest and most liberal view—I mean of a practical scheme; but it has struck me that they sometimes throw off a bold conception—such as a man would not have risen to—with singular serenity. "Simply ask them to take you in on the footing of a lodger"—I don't think that unaided I should have risen to that. I was beating about the bush, trying to be ingenious, wondering by

10/12 Janson x 16p3

I had taken Mrs. Prest into my confidence; in truth without her I should have made but little advance, for the fruitful idea in the whole business dropped from her friendly lips. It was she who invented the short cut, who severed the Gordian knot. It is not supposed to be the nature of women to rise as a general thing to the largest and most liberal view—I mean of a practical scheme; but it has struck me that they sometimes throw off a

10/12 Janson x 10p4

I had taken Mrs. Prest into my confidence; in truth without her I should have made but little advance, for the fruitful idea in the whole business dropped from her friendly lips. It was she who invented the short cut, who severed the Gordian knot. It is not supposed to be the nature of women to rise as a general thing to the largest and most liberal view—I mean of a practical scheme; but it has struck me that they sometimes throw off a bold conception—such as a man would not have risen to—with singular serenity. "Simply ask them to take you in on the footing of a lodger"—I don't think that unaided I should have risen to that. I was beating about the

10/13 Janson x 16p3

I had taken Mrs. Prest into my confidence; in truth without her I should have made but little advance, for the fruitful idea in the whole business dropped from her friendly lips. It was she who invented the short cut, who severed the Gordian knot. It is not supposed to be the nature of women to rise as a general thing to the largest and most liberal view—I mean of a practical scheme; but it has struck me that

10/13 Janson x 10p4

90

Before desktop publishing, designers ordered type from their local typesetter. These vendors supplied their clients with type specimen books, showing samples of their typefaces at various sizes. Display sizes (typically above 14 pt.) were shown as full alphabets, numerals, and some punctuation. Sizes 12 pt. and below were generally shown as they would most often be used: as blocks of text.

Despite the fact that we work primarily on a monitor, fonts at hand with the click of the mouse, there is still great value in having a specimen book of one's own. Without printed pages showing samples of a typeface at different sizes, no one can make a reasonable choice of type. Typical text at actual size on a screen is simply impossible to read. Even on the best monitor, 8 pt. Bembo is indistinguishable from 8 pt. Garamond.

Your specimen book need not show every size of a typeface. Its purpose, after all, is to provide an accurate reference for what's available on your machine—a departure point.

Univers 55

34 pt.

ABCDEFGHIJKLMNOPQRS
TUVWXYZ
abcdefghijklmnopqrs
tuvwxyz
1234567890
!@#$%^&*()_+{}[]|\:;"'<>,.?/

26 pt.

ABCDEFGHIJKLMNOPQRSTUVWXYZ
abcdefghijklmnopqrstuvwxyz
1234567890
!@#$%^&*()_+{}[]|\:;"'<>,.?/

21 pt.

ABCDEFGHIJKLMNOPQRSTUVWXYZ
abcdefghijklmnopqrstuvwxyz
1234567890
!@#$%^&*()_+{}[]|\:;"'<>,.?/

16 pt.

ABCDEFGHIJKLMNOPQRSTUVWXYZ
abcdefghijklmnopqrstuvwxyz
1234567890
!@#$%^&*()_+{}[]|\:;"'<>,.?/

Above and opposite:
Reduced specimen pages on A4 sheets. The sizes chosen for display on the page above were taken from two Fibonacci sequences—base 1 and base 2. (See pages 118–119 for a further discussion of Fibonacci sequences.)

The nonsensical words used on the specimen page opposite are called 'greeking,' despite the fact that most of the words are Latin or corruptions of Latin words. Typesetters use greeking files to generate sample type for their clients, who often have to design a piece before it is written.

12 pt.

ABCDEFGHIJKLMNOPQRS
TUVWXYZ
abcdefghijklmnopqrstuvwxyz
1234567890
!@#$%^&*()_+{}[]|\:;"'<>,.?/

Lorem ipsum dolor sit amet, con-
sectetuer adipiscing elit, sed
diam nonummy nibh euismod
tincidunt ut laoreet dolore
magna aliquam erat volutpat. Ut
wisi enim ad minim veniam, quis
nostrud exerci tation ullamcorp-

10 pt.

ABCDEFGHIJKLMNOPQRSTUVWXYZ
abcdefghijklmnopqrstuvwxyz
1234567890
!@#$%^&*()_+{}[]|\:;"'<>,.?/

Lorem ipsum dolor sit amet, con-
sectetuer adipiscing elit, sed diam non-
ummy nibh euismod tincidunt ut
laoreet dolore magna aliquam erat
volutpat. Ut wisi enim ad minim veni-
am, quis nostrud exerci tation ullamcor
per. Suscipit lobortis nisl ut aliquip ex
ea commodo consequat. Duis autem
vel eum iriure dolor in hendrerit in

9 pt.

ABCDEFGHIJKLMNOPQRSTUVWXYZ
abcdefghijklmnopqrstuvwxyz
1234567890
!@#$%^&*()_+{}[]|\:;"'<>,.?/

Lorem ipsum dolor sit amet, consectetuer
adipiscing elit, sed diam nonummy nibh
euismod tincidunt ut laoreet dolore magna
aliquam erat volutpat. Ut wisi enim ad
minim veniam, quis nostrud exerci tation
ullamcorper. Suscipit lobortis nisl ut aliquip
ex ea commodo consequat. Duis autem vel
eum iriure dolor in hendrerit in vulputate
velit esse molestie consequat, vel illum
dolore eu feugiat nulla facilisis at vero eros
et accumsan. Iusto odio dignissim qui
blandit praesent luptatum zzril delenit augue
duis dolore te feugait nulla facilisi. Lorem

8 pt.

ABCDEFGHIJKLMNOPQRSTU-
VWXYZ
abcdefghijklmnopqrstuvwxyz
1234567890
!@#$%^&*()_+{}[]|\:;"'<>,.?/

Lorem ipsum dolor sit amet,
consectetuer adipiscing elit,
sed diam nonummy nibh euis-
mod tincidunt ut laoreet dolore
magna aliquam erat volutpat.
Ut wisi enim ad minim veniam,
quis nostrud exerci tation
ullamcorper. Suscipit lobortis
nisl ut aliquip ex ea commodo
consequat. Duis autem vel eum
iriure dolor in hendrerit in
vulputate velit esse molestie
consequat, vel illum dolore eu

7 pt.

ABCDEFGHIJKLMNOPQRSTU-
VWXYZ
abcdefghijklmnopqrstuvwxyz
1234567890
!@#$%^&*()_+{}[]|\:;"'<>,.?/

Lorem ipsum dolor sit amet, con-
sectetuer adipiscing elit, sed diam
nonummy nibh euismod tincidunt
ut laoreet dolore magna aliquam
erat volutpat. Ut wisi enim ad
minim veniam, quis nostrud exerci
tation ullamcorper. Suscipit lobortis
nisl ut aliquip ex ea commodo con-
sequat. Duis autem vel eum iriure
dolor in hendrerit in vulputate velit
esse molestie consequat, vel illum
dolore eu feugiat nulla facilisis at
vero eros et accumsan. Iusto odio

6 pt.

ABCDEFGHIJKLMNOPQRSTUVWXYZ
abcdefghijklmnopqrstuvwxyz
1234567890
!@#$%^&*()_+{}[]|\:;"'<>,.?/

Lorem ipsum dolor sit amet, consectetuer
adipiscing elit, sed diam nonummy nibh
euismod tincidunt ut laoreet dolore
magna aliquam erat volutpat. Ut wisi
enim ad minim veniam, quis nostrud
exerci tation ullamcorper. Suscipit lobortis
nisl ut aliquip ex ea commodo consequat.
Duis autem vel eum iriure dolor in hen-
drerit in vulputate velit esse molestie con-
sequat, vel illum dolore eu feugiat nulla
facilisis at vero eros et accumsan. Iusto
odio dignissim qui blandit praesent lupta-
tum zzril delenit augue duis dolore te feu-
gait nulla facilisi. Lorem ipsum dolor sit

Lorem ipsum dolor sit amet, consectetuer adipiscing elit, sed diam nonummy nibh euismod tincidunt ut laoreet dolore magna aliquam erat volutpat. Ut wisi enim ad minim veniam, quis nostrud exerci tation ullamcorper. Suscipit lobortis nisl ut aliquip ex ea commodo consequat. Duis autem vel eum iriure dolor in hendrerit in vulputate velit esse molestie consequat, vel illum dolore eu feugiat nulla facilisis at vero eros et accumsan. Iusto odio dignissim qui blandit praesent luptatum zzril delenit augue duis dolore te feugait nulla facilisi. Lorem ipsum dolor sit amet, consectetuer adipiscing elit, sed diam nonummy nibh euismod tincidunt ut laoreet dolore magna aliquam erat volutpat. Ut wisi enim ad minim veniam, quis nostrud exerci tation ullamcorper suscipit lobortis nisl ut aliquip ex ea commodo consequat. Duis autem vel eum iriure dolor in hendrerit in vulputate velit esse molestie consequat, vel illum dolore eu feugiat nulla facilisis at vero eros et iusto odio dignissim qui blandit praesent luptatum zzril delenit augue duis dolore te feugait nulla facilisi. Nam liber tempor cum soluta nobis eleifend option congue nihil imperdiet doming id quod mazim placerat facer possim assum. Lorem ipsum dolor sit amet, consectetuer adipiscing elit, sed diam nonummy nibh euismod tincidunt ut laoreet dolore magna aliquam erat volutpat. Ut wisi enim ad minim veniam, quis nostrud exerci tation ullamcorper suscipit lobortis nisl ut aliquip ex ea commodo consequat. Duis autem vel eum iriure dolor in hendrerit in vulputate velit esse molestie consequat, vel illum dolore eu feugiat nulla facilisis at vero eros et accumsan et iusto odio dignissim qui blandit praesent luptatum zzril delenit augue duis dolore te feugait nulla facilisi. Lorem ipsum dolor sit amet, consectetuer adipiscing elit, sed diam nonummy nibh euismod tincidunt ut laoreet dolore magna aliquam erat volutpat. Ut wisi enim ad minim veniam, quis nostrud exerci tation ullamcorper suscipit lobortis nisl ut aliquip ex ea commodo consequat. Duis autem vel eum iriure dolor in hendrerit in vulputate velit esse molestie consequat, vel illum dolore eu feugiat nulla facilisis at vero eros et accumsan et iusto odio dignissim qui blandit praesent luptatum zzril delenit augue duis dolore

Lorem ipsum dolor sit amet, consectetuer adipiscing elit, sed diam nonummy nibh euismod tincidunt ut laoreet dolore magna aliquam erat volutpat. Ut wisi enim ad minim veniam, quis nostrud exerci tation ullamcorper. Suscipit lobortis nisl ut aliquip ex ea commodo consequat. Duis autem vel eum iriure dolor in hendrerit in vulputate velit esse molestie consequat, vel illum dolore eu feugiat nulla facilisis at vero eros et accumsan. Iusto odio dignissim qui blandit praesent luptatum zzril delenit augue duis dolore te feugait nulla facilisi. Lorem ipsum dolor sit amet, consectetuer adipiscing elit, sed diam nonummy nibh euismod tincidunt ut laoreet dolore magna aliquam erat volutpat. Ut wisi enim ad minim veniam, quis nostrud exerci tation ullamcorper suscipit lobortis nisl ut aliquip ex ea commodo consequat. Duis autem vel eum iriure dolor in hendrerit in vulputate velit esse molestie consequat, vel illum dolore eu feugiat nulla facilisis at vero eros et accumsan et iusto odio dignissim qui blandit praesent luptatum zzril delenit augue duis dolore te feugait nulla facilisi. Nam liber tempor cum soluta nobis eleifend option congue nihil imperdiet doming id quod mazim placerat facer possim assum. Lorem ipsum dolor sit amet, consectetuer adipiscing elit, sed diam nonummy nibh euismod tincidunt ut laoreet dolore magna aliquam erat volutpat. Ut wisi enim ad minim veniam, quis nostrud exerci tation ullamcorper suscipit lobortis nisl ut aliquip ex ea commodo consequat. Duis autem vel eum iriure dolor in hendrerit in vulputate velit esse molestie consequat, vel illum dolore eu feugiat nulla facilisis at vero eros et accumsan et iusto odio dignissim qui blandit praesent luptatum zzril delenit augue duis dolore te feugait nulla facilisi. Lorem ipsum dolor sit amet, consectetuer adip Lorem ipsum dolor

Compositional requirements

Text type should create a field that can occupy the page much as a photograph does. Think of your ideal text as having a middle gray value (above, left), not as a series of stripes (above, right).

It is often useful to enlarge type 400% on the screen to get a clear sense of the relationship between descenders on one line and ascenders on the line below. Here you can clearly see the difference one point of leading can make—a difference that is unrecognizable at 100% on most monitors.

Keep in mind that nothing replaces looking closely at an actual print-out of your work. The best screen is still an electronic approximation of the printed page.

I had taken Mrs. Prest into my confidence; in truth without her I should have made but little advance, for the fruitful idea in the whole business dropped from her friendly lips. It was she who invented the short cut, who

10/12 Janson @ 400%

I had taken Mrs. Prest into my confidence; in truth without her I should have made but little advance, for the fruitful idea in the whole business dropped from her friendly lips. It was she who

10/13 Janson @ 400%

Lorem ipsum dolor sit amet, con
adipiscing elit, sed diam nonumn
euismod tincidunt ut laoreet dolc
aliquam erat volutpat. Ut wisi en
minim veniam, quis nostrud exer
ullamcorper suscipit lobortis nisl
ex ea commodo consequat. ¶ Du
vel eum iriure dolor in hendrerit
tate velit esse molestie consequat
dolore eu feugiat nulla facilisis at
et accumsan et iusto odio digniss
blandit praesent luptatum zzril de
augue duis dolore. ¶ Ut wisi enin
minim veniam, quis nostrud exer
ullamcorper suscipit lobortis nisl
ex ea commodo consequat. Duis
eum iriure dolor in hendrerit in

Lorem ipsum dolor sit amet, con
adipiscing elit, sed diam nonumn
euismod tincidunt ut laoreet dolc
aliquam erat volutpat.
Duis autem vel eum iriure dolor
drerit in vulputate velit esse mole
sequat, vel illum dolore eu feugia
facilisis at vero eros et accumsan
odio dignissim qui blandit praese
tum zzril delenit augue duis dolo
gait nulla facilisi.
Lorem ipsum dolor sit amet elit,
nonummy nibh euismod tincidun
laoreet dolore magna aliquam era
pat.
Ut wisi enim ad minim veniam, c
trud exerci tation ullamcorper su

There are several options for indicat-
ing paragraphs. In the first example,
we see the 'pilcrow' (¶), a holdover
from medieval manuscripts seldom
used today.

In the second example, paragraphs
are indicated simply by the start of a
new line. If you employ this method,
keep in mind that a long line at the
end of one paragraph may make it
difficult to read the start of the next.
Similarly, a sentence within a para-
graph that happens to fall at the
beginning of a line may be mistaken
for a new paragraph.

Lorem ipsum dolor sit amet, con adipiscing elit, sed diam nonumn euismod tincidunt ut laoreet dolc aliquam erat volutpat. Ut wisi en minim veniam, quis nostrud exer ullamcorper suscipit lobortis nisl ex ea commodo consequat.

Duis autem vel eum iriure dolor drerit in vulputate velit esse mole sequat, vel illum dolore eu feugia facilisis at vero eros et accumsan odio dignissim qui blandit praese tum zzril delenit augue duis dolo gait nulla facilisi. Lorem ipsum d amet elit, sed diam nonummy nib mod tincidunt ut laoreet dolore r

Lorem ipsum dolor sit amet, con adipiscing elit, sed diam nonumn euismod tincidunt ut laoreet dolc aliquam erat volutpat. Ut wisi en minim veniam, quis nostrud exer ullamcorper suscipit lobortis nisl ex ea commodo consequat.
　　Duis autem vel eum iriure dol hendrerit in vulputate velit esse n consequat, vel illum dolore eu fet facilisis at vero eros et accumsan odio dignissim qui blandit praese tum zzril delenit augue duis dolo gait nulla facilisi. Lorem ipsum d amet elit, sed diam nonummy nit mod tincidunt ut laoreet dolore r quam erat volutpat.

The example shown above left (and throughout this book) is a line space between paragraphs. Some design-ers occasionally set this space to be less than a full line, a solution that can be elegant in pages with a single column of text, but one that works against cross-alignment in layouts with multiple columns.

In the example above right, you can see the standard indentation. Typically, the indent is the same size as the leading (as shown above—in this case, 13.5 pts.) or the same as the point size of the text.

Lorem ipsum dolor sit amet, con
adipiscing elit, sed diam nonumn
euismod tincidunt ut laoreet dol
aliquam erat volutpat. Ut wisi en
minim veniam, quis nostrud exer
ullamcorper suscipit lobortis nisl
ex ea commodo consequat.

Duis autem vel
dolor in hendrerit in vulputate ve
molestie consequat, vel illum dol
feugiat nulla facilisis at vero eros
san et iusto odio dignissim qui bl
praesent luptatum zzril delenit au
dolore.

Ut wisi enim ad
veniam, quis nostrud exerci tatior
corper suscipit lobortis nisl ut ali

Lorem ipsum dolor sit amet, con
adipiscing elit, sed diam nonu
euismod tincidunt ut laoreet d
magna aliquam erat volutpat.
enim ad minim veniam, quis n
exerci tation ullamcorper susc
tis nisl ut aliquip ex ea comm
quat.
Duis autem vel eum iriure dolor
drerit in vulputate velit esse m
consequat, vel illum dolore eu
nulla facilisis at vero eros et a
et iusto odio dignissim qui bla
sent luptatum zzril delenit aug
dolore.
Ut wisi enim ad minim veniam,
trud exerci tation ullamcorper

Here, two less predictable methods
for indicating new paragraphs. In the
first, type indents radically. This
approach requires great care not to
create widows (see page 97) at the
end of the paragraph (as seen in the
second paragraph). In the second
example, the first line of the para-
graph is exdented. This method
creates unusually wide gutters
between columns of text. Despite
these problems, there can be strong
compositional reasons for consider-
ing either option.

In traditional typesetting (the kind that still endures among fine book publishers and conscientious commercial publishers), there are two unpardonable gaffes—widows and orphans.

A widow is a short line of type left alone at the end of a column of text. An orphan is a short line of type left alone at the start of a new column. Consider the example opposite. You know already that text is meant to read as a field of a more-or-less middle tone. You can see how an unusually short line at the top or bottom of a paragraph disrupts that reading—in fact, creates a shape that draws attention away from simple reading.

In justified text, both widows and orphans are considered serious gaffes. Flush left, ragged right text is somewhat more forgiving towards widows, but only a bit. Orphans remain unpardonable.

The only solution to widows is to rebreak your line endings throughout your paragraph so that the last line of any paragraph is not noticeably short. Orphans, as you might expect, require more care. Careful typographers make sure that no column of text starts with the last line of the preceding paragraph.

Eleifend option congue nihil imperdiet doming id quod mazim placerat facer possim assum. Lorem ipsum dolor sit amet, consectetuer adipiscing elit, sed diam nonummy nibh euismod tincidunt ut laoreet dolore magna aliquam erat volutpat. Ut wisi enim ad minim veniam, quis nostrud exerci tation ullamcorper suscipit lobortis nisl ut aliquip ex ea commodo consequat. Duis autem vel eum iriure dolor in hendrerit in vulputate velit esse molestie consequat, vel illum dolore eu feugiat nulla facilisis at vero eros et accumsan et iusto odio dignissim qui blandit praesent luptatum

zzril delenit augue duis dolore te feugait nulla facilisi. Lorem ipsum dolor sit amet, consectetuer adip Lorem ipsum dolor sit amet, consectetuer adipiscing elit, sed diam nonummy nibh euismod tincidunt ut laoreet dolore magna aliquam erat volutpat. Ut wisi enim ad minim veniam, quis nostrud exerci tation ullamcorper suscipit lobortis nisl ut aliquip ex ea commodo consequat. Duis autem vel eum iriure dolor in hendrerit in vulputate velit esse molestie consequat, vel illum dolore eu feugiat nulla facilisis at vero eros et accumsan et iusto odio dignissim qui blandit praesent luptatum zzril delenit augue duis dolore te feugait nulla facilisi. Lorem ipsum dolor sit amet, consectetuer adipiscing elit, sed diam nonummy nibh euismod tincidunt ut laoreet dolore magna aliquam erat volutpat. Ut wisi enim ad minim veniam, quis nostrud exerci tation ullamcorper suscipit nisl ut aliquip

si. Nam
liber tempor cum soluta nobis eleifend option congue nihil imperdiet doming id quod mazim placerat facer possim assum. Lorem ipsum dolor sit amet, consectetuer adipiscing elit, sed diam nonummy nibh euismod tincidunt ut laoreet dolore magna aliquam erat volutpat. Ut wisi enim ad minim veniam, quis nostrud exerci tation ullamcorper suscipit lobortis nisl ut aliquip ex ea commodo consequat. Duis autem vel eum iriure dolor in hendrerit in vulputate velit esse molestie consequat, vel illum dolore eu feugiat nulla facilisis at vero eros et accumsan et iusto odio dignissim qui blandit praesent luptatum zzril delenit augue duis dolore te feugait nulla facilisi. Lorem ipsum dolor sit amet, consectetuer adip

**Two widows and an orphan
(above).**

Lorem ipsum dolor sit amet, con
adipiscing elit, sed diam nonumm
euismod tincidunt ut laoreet dolc
aliquam erat volutpat. Ut wisi eni
minim veniam, quis nostrud exerc
ullamcorper.

Suscipit lobortis nisl ut aliquip ex ea
consequat. Duis autem vel eum iriu
hendrerit in vulputate velit esse mol
quat, vel illum dolore eu feugiat nul
at vero eros et accumsan.

Iusto odio dignissim qui blandit p
luptatum zzril delenit augue duis
feugait nulla facilisi. Lorem ipsun
sit amet, consectetuer adipiscing

Italic type

Lorem ipsum dolor sit amet, con
adipiscing elit, sed diam nonumm
euismod tincidunt ut laoreet dolc
aliquam erat volutpat. Ut wisi eni
minim veniam, quis nostrud exerc
ullamcorper.

Suscipit lobortis nisl ut aliquip
commodo consequat. Duis aut
eum iriure dolor in hendrerit i
tate velit esse molestie consequ
illum dolore eu feugiat nulla fa
vero eros et accumsan.

Iusto odio dignissim qui blandit p
luptatum zzril delenit augue duis
feugait nulla facilisi. Lorem ipsun

Boldface serif type

Some simple ways to highlight content within a column of text are shown here. Note that different kinds of emphasis require different kinds of contrast.

In the first example, type is highlighted with italic, in the second with boldface. In terms of 'color', the contrast established by the bold is obviously clearer. In the third example, a sans serif bold (Univers 75) is used instead of the bold serif type (Janson) for even stronger contrast. In this example, the size of the Univers 75 has been reduced to 8.5 pts. to make its x-height match that of the 10 pt. Janson (see detail opposite). Finally, in the fourth example, the actual color itself is changed from black to red.

Lorem ipsum dolor sit amet, con
adipiscing elit, sed diam nonumn
euismod tincidunt ut laoreet dolo
aliquam erat volutpat. Ut wisi en
minim veniam, quis nostrud exer
ullamcorper.

Suscipit lobortis nisl ut aliquip
commodo consequat. Duis aut
eum iriure dolor in hendrerit in
tate velit esse molestie conseq
illum dolore eu feugiat nulla fa
vero eros et accumsan.

Iusto odio dignissim qui blandit
luptatum zzril delenit augue duis
feugait nulla facilisi. Lorem ipsu

Boldface sans serif type

Lorem ipsum dolor sit amet, con
adipiscing elit, sed diam nonumn
euismod tincidunt ut laoreet dolo
aliquam erat volutpat. Ut wisi en
minim veniam, quis nostrud exer
ullamcorper.

Suscipit lobortis nisl ut aliquip ex
modo consequat. Duis autem vel
ure dolor in hendrerit in vulputat
esse molestie consequat, vel illum
eu feugiat nulla facilisis at vero e
accumsan.

Iusto odio dignissim qui blandit
luptatum zzril delenit augue duis
feugait nulla facilisi. Lorem ipsu

Colored type

Loreipsum

Loreipsum

Matching x-heights between type-
faces. Top, 8.5 pt. Univers 75
against 10 pt. Janson. Bottom,
10 pt. Univers 75 against 10 pt.
Janson. (Examples at 400%.)

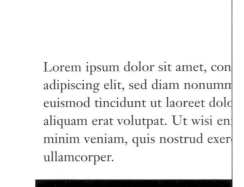

Lorem ipsum dolor sit amet, con
adipiscing elit, sed diam nonumn
euismod tincidunt ut laoreet dolo
aliquam erat volutpat. Ut wisi en
minim veniam, quis nostrud exer
ullamcorper.

Suscipit lobortis nisl ut aliquip ex
modo consequat. Duis autem vel
ure dolor in hendrerit in vulputa
esse molestie consequat, vel illum
eu feugiat nulla facilisis at vero e
accumsan.

Iusto odio dignissim qui blandit p
luptatum zzril delenit augue duis
feugait nulla facilisi. Lorem ipsur

Lorem ipsum dolor sit amet, con
adipiscing elit, sed diam nonumn
euismod tincidunt ut laoreet dolo
aliquam erat volutpat. Ut wisi en
minim veniam, quis nostrud exer
ullamcorper.

Suscipit lobortis nisl ut aliquip
commodo consequat. Duis aute
eum iriure dolor in hendrerit in
velit esse molestie consequat, ve
dolore eu feugiat nulla facilisis a
eros et accumsan.

Iusto odio dignissim qui blandit p
luptatum zzril delenit augue duis
feugait nulla facilisi. Lorem ipsur

Reversed type

Reversed, indented type

Here, the type has been highlighted
by placing it in a field of color. In the
first example, the type has simply
been dropped out of a field the
same color as the text. In the third
example, the type is surprinted over
a field in a second color. In both
instances, the left axis (or margin) of
the type remains constant. The fields
are expanded to accommodate the
type. Keep in mind the importance of
a gutter between columns large
enough to allow space between two
color fields.

Maintaining a consistent left type
axis in these two examples facili-
tates reading, without compromising
the purpose of the highlight. If the
fields were to align with the text
margins and the type subsequently
indent (the second and fourth exam-
ples), readability suffers.

Lorem ipsum dolor sit amet, con
adipiscing elit, sed diam nonumn
euismod tincidunt ut laoreet dolo
aliquam erat volutpat. Ut wisi en
minim veniam, quis nostrud exer
ullamcorper.

Suscipit lobortis nisl ut aliquip ex
modo consequat. Duis autem vel
ure dolor in hendrerit in vulputat
esse molestie consequat, vel illum
eu feugiat nulla facilisis at vero er
accumsan.

Iusto odio dignissim qui blandit p
luptatum zzril delenit augue duis
feugait nulla facilisi. Lorem ipsun

Surprinted type

Lorem ipsum dolor sit amet, con
adipiscing elit, sed diam nonumn
euismod tincidunt ut laoreet dolo
aliquam erat volutpat. Ut wisi en
minim veniam, quis nostrud exer
ullamcorper.

Suscipit lobortis nisl ut aliquip
commodo consequat. Duis aute
eum iriure dolor in hendrerit in
velit esse molestie consequat, ve
dolore eu feugiat nulla facilisis a
eros et accumsan.

Iusto odio dignissim qui blandit p
luptatum zzril delenit augue duis
feugait nulla facilisi. Lorem ipsun

Surprinted, indented type

Lorem ipsum dolor sit amet, con
adipiscing elit, sed diam nonumm
euismod tincidunt ut laoreet dolo
aliquam erat volutpat:
• Ut wisi enim ad minim veniam
• Quis nostrud exerci tation ullar
suscipit
• Lobortis nisl ut aliquip ex ea co
consequat.

Duis autem vel eum iriure dolor
drerit in vulputate velit esse mole
sequat, vel illum dolore eu feugia
facilisis at vero eros et accumsan
odio dignissim qui blandit praese
tum zzril delenit augue duis dolo
gait nulla facilisi. Lorem ipsum d

Lorem ipsum dolor sit amet, con
adipiscing elit, sed diam nonumm
euismod tincidunt ut laoreet dolo
aliquam erat volutpat:
• Ut wisi enim ad minim veniam
• Quis nostrud exerci tation ullamo
suscipit
• Lobortis nisl ut aliquip ex ea con
consequat.

Duis autem vel eum iriure dolor
drerit in vulputate velit esse mole
sequat, vel illum dolore eu feugia
facilisis at vero eros et accumsan
odio dignissim qui blandit praese
tum zzril delenit augue duis dolo
gait nulla facilisi. Lorem ipsum d

Exdenting text
Sometimes it's necessary to place
certain typographic elements outside
the left margin of a column of type
('exdenting,' as opposed to indenting)
to maintain a strong visual axis.

Notice, in the first example, that
even though the bulleted list aligns
with the left type margin, the bullets
themselves produce obvious indents,
thereby weakening the left axis. In
the second example, the bullets have
been exdented, maintaining the axis.

a prime is not a single quote or an
apostrophe, nor are double primes
quotes. Compare:

> "Lorem ipsum dolor sit amet, con
> adipiscing elit, sed diam nonumn
> euismod tincidunt ut laoreet dolc
> aliquam erat volutpat. Ut wisi en
> minim veniam, quis nostrud exer
> ullamcorper suscipit lobortis nisl
> ex ea commodo consequat.
>
> "Duis autem vel eum iriure dolor
> drerit in vulputate velit esse mole
> sequat, vel illum dolore eu feugia
> facilisis at vero eros et accumsan
> odio dignissim qui blandit praese
> tum zzril delenit augue duis dolo
> gait nulla facilisi. Lorem ipsum d
> amet, consectetuer adipiscing elit
> diam nonummy nibh euismod tir

The prime is an abbreviation for feet
or for the minutes of arc. The double
prime is an abbreviation for inches or
the seconds of arc. Because of the
limited number of keys, they were
used on typewriters as substitutes
for single and double quotes and
apostrophes, and came to be known
as 'dumb quotes.' When used as
quotes in typesetting, they aren't just
'dumb'—they're criminal.

Quotation marks, like bullets, can
create a clear indent when they're
aligned with the text margin.
Compare the exdented quote at the
top of the column with the aligned
quote in the middle.

Lorem ipsum dolor sit amet, con
adipiscing elit, sed diam nonumm
euismod tincidunt ut laoreet dolo
aliquam erat volutpat. Ut wisi eni
minim veniam, quis nostrud exerc
ullamcorper.

A head

Suscipit lobortis nisl ut aliquip ex
modo consequat. Duis autem vel
ure dolor in hendrerit in vulputat
esse molestie consequat, vel illum
eu feugiat nulla facilisis at vero er
accumsan.
	Justo odio dignissim qui bland

Lorem ipsum dolor sit amet, con
adipiscing elit, sed diam nonumm
euismod tincidunt ut laoreet dolo
aliquam erat volutpat. Ut wisi eni
minim veniam, quis nostrud exerc
ullamcorper.

A HEAD IN SMALL CAPS

Suscipit lobortis nisl ut aliquip ex
modo consequat. Duis autem vel
ure dolor in hendrerit in vulputat
esse molestie consequat, vel illum
eu feugiat nulla facilisis at vero er
accumsan.
	Justo odio dignissim qui bland

Many kinds of text have subdivisions within major sections (like chapters), which are typically indicated by subheads within the text. These subheads are labeled according to the level of their importance: A heads, B heads, C heads, etc. (only the most technically written texts have three or more levels of subheads). The typographer's task is to make sure that these heads clearly signify to the reader, in regard both to their relative importance within the text and to their relationship to each other.

A heads
A heads indicate a clean break between topics within a section. They need to offer readers a palpable pause, a chance to catch their breath. Space—typically, more than one line space—between topics clearly suggests this sense of resting. In the first three examples here, A heads are set larger than the text, in small caps, and in bold. The fourth example shows an A head exdented to the left of the text.

Lorem ipsum dolor sit amet, con
adipiscing elit, sed diam nonumn
euismod tincidunt ut laoreet dolc
aliquam erat volutpat. Ut wisi en:
minim veniam, quis nostrud exer
ullamcorper.

A head in bold

Suscipit lobortis nisl ut aliquip ex
modo consequat. Duis autem vel
ure dolor in hendrerit in vulputat
esse molestie consequat, vel illun
eu feugiat nulla facilisis at vero ei
accumsan.
 Iusto odio dignissim qui bland

Lorem ipsum dolc
adipiscing elit, sec
euismod tincidunt
aliquam erat volut
minim veniam, qu
ullamcorper.

A head in bold

Suscipit lobortis r
modo consequat.
ure dolor in hend
esse molestie cons
eu feugiat nulla fa
accumsan.
 Iusto odio digr
sent luptatum zzri
dolore te feugait r

Lorem ipsum dolor sit amet, con
adipiscing elit, sed diam nonumn
euismod tincidunt ut laoreet dolc
aliquam erat volutpat. Ut wisi eni
minim veniam, quis nostrud exerc
ullamcorper.

B HEAD IN SMALL CAPS
Suscipit lobortis nisl ut aliquip ex
modo consequat. Duis autem vel
ure dolor in hendrerit in vulputat
esse molestie consequat, vel illum
eu feugiat nulla facilisis at vero er
accumsan.

Iusto odio dignissim qui bland
sent luptatum zzril delenit augue
dolore te feugait nulla facilisi. Lo

Lorem ipsum dolor sit amet, con
adipiscing elit, sed diam nonumn
euismod tincidunt ut laoreet dolc
aliquam erat volutpat. Ut wisi eni
minim veniam, quis nostrud exerc
ullamcorper.

B head in italics
Suscipit lobortis nisl ut aliquip ex
modo consequat. Duis autem vel
ure dolor in hendrerit in vulputat
esse molestie consequat, vel illum
eu feugiat nulla facilisis at vero er
accumsan.

Iusto odio dignissim qui bland
sent luptatum zzril delenit augue
dolore te feugait nulla facilisi. Lo

B heads
Subordinate to A heads, B heads
indicate a new supporting argument
or example for the topic at hand. As
such, they should not interrupt the
text as strongly as A heads do. Here,
B heads are shown in small caps,
italic, bold serif, and bold sans serif.

Lorem ipsum dolor sit amet, con
adipiscing elit, sed diam nonumn
euismod tincidunt ut laoreet dolc
aliquam erat volutpat. Ut wisi en:
minim veniam, quis nostrud exer
ullamcorper.

B head in bold
Suscipit lobortis nisl ut aliquip ex
modo consequat. Duis autem vel
ure dolor in hendrerit in vulputat
esse molestie consequat, vel illum
eu feugiat nulla facilisis at vero ei
accumsan.
　　Iusto odio dignissim qui bland
sent luptatum zzril delenit augue
dolore te feugait nulla facilisi. Lo

Lorem ipsum dolor sit amet, con
adipiscing elit, sed diam nonumn
euismod tincidunt ut laoreet dolc
aliquam erat volutpat. Ut wisi en:
minim veniam, quis nostrud exer
ullamcorper.

B head in bold
Suscipit lobortis nisl ut aliquip ex
modo consequat. Duis autem vel
ure dolor in hendrerit in vulputat
esse molestie consequat, vel illum
eu feugiat nulla facilisis at vero ei
accumsan.
　　Iusto odio dignissim qui bland
sent luptatum zzril delenit augue
dolore te feugait nulla facilisi. Lo

Lorem ipsum dolor sit amet, con adipiscing elit, sed diam nonumn euismod tincidunt ut laoreet dold aliquam erat volutpat. Ut wisi en: minim veniam, quis nostrud exer ullamcorper.

C HEAD IN SMALL CAPS Suscipit lo ut aliquip ex ea commodo conseq autem vel eum iriure dolor in her vulputate velit esse molestie cons illum dolore eu feugiat nulla facil vero eros et accumsan.

Iusto odio dignissim qui bland sent luptatum zzril delenit augue dolore te feugait nulla facilisi. Lo ipsum dolor sit amet consectetul

Lorem ipsum dolor sit amet, con adipiscing elit, sed diam nonumn euismod tincidunt ut laoreet dold aliquam erat volutpat. Ut wisi en: minim veniam, quis nostrud exer ullamcorper.

C head in italics Suscipit lobortis aliquip ex ea commodo consequa autem vel eum iriure dolor in her vulputate velit esse molestie cons illum dolore eu feugiat nulla facil vero eros et accumsan.

Iusto odio dignissim qui bland sent luptatum zzril delenit augue dolore te feugait nulla facilisi. Lo ipsum dolor sit amet consectetul

C heads
Although not common, C heads highlight specific facets of material within B head text. They should not materially interrupt the flow of reading. As with B heads, these C heads are shown in small caps, italics, serif bold, and sans serif bold. C heads in this configuration are followed by at least an em space, to distinguish them from the text that follows.

Lorem ipsum dolor sit amet, con
adipiscing elit, sed diam nonumn
euismod tincidunt ut laoreet dolc
aliquam erat volutpat. Ut wisi en
minim veniam, quis nostrud exerc
ullamcorper.

C head in bold Suscipit lobortis
aliquip ex ea commodo consequa
autem vel eum iriure dolor in her
vulputate velit esse molestie cons
illum dolore eu feugiat nulla facil
vero eros et accumsan.

 Iusto odio dignissim qui bland
sent luptatum zzril delenit augue
dolore te feugait nulla facilisi. Lo
ipsum dolor sit amet, consectetue

Lorem ipsum dolor sit amet, con
adipiscing elit, sed diam nonumn
euismod tincidunt ut laoreet dolc
aliquam erat volutpat. Ut wisi en
minim veniam, quis nostrud exerc
ullamcorper.

C head in bold Suscipit loborti
aliquip ex ea commodo consequa
autem vel eum iriure dolor in her
vulputate velit esse molestie cons
illum dolore eu feugiat nulla facil
vero eros et accumsan.

 Iusto odio dignissim qui bland
sent luptatum zzril delenit augue
dolore te feugait nulla facilisi. Lo
ipsum dolor sit amet, consectetu

Putting together a sequence of subheads: hierarchy

Here are three examples of subhead treatment within text. In the first, hierarchy of subheads is indicated by size and style of type. In the second, a hierarchy of consistently bold subheads is indicated simply by the relationship of head to text. In the third, hierarchy is established by color of type (bold/italic) and position relative to text.

Obviously, there is no single way to express hierarchy within text; in fact, the possibilities are virtually limitless. Once clarity has been established, the typographer can—and should—establish a palette of weights and styles that best suits the material at hand and the voice of the author.

euismod tincidunt ut laoreet dolo aliquam erat volutpat. Ut wisi en minim veniam, quis nostrud exer ullamcorper.

A head

Suscipit lobortis nisl ut aliquip ex modo consequat. Duis autem vel ure dolor in hendrerit in vulputat esse molestie consequat, vel illum eu feugiat nulla facilisis at vero e accumsan.

B HEAD IN SMALL CAPS
Iusto odio dignissim qui blandit p luptatum zzril delenit augue duis feugait nulla facilisi. Lorem ipsur sit amet, consectetuer adipiscing diam nonummy nibh euismod tir laoreet dolore magna aliquam era pat.

C head in italic Ut wisi enim ad n veniam, quis nostrud exerci tatior corper suscipit lobortis nisl ut ali commodo consequat. Duis autem iriure dolor in hendrerit in vulpu

euismod tincidunt ut laoreet dol
aliquam erat volutpat. Ut wisi en
minim veniam, quis nostrud exer
ullamcorper.

A head in bold

Suscipit lobortis nisl ut aliquip ex
modo consequat. Duis autem vel
ure dolor in hendrerit in vulputat
esse molestie consequat, vel illum
eu feugiat nulla facilisis at vero e
accumsan.

B head in bold
Iusto odio dignissim qui blandit p
luptatum zzril delenit augue duis
feugait nulla facilisi. Lorem ipsum
sit amet, consectetuer adipiscing
diam nonummy nibh euismod tin
laoreet dolore magna aliquam era
pat.

C head in bold Ut wisi enim ac
veniam, quis nostrud exerci tatior
corper suscipit lobortis nisl ut ali
commodo consequat. Duis autem
iriure dolor in hendrerit in vulpu

euismod tincidunt
aliquam erat volutp
minim veniam, quis
ullamcorper.

A head in bold

Suscipit lobortis nis
modo consequat. D
ure dolor in hendre
esse molestie conse
eu feugiat nulla faci
accumsan.

B head in bold
Iusto odio dignissir
luptatum zzril dele
feugait nulla facilisi
sit amet, consectetu
diam nonummy nib
laoreet dolore magi
pat.

C head in italic Ut
veniam, quis nostru
corper suscipit lob
commodo consequa
iriure dolor in hen
esse molestie conse
eu feugiat nulla faci

112

Euismod tincidunt ut laoreet dolore magna aliquam erat volutpat. Ut wisi enim ad minim veniam, quis nostrud exerci tation ullamcorper suscipit lobortis nisl ut aliquip ex ea commodo consequat. Duis autem vel eum iriure dolor in hendrerit in vulputate velit esse molestie consequat, vel illum dolore eu feugiat nulla facilisis at vero eros et accumsan et iusto odio dignissim qui blandit praesent luptatum zzril delenit augue duis dolore te feugait nulla facilisi. Lorem ipsum dolor

Lorem ipsum dolor sit amet, consectetuer adipiscing elit, sed diam nonummy nibh euismod tincidunt ut laoreet dolore magna aliquam erat volutpat. Ut wisi enim ad minim veniam, quis nostrud exerci tation ullamcorper suscipit lobortis nisl ut aliquip ex ea commodo consequat. Duis autem vel eum iriure dolor in hendrerit in vulputate velit esse molestie consequat, vel illum dolore eu feugiat nulla facilisis at vero eros et accumsan et iusto odio dignissim qui blandit praesent luptatum zzril delenit augue duis dolore te feugait nulla facilisi. Lorem ipsum dolor sit amet, consectetuer adipiscing elit, sed diam nonummy nibh euismod tincidunt ut laoreet dolore magna aliquam erat volutpat. Ut wisi enim ad minim veniam, quis nostrud exerci tation ullamcorper suscipit lobortis nisl ut aliquip ex ea commodo consequat. Duis autem vel eum iriure dolor in hendrerit in vulputate velit esse molestie consequat, vel illum dolore eu feugiat nulla facilisis at vero eros et accumsan et iusto odio dignissim qui blandit praesent luptatum zzril delenit augue duis dolore te feugait nulla facilisi. Nam liber tempor cum soluta nobis eleifend option congue nihil imperdiet doming id quod mazim placerat facer possim assum. Lorem ipsum dolor sit amet, consectetuer adipiscing elit, sed diam nonummy nibh euismod tincidunt ut laoreet dolore magna aliquam erat volutpat. Ut wisi enim ad minim veniam,

7/9 Univers 75 x 10p4

10/13.5 Janson x 22p3

Cross-aligning headlines and captions with text type reinforces the architectural sense of the page—the structure—while articulating the complementary vertical rhythms. In this example, four lines of caption type (leaded to 9 pts.) cross-align with three lines of text type (leaded to 13.5 pts.).

Lorem ipsum dolor sit amet, consectetuer quam erat volutpat.

Ut wisi enim ad minim veniam, quis nostrud exercitation

24/27 Janson x 16p (top)
14/18 Univers 75 x 10p4 (bottom)

Lorem ipsum dolor sit amet, consectetuer adipiscing elit, sed diam nonummy nibh euismod tincidunt ut laoreet dolore magna aliquam erat volutpat. Ut wisi enim ad minim veniam, quis nostrud exerci tation ullamcorper suscipit lobortis nisl ut aliquip ex ea commodo consequat. Duis autem vel eum iriure dolor in hendrerit in vulputate velit esse molestie consequat, vel illum dolore eu feugiat nulla facilisis at vero eros et accumsan et iusto odio dignissim qui blandit praesent luptatum zzril delenit augue duis dolore te feugait nulla facilisi. Lorem ipsum dolor sit amet, consectetuer adipiscing elit, sed diam nonummy nibh euismod tincidunt ut laoreet dolore magna aliquam erat volutpat. Ut wisi enim ad minim veniam, quis nostrud exerci tation ullamcorper suscipit lobortis nisl ut aliquip ex ea commodo consequat. Duis autem vel eum iriure dolor in hendrerit in vulputate velit esse molestie consequat, vel illum dolore eu feugiat nulla facilisis at vero eros et accum-

10/13.5 Janson x 16p

Above (top left), one line of headline type cross-aligns with two lines of text type, and (bottom left) four lines of headline type cross-align with five lines of text type.

Simple organization

116

A designer's first consideration is the size and shape of the page. Although practical limitations—particularly economies of paper—often limit the designer's options, it is extremely useful to understand how the proportions we work with have evolved, and then to test your own responses against the received wisdom. Remember that these proportions—like so much else in typography and design in general—are the result of direct observation of, and interaction with, the world around us. Only your own practice and experimentation will give you a feel for what page size is most appropriate for each project.

The golden section

A dominant influence on the sense of proportion in Western art is the golden section. The term 'golden section' describes a relationship that occurs between two numbers when the ratio of the smaller to the larger is the same as the ratio of the larger to the sum of the two. The formula expressing this relationship is

a : b = b : (a+b).

The aspect ratio described by a golden section is 1:1.618.

The golden section has existed as a model for proportion since classical times, employed by architects and visual artists in determining composition at all scales, from the shape of a page to the façade of a building. Its relation to contemporary graphic design has become somewhat attenuated (see page 124).

To find the golden section in a square:

1
Draw the square abcd.

2
Bisect the square with line ef.
Draw an isosceles triangle cde.

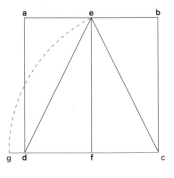

3
Project the line ce along the base of the square, forming line cg.

When you remove the square from a golden rectangle, you are left with another golden rectangle.

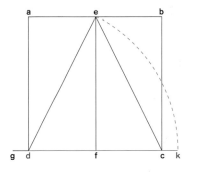

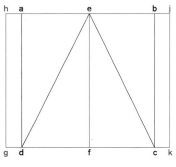

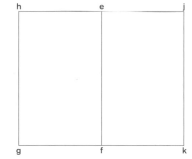

4
Project the line de along the base of the square, forming line dk.

5
Draw the new rectangles efgh and efkj.

Both rectangles efgh and efkj have the proportions of the golden section; the relationship of eh to gh is the same as the relationship of gh to (eh + gh). Similarly, the relationship of ej to jk is the same as the relationship of jk to (ej + jk)—all are 1:1.618.

Fibonacci sequence

Another useful model when consid-
ering proportions is the Fibonacci
sequence. Named for Italian mathe-
matician Leonardo Fibonacci (c. 1170
−1240), a Fibonacci sequence
describes a sequence in which
each number is the sum of the two
preceding numbers:

0
1
1 [1+0]
2 [1+1]
3 [1+2]
5 [2+3]
8 [3+5]
13 [5+8]
21 [8+13]
34 [13+21]
...

As the numbers in a Fibonacci
sequence increase, the proportion
between any two numbers very
closely approximates the proportion
in a golden section (1:1.618). For
example, 21:34 approximately
equals 1:1.618. Nature is full of
examples of the Fibonacci sequence
and the golden section, from the
intervals of branches on a tree to
the shell of a chambered nautilus.

Fibonacci's sequence always began
with 1, but the proportion between
any two numbers remains constant
when the sequence is multiplied:

0	0	0
2	3	4
2	3	4
4	6	8
6	9	12
10	15	20
16	24	32
26	39	52
42	63	84
68	102	136
...

Above, a spiral describes a
Fibonacci series (and the
growth of a chambered
nautilus). The red rectangle
on the upper right approxi-
mates a golden section. As
each square in the sequence
is added, the orientation of
the golden section changes
from vertical to horizontal.

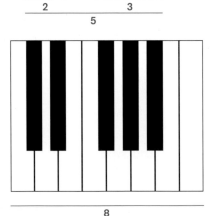

Left, one of the many exam-
ples of a Fibonacci
sequence is the musical
octave as seen on a piano—
eight white keys, five black
keys (separated into a group
of two and a group of three).

Series of type sizes based on a
Fibonacci sequence:

The basic sequence
(beginning at 1):
5 pt., 8 pt., 13 pt., 21 pt., 34 pt.,
and 55 pt.

Aa Aa Aa Aa **Aa** **Aa**

The sequence doubled:
6 pt., 10 pt., 16 pt., 26 pt., 42 pt.,
and 68 pt.

Aa Aa Aa Aa **Aa** **Aa**

The sequence tripled:
6 pt., 9 pt., 15 pt., 24 pt., 39 pt.,
and 63 pt.

Aa Aa Aa Aa **Aa** **Aa**

The sequence quadrupled:
8 pt., 12 pt., 20 pt., 32 pt., 52 pt.,
and 84 pt.

Aa Aa Aa Aa **Aa** **Aa**

The first and second sequences
interlaced:
6 pt., 8 pt., 10 pt., 13 pt., 16 pt.,
21 pt., 26 pt., 34 pt., and 42 pt.

Aa Aa Aa Aa Aa Aa Aa **Aa** **Aa**

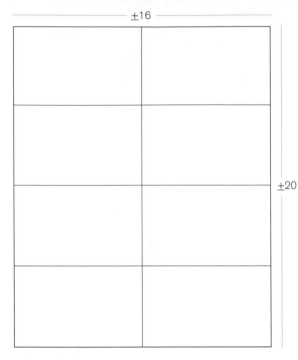

Sheet

Folio

±10

±16

±8

±10

Quarto

±5

±8

Octavo

±16

±20

Traditional page sizes

For the first 300 years of printing, the standard printing sheet ran anywhere between 16 x 20" (406 x 508 mm) and 19 x 24" (482 x 609 mm). Page sizes were referred to as folio (half sheet), quarto (quarter sheet), and octavo (eighth sheet). Specific dimensions of these page sizes varied according to the size of the basic sheet. Note that only the folio and octavo sizes approximate the golden section.

Standard American paper sizes

In American printing (and in those countries dependent upon American suppliers), most paper sizes are based on a page size of 8½ x 11" (216 x 279 mm) or 9 x 12" (229 x 305 mm). As you can see opposite, these sizes derive from the traditional sheet, although they have been modified based on the economies of the current standard printing sheet. There is no longer any relationship to the golden section except for the 5½ x 8½" (140 x 216 mm) sheet.

8½ x 11" (216 x 279 mm) sheet
Aspect ratio 1:1.294

9 x 12" (229 x 355 mm) sheet
Aspect ratio 1:1.333

5½ x 8½" (140 x 216 mm)
sheet
Aspect ratio 1:1.545

6 x 9" (152 x 229 mm) sheet
Aspect ratio 1:1.5

An A0 sheet, divided into component parts. An A0 sheet measures exactly 1m².

			Approximate inches
A0	=	841 x 1189 mm	$33\frac{1}{8}$ x $46\frac{3}{4}$"
A1	=	594 x 841 mm	$23\frac{3}{8}$ x $33\frac{1}{8}$"
A2	=	420 x 594 mm	$16\frac{1}{2}$ x $23\frac{3}{8}$"
A3	=	297 x 420 mm	$11\frac{3}{4}$ x $16\frac{1}{2}$"
A4	**=**	**210 x 297 mm**	**$8\frac{1}{4}$ x $11\frac{3}{4}$"**
A5	=	148 x 210 mm	$5\frac{7}{8}$ x $8\frac{1}{4}$"
A6	=	105 x 148 mm	$4\frac{1}{8}$ x $5\frac{7}{8}$"
A7	=	74 x 105 mm	$2\frac{7}{8}$ x $4\frac{1}{8}$"
A8	=	52 x 74 mm	2 x $2\frac{7}{8}$"
A9	=	37 x 52 mm	$1\frac{1}{2}$ x 2"
A10	=	26 x 37 mm	1 x $1\frac{1}{2}$"

Relative size and proportion of
A4 (black), 8½ x 11" (216 x
279 mm; red), and golden section
taken from A4 (dotted black)
and 8½ x 11" (216 x 279 mm;
dotted red)

European paper: the ISO system
In Europe—and many other parts
of the world—paper sizes are based
on what is known as the ISO
(International Organization for
Standardization) system.

The ISO system was originated at
the beginning of the twentieth
century by Nobel laureate Wilhelm
Ostwald, who proposed an aspect
ratio of 1 to the square root of 2
(1.414) as the basis for all printed
matter—from postage stamps to
oversized posters. The beauly of this
ratio is that any sheet of paper
trimmed to this format, when cut or
folded in half, produces a sheet with
exactly the same aspect ratio
(1:1.414).

The basic ISO sheet sizes are:

A0 (841 x 1189 mm/33⅛ x 46¾")
B0 (1000 x 1414 mm/39⅜ x 55⅝")
C0 (917 x 1297 mm/36⅛ x 51")

In practical applications, the A series
is the basic page size (A4 is the
equivalent of the American 8½ x 11"
sheet). The B series is often used
for books and flyers.

Other than the mathematical
elegance of the ISO system and the
possible esthetic preference for its
proportions, nothing necessarily
recommends ISO over American
format more than use. And there is
nothing to say that only standard
sizes are appropriate for any particu-
lar task, as we shall see later.

124

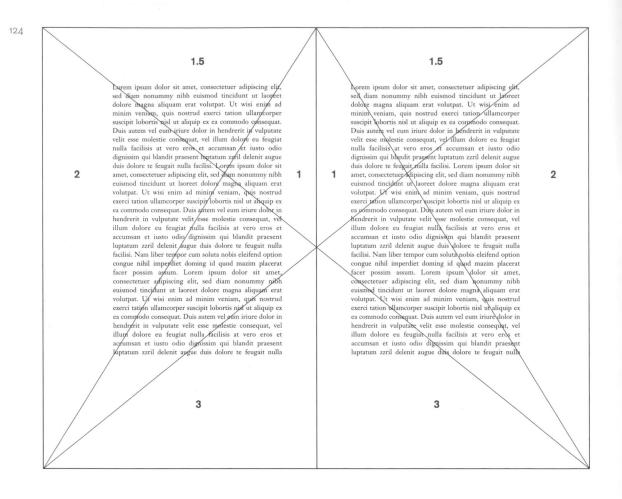

1.5

Lorem ipsum dolor sit amet, consectetuer adipiscing elit, sed diam nonummy nibh euismod tincidunt ut laoreet dolore magna aliquam erat volutpat. Ut wisi enim ad minim veniam, quis nostrud exerci tation ullamcorper suscipit lobortis nisl ut aliquip ex ea commodo consequat. Duis autem vel eum iriure dolor in hendrerit in vulputate velit esse molestie consequat, vel illum dolore eu feugiat nulla facilisis at vero eros et accumsan et iusto odio dignissim qui blandit praesent luptatum zzril delenit augue duis dolore te feugait nulla facilisi. Lorem ipsum dolor sit amet, consectetuer adipiscing elit, sed diam nonummy nibh euismod tincidunt ut laoreet dolore magna aliquam erat volutpat. Ut wisi enim ad minim veniam, quis nostrud exerci tation ullamcorper suscipit lobortis nisl ut aliquip ex ea commodo consequat. Duis autem vel eum iriure dolor in hendrerit in vulputate velit esse molestie consequat, vel illum dolore eu feugiat nulla facilisis at vero eros et accumsan et iusto odio dignissim qui blandit praesent luptatum zzril delenit augue duis dolore te feugait nulla facilisi. Nam liber tempor cum soluta nobis eleifend option congue nihil imperdiet doming id quod mazim placerat facer possim assum. Lorem ipsum dolor sit amet, consectetuer adipiscing elit, sed diam nonummy nibh euismod tincidunt ut laoreet dolore magna aliquam erat volutpat. Ut wisi enim ad minim veniam, quis nostrud exerci tation ullamcorper suscipit lobortis nisl ut aliquip ex ea commodo consequat. Duis autem vel eum iriure dolor in hendrerit in vulputate velit esse molestie consequat, vel illum dolore eu feugiat nulla facilisis at vero eros et accumsan et iusto odio dignissim qui blandit praesent luptatum zzril delenit augue duis dolore te feugait nulla

1.5

Lorem ipsum dolor sit amet, consectetuer adipiscing elit, sed diam nonummy nibh euismod tincidunt ut laoreet dolore magna aliquam erat volutpat. Ut wisi enim ad minim veniam, quis nostrud exerci tation ullamcorper suscipit lobortis nisl ut aliquip ex ea commodo consequat. Duis autem vel eum iriure dolor in hendrerit in vulputate velit esse molestie consequat, vel illum dolore eu feugiat nulla facilisis at vero eros et accumsan et iusto odio dignissim qui blandit praesent luptatum zzril delenit augue duis dolore te feugait nulla facilisi. Lorem ipsum dolor sit amet, consectetuer adipiscing elit, sed diam nonummy nibh euismod tincidunt ut laoreet dolore magna aliquam erat volutpat. Ut wisi enim ad minim veniam, quis nostrud exerci tation ullamcorper suscipit lobortis nisl ut aliquip ex ea commodo consequat. Duis autem vel eum iriure dolor in hendrerit in vulputate velit esse molestie consequat, vel illum dolore eu feugiat nulla facilisis at vero eros et accumsan et iusto odio dignissim qui blandit praesent luptatum zzril delenit augue duis dolore te feugait nulla facilisi. Nam liber tempor cum soluta nobis eleifend option congue nihil imperdiet doming id quod mazim placerat facer possim assum. Lorem ipsum dolor sit amet, consectetuer adipiscing elit, sed diam nonummy nibh euismod tincidunt ut laoreet dolore magna aliquam erat volutpat. Ut wisi enim ad minim veniam, quis nostrud exerci tation ullamcorper suscipit lobortis nisl ut aliquip ex ea commodo consequat. Duis autem vel eum iriure dolor in hendrerit in vulputate velit esse molestie consequat, vel illum dolore eu feugiat nulla facilisis at vero eros et accumsan et iusto odio dignissim qui blandit praesent luptatum zzril delenit augue duis dolore te feugait nulla

2 1 1 2

3 3

Just as the golden section can be seen as one ideal of proportion, there is also an ideal layout based on the golden section. Shown above, this layout has been considered an ideal since the creation of illuminated books in the Middle Ages, although by the advent of printing, it was a 'custom more honored in the breach than the observance' (Shakespeare).

The rules for this layout are simple:

1
The height of the text field equals the width of the full page.

2
The placement of the text field is determined by the diagonals that describe both the page and the field.

3
The margins at the gutter of the spread (along the spine of the book) define **1** unit of measure. The margin at the top of the page equals **1.5** units. The margins to the outside of the page equal **2** units. And the margin at the bottom equals **3** units.

Note that part of what makes this layout appealing is the tension created by the different margins. Text occupies approximately 40% of the page area.

Lorem ipsum dolor sit amet, consectetuer adipiscing elit, sed diam nonummy nibh euismod tincidunt ut laoreet dolore magna aliquam erat volutpat. Ut wisi enim ad minim veniam, quis nostrud exerci tation ullamcorper suscipit lobortis nisl ut aliquip ex ea commodo consequat. Duis autem vel eum iriure dolor in hendrerit in vulputate velit esse molestie consequat, vel illum dolore eu feugiat nulla facilisis at vero eros et accumsan et iusto odio dignissim qui blandit praesent luptatum zzril delenit augue duis dolore te feugait nulla facilisi. Lorem ipsum dolor sit amet, consectetuer adipiscing elit, sed diam nonummy nibh euismod tincidunt ut laoreet dolore magna aliquam erat volutpat. Ut wisi enim ad minim veniam, quis nostrud exerci tation ullamcorper suscipit lobortis nisl ut aliquip ex ea commodo consequat. Duis autem vel eum iriure dolor in hendrerit in vulputate velit esse molestie consequat, vel illum dolore eu feugiat nulla facilisis at vero eros et accumsan et iusto odio dignissim qui blandit praesent luptatum zzril delenit augue duis dolore te feugait nulla facilisi. Nam liber tempor cum soluta nobis eleifend option congue nihil imperdiet doming id quod mazim placerat facer possim assum. Lorem ipsum dolor sit amet, consectetuer adipiscing elit, sed diam nonummy nibh euismod tincidunt ut laoreet dolore magna aliquam erat volutpat. Ut wisi enim ad minim veniam, quis nostrud exerci tation ullamcorper suscipit lobortis nisl ut aliquip ex ea commodo consequat. Duis autem vel eum iriure dolor in hendrerit in vulputate velit esse molestie consequat, vel illum dolore eu feugiat nulla facilisis at vero eros et accumsan et iusto odio dignissim qui blandit praesent luptatum zzril delenit augue duis

8¹/₂ x 11" (216 x 279 mm)

Lorem ipsum dolor sit amet, consectetuer adipiscing elit, sed diam nonummy nibh euismod tincidunt ut laoreet dolore magna aliquam erat volutpat. Ut wisi enim ad minim veniam, quis nostrud exerci tation ullamcorper suscipit lobortis nisl ut aliquip ex ea commodo consequat. Duis autem vel eum iriure dolor in hendrerit in vulputate velit esse molestie consequat, vel illum dolore eu feugiat nulla facilisis at vero eros et accumsan et iusto odio dignissim qui blandit praesent luptatum zzril delenit augue duis dolore te feugait nulla facilisi. Lorem ipsum dolor sit amet, consectetuer adipiscing elit, sed diam nonummy nibh euismod tincidunt ut laoreet dolore magna aliquam erat volutpat. Ut wisi enim ad minim veniam, quis nostrud exerci tation ullamcorper suscipit lobortis nisl ut aliquip ex ea commodo consequat. Duis autem vel eum iriure dolor in hendrerit in vulputate velit esse molestie consequat, vel illum dolore eu feugiat nulla facilisis at vero eros et accumsan et iusto odio dignissim qui blandit praesent luptatum zzril delenit augue duis dolore te feugait nulla facilisi. Nam liber tempor cum soluta nobis eleifend option congue nihil imperdiet doming id quod mazim placerat facer possim assum. Lorem ipsum dolor sit amet, consectetuer adipiscing elit, sed diam nonummy nibh euismod tincidunt ut laoreet dolore magna aliquam erat volutpat. Ut wisi enim ad minim veniam, quis nostrud exerci tation ullamcorper suscipit lobortis nisl ut aliquip ex ea commodo consequat. Duis autem vel eum iriure dolor in hendrerit in vulputate velit esse molestie consequat, vel illum dolore eu feugiat nulla facilisis at vero eros et accumsan et iusto odio dignissim qui blandit praesent luptatum zzril delenit augue duis

A4

The requirements of contemporary printing take us far away from the medieval ideal. The examples above show how the same amount of type as used in the golden rectangle example would fit on an 8¹/₂ x 11" (216 x 279 mm) or A4 sheet today. We live in an era when xerography rules, and, as often as not, whatever comes most easily out of the nearest copier or laser printer determines the most appropriate paper sizes—none of which approximates a golden rectangle.

Book printing allows for more freedom in choosing page sizes, but economies of paper typically demand far narrower margins and longer lines than the ancients would have tolerated (look at any textbook). Commerce demands printed pieces that are best suited to sizes and shapes of paper unimagined in 1455 (consider flyers, mailers, brochures, folders, schedules— and on and on). Very few of the messages in these pieces demand the kind of sustained reading best served by a single field of text carefully placed on the page.

So typographers now operate in a world where readability, meaning, clarity, and appropriateness are constantly being tested against the realities of the marketplace and the specific requirements of the page. Our task becomes that of applying what we can of the old principles to contemporary situations.

The use of columnar layouts dates back to Gutenberg's 42-line bible (1455).

Lorem ipsum dolor sit amet

Lorem ipsum dolor sit amet, consectetuer adipiscing elit, sed diam nonummy nibh euismod tincidunt ut laoreet dolore magna aliquam erat volutpat. Ut wisi enim ad minim veniam, quis nostrud exerci tation ullamcorper suscipit lobortis nisl ut aliquip ex ea commodo consequat. Duis autem vel eum iriure dolor in hendrerit in vulputate velit esse molestie consequat, vel illum dolore eu feugiat nulla facilisis at vero eros et accumsan et iusto odio dignissim qui blandit praesent luptatum zzril delenit augue duis dolore te feugait nulla facilisi. Lorem ipsum dolor sit amet, consectetuer adipiscing elit, sed diam nonummy nibh euismod tincidunt ut laoreet dolore magna aliquam erat volutpat. Ut wisi enim ad minim veniam, quis nostrud exerci tation ullamcorper suscipit lobortis nisl ut aliquip ex ea commodo consequat. Duis autem vel eum iriure dolor in hendrerit in vulputate velit esse molestie consequat, vel illum dolore eu feugiat nulla facilisis at vero eros et accumsan et iusto odio dignissim qui blandit praesent luptatum zzril delenit augue duis dolore te feugait nulla facilisi. Nam liber tempor cum soluta nobis eleifend option congue nihil imperdiet doming id quod mazim placerat facer possim assum. Lorem ipsum dolor sit amet, consectetuer adipiscing elit, sed diam nonummy nibh euismod tincidunt ut laoreet dolore magna aliquam erat volutpat. Ut wisi enim ad minim veniam, quis nostrud exerci tation ullamcorper suscipit lobortis nisl ut aliquip ex ea commodo consequat. Duis autem vel eum iriure dolor in hendrerit in vulputate velit esse molestie consequat, vel illum dolore eu feugiat nulla facilisis at vero eros et accumsan et iusto odio dignissim qui blandit praesent lupta-

nisl ut aliquip ex ea commodo consequat. Duis autem vel eum iriure dolor in hendrerit in vulputate velit esse molestie consequat, vel illum dolore eu feugiat nulla facilisis at vero eros et accumsan et iusto odio dignissim qui blandit praesent luptatum zzril delenit augue duis dolore te feugait nulla facilisi. Lorem ipsum dolor sit amet, consectetuer adipiscing elit, sed diam nonummy nibh euismod tincidunt ut laoreet dolore magna aliquam erat volutpat. Ut wisi enim ad minim veniam, quis nostrud exerci tation ullamcorper suscipit lobortis nisl ut aliquip ex ea commodo consequat. Duis autem vel eum iriure dolor in hendrerit in vulputate velit esse molestie consequat, vel illum dolore eu feugiat nulla facilisis at vero eros et accumsan et iusto odio dignissim qui blandit praesent luptatum zzril delenit augue duis dolore te feugait nulla facilisi. Lorem ipsum dolor sit amet, consectetuer adipiscing elit, sed diam nonummy nibh euismod tincidunt ut laoreet dolore magna aliquam erat volutpat. Ut wisi enim ad minim veniam, quis nostrud exerci tation ullamcorper suscipit lobortis nisl ut aliquip ex ea commodo consequat. Duis autem vel eum iriure dolor in hendrerit in vulputate velit esse molestie consequat, vel illum dolore eu feugiat nulla facilisis at vero eros et accumsan et iusto odio dignissim qui blandit praesent lupta-

2-column layout

Lorem ipsum dolor sit amet

Lorem ipsum dolor sit amet, consectetuer adipiscing elit, sed diam nonummy nibh euismod tincidunt ut laoreet dolore magna aliquam erat volutpat. Ut wisi enim ad minim veniam, quis nostrud exerci tation ullamcorper suscipit lobortis nisl ut aliquip ex ea commodo consequat. Duis autem vel eum iriure dolor in hendrerit in vulputate velit esse molestie consequat, vel illum dolore eu feugiat nulla facilisis at vero eros et accumsan et iusto odio dignissim qui blandit prae-sent luptatum zzril delenit augue duis dolore te feugait nulla facil-isi. Lorem ipsum dolor sit amet, consectetuer adipiscing elit, sed diam nonummy nibh euismod tincidunt ut laoreet dolore magna aliquam erat volutpat. Ut wisi enim ad minim veniam, quis nos-trud exerci tation ullamcorper suscipit lobortis nisl ut aliquip ex ea commodo consequat. Duis autem vel eum iriure dolor in hendrerit in vulputate velit esse molestie consequat, vel illum dolore eu feugiat nulla facilisis at vero eros et accumsan et iusto odio dignissim qui blandit prae-sent luptatum zzril delenit augue duis dolore te feugait nulla facil-isi. Nam liber tempor cum soluta nobis eleifend option congue nihil imperdiet doming id quod mazim placerat facer possim assum. Lorem ipsum dolor sit amet, consectetuer adipiscing elit, sed diam nonummy nibh euismod tincidunt ut laoreet dolore magna aliquam erat volut-pat. Ut wisi enim ad minim veni-am, quis nostrud exerci tation ullamcorper suscipit lobortis nisl ut aliquip ex ea commodo conse-quat. Duis autem vel eum iriure

dolor in hendrerit in vulputate velit esse molestie consequat, vel illum dolore eu feugiat nulla facilisis at vero eros et accumsan et iusto odio dignissim qui blandit praesent luptatum zzril delenit augue duis dolore te feugait nulla facilisi. Lorem ipsum dolor sit amet, consectetuer adip Lorem ipsum dolor sit amet, con-sectetuer adipiscing elit, sed diam nonummy nibh euismod tin-cidunt ut laoreet dolore magna aliquam erat volutpat. Ut wisi enim ad minim veniam, quis nos-trud exerci tation ullamcorper suscipit lobortis nisl ut aliquip ex ea commodo consequat. Duis autem vel eum iriure dolor in hendrerit in vulputate velit esse molestie consequat, vel illum dolore eu feugiat nulla facilisis at vero eros et accumsan et iusto odio dignissim qui blandit prae-sent luptatum zzril delenit augue duis dolore te feugait nulla facil-isi. Lorem ipsum dolor sit amet, consectetuer adipiscing elit, sed diam nonummy nibh euismod tincidunt ut laoreet dolore magna aliquam erat volutpat. Ut wisi enim ad minim veniam, quis nos-trud exerci tation ullamcorper suscipit lobortis nisl ut aliquip ex ea commodo consequat. Duis autem vel eum iriure dolor in hendrerit in vulputate velit esse molestie consequat, vel illum dolore eu feugiat nulla facilisis at vero eros et accumsan et iusto odio dignissim qui blandit prae-sent luptatum zzril delenit augue duis dolore te feugait nulla facil-isi. Nam liber tempor cum soluta nobis eleifend option congue nihil imperdiet doming id quod mazim placerat facer possim assum. Lorem ipsum dolor sit

amet, consectetuer adipiscing elit, sed diam nonummy nibh euismod tincidunt ut laoreet dolore magna aliquam erat volut-pat. Ut wisi enim ad minim veni-am, quis nostrud exerci tation ullamcorper suscipit lobortis nisl ut aliquip ex ea commodo conse-quat. Duis autem vel eum iriure dolor in hendrerit in vulputate velit esse molestie consequat, vel illum dolore eu feugiat nulla facilisis at vero eros et accumsan et iusto odio dignissim qui bland-it praesent luptatum zzril delenit augue duis dolore te feugait nulla facilisi. Lorem ipsum dolor sit amet, consectetuer adip Lorem ipsum dolor sit amet, con-sectetuer adipiscing elit, sed diam nonummy nibh euismod tin-cidunt ut laoreet dolore magna aliquam erat volutpat. Ut wisi enim ad minim veniam, quis nos-trud exerci tation ullamcorper suscipit lobortis nisl ut aliquip ex ea commodo consequat. Duis autem vel eum iriure dolor in hendrerit in vulputate velit esse molestie consequat, vel illum dolore eu feugiat nulla facilisis at vero eros et accumsan et iusto odio dignissim qui blandit prae-sent luptatum zzril delenit augue duis dolore te feugait nulla facil-isi. Lorem ipsum dolor sit amet, consectetuer adipiscing elit, sed diam nonummy nibh euismod tincidunt ut laoreet dolore magna aliquam erat volutpat. Ut wisi enim ad minim veniam, quis nos-trud exerci tation ullamcorper suscipit lobortis nisl ut aliquip ex ea commodo consequat. Duis autem vel eum iriure dolor in hendrerit in vulputate velit esse molestie consequat, vel illum dolore eu feugiat nulla facilisis at

3-column layout

One place to begin is to think of your text area divided into columns— consistent horizontal intervals that allow for more than one field of text per page. Working with columnar layouts helps you maintain a manageable line length and allows white space onto the page in places other than the margins. Keep in mind the dynamic relationship between type size, leading, and line length. Altering the last always affects the first and the second.

Lorem ipsum dolor sit amet

Lorem ipsum dolor sit amet

5-column layout

Notice how a 5-column layout allows for two fields of text and a third, narrower field for secondary information, such as notes, author profile, etc. The narrower field may in fact be too narrow for any kind of sustained reading.

8-column layout

You can see how this application does much the same as a 5-column layout, with slightly narrower fields of text and a wider field for supplemental information. Obviously, many other variations are possible.

128 Horizontal layouts allow for wider fields of text, which tend to support sustained reading more comfortably than narrower fields.

Lorem ipsum dolor sit amet

Lorem ipsum dolor sit amet, consectetuer adipiscing elit, sed diam nonummy nibh euismod tincidunt ut laoreet dolore magna aliquam erat volutpat. Ut wisi enim ad minim veniam, quis nostrud exerci tation ullamcorper suscipit lobortis nisl ut aliquip ex ea commodo consequat. Duis autem vel eum iriure dolor in hendrerit in vulputate velit esse molestie consequat, vel illum dolore eu feugiat nulla facilisis at vero eros et accumsan et iusto odio dignissim qui blandit praesent luptatum zzril delenit augue duis dolore te feugait nulla facilisi. Lorem ipsum dolor sit amet, consectetuer adipiscing elit, sed diam nonummy nibh euismod tincidunt ut laoreet dolore magna aliquam erat volutpat. Ut wisi enim ad minim veniam, quis nostrud exerci tation ullamcorper suscipit lobortis nisl ut aliquip ex ea commodo consequat. Duis autem vel eum iriure dolor in hendrerit in vulputate velit esse molestie consequat, vel illum dolore eu feugiat nulla facilisis at vero eros et accumsan et iusto odio dignissim qui blandit prae- sent luptatum zzril delenit augue duis dolore te feugait nulla facilisi. Nam liber tempor cum soluta nobis eleifend option congue nihil imperdiet doming id quod mazim placerat facer possim assum. Lorem ipsum dolor sit amet, con- sectetuer adipiscing elit, sed diam nonummy nibh euismod tincidunt ut laoreet dolore magna aliquam erat volutpat. Ut wisi enim ad minim veniam, quis nos- trud exerci tation ullamcorper suscipit lobortis nisl ut aliquip ex ea commodo consequat. Duis autem vel eum iriure dolor in hendrerit in vulputate velit esse molestie consequat, vel illum dolore eu feugiat nulla facilisis at vero eros et accumsan et iusto odio dignissim qui blandit praesent luptatum zzril delenit augue duis dolore te feugait nulla facilisi. Lorem ipsum dolor sit amet, con- sectetuer adip Lorem ipsum dolor sit amet, consectetuer adipiscing elit, sed diam nonummy nibh euismod tincidunt ut laoreet dolore magna aliquam erat volutpat. Ut wisi enim ad minim veniam, quis nostrud exerci tation ullamcorp-

er suscipit lobortis nisl ut aliquip ex ea commodo consequat. Duis autem vel eum iriure dolor in hendrerit in vulputate velit esse molestie consequat, vel illum dolore eu feugiat nulla facilisis at vero eros et accumsan et iusto odio dig- nissim qui blandit praesent luptatum zzril delenit augue duis dolore te feugait nulla facilisi. Lorem ipsum dolor sit amet, consectetuer adipiscing elit, sed diam nonummy nibh euismod tincidunt ut laoreet dolore magna aliquam erat volutpat. Ut wisi enim ad minim veniam, quis nostrud exerci tation ullamcorp- er suscipit lobortis nisl ut aliquip ex ea commodo consequat. Duis autem vel eum iriure dolor in hendrerit in vulputate velit esse molestie consequat, vel illum dolore eu feugiat nulla facilisis at vero eros et accumsan et iusto odio dig- nissim qui blandit praesent luptatum zzril delenit augue duis dolore te feugait nulla facilisi. Nam liber tempor cum soluta nobis eleifend option congue nihil imperdiet doming id quod mazim placerat facer possim assum. Lorem ipsum dolor sit amet, consectetuer adipiscing elit, sed diam nonummy nibh euismod tincidunt ut laoreet dolore magna aliquam erat volutpat. Ut wisi enim ad minim veniam, quis nostrud exerci tation ullamcorper suscipit lobortis nisl ut aliquip ex ea commodo consequat. Duis autem vel eum iriure dolor in hen- drerit in vulputate velit esse molestie consequat, vel illum dolore eu feugiat nulla facilisis at vero eros et accumsan et iusto odio dignissim qui blandit prae- sent luptatum zzril delenit augue duis dolore te feugait nulla facilisi. Lorem ipsum dolor sit amet, consectetuer adipiscing elit, sed diam nonummy nibh euismod tincidunt ut laoreet dolore magna aliquam erat volutpat. Ut wisi enim ad minim veniam, quis nostrud exerci tation ullamcorper suscipit lobortis nisl ut aliquip ex ea commodo consequat. Duis autem vel eum iriure dolor in hen- drerit in vulputate velit esse molestie consequat, vel illum dolore eu feugiat nulla facilisis at vero eros et accumsan et iusto odio dignissim qui blandit prae- sent luptatum zzril delenit augue duis dolore te feugait nulla facilisi. Lorem ipsum dolor sit amet, con- sectetuer adipiscing elit, sed diam nonummy nibh euismod tincidunt ut laoreet dolore magna aliquam erat volutpat. Ut wisi enim ad minim veniam, quis nostrud exerci tation ullamcorper suscipit lobortis nisl ut aliquip ex ea commodo consequat. Duis autem vel eum iriure dolor in hen- drerit in vulputate velit esse molestie consequat, vel illum dolore eu feugiat nulla facilisis at vero eros et

2-column layout

Lorem ipsum dolor sit amet

Lorem ipsum dolor sit amet, consectetuer adipisc- ing elit, sed diam nonummy nibh euismod tin- cidunt ut laoreet dolore magna aliquam erat volut- pat. Ut wisi enim ad minim veniam, quis nostrud exerci tation ullamcorper suscipit lobortis nisl ut aliquip ex ea commodo consequat. Duis autem vel eum iriure dolor in hendrerit in vulputate velit esse molestie consequat, vel illum dolore eu feugiat nulla facilisis at vero eros et accumsan et iusto odio dignissim qui blandit praesent luptatum zzril delenit augue duis dolore te feugait nulla facilisi. Lorem ipsum dolor sit amet, consectetuer adipisc- ing elit, sed diam nonummy nibh euismod tin- cidunt ut laoreet dolore magna aliquam erat volut- pat. Ut wisi enim ad minim veniam, quis nostrud exerci tation ullamcorper suscipit lobortis nisl ut aliquip ex ea commodo consequat. Duis autem vel eum iriure dolor in hendrerit in vulputate velit esse molestie consequat, vel illum dolore eu feugiat nulla facilisis at vero eros et accumsan et iusto odio dignissim qui blandit praesent luptatum zzril delenit augue duis dolore te feugait nulla facilisi. Nam liber tempor cum soluta nobis eleifend option congue nihil imperdiet doming id quod mazim placerat facer possim assum. Lorem ipsum dolor sit amet, consectetuer adipiscing elit, sed

diam nonummy nibh euismod tincidunt ut laoreet dolore magna aliquam erat volutpat. Ut wisi enim ad minim veniam, quis nostrud exerci tation ullam- corper suscipit lobortis nisl ut aliquip ex ea com- modo consequat. Duis autem vel eum iriure dolor in hendrerit in vulputate velit esse molestie conse- quat, vel illum dolore eu feugiat nulla facilisis at vero eros et accumsan et iusto odio dignissim qui blandit praesent luptatum zzril delenit augue duis dolore te feugait nulla facilisi. Lorem ipsum dolor sit amet, consectetuer Lorem ipsum dolor sit amet, consectetuer adipiscing elit, sed diam non- ummy nibh euismod tincidunt ut laoreet dolore magna aliquam erat volutpat. Ut wisi enim ad minim veniam, quis nostrud exerci tation ullamcor- per suscipit lobortis nisl ut aliquip ex ea commodo consequat. Duis autem vel eum iriure dolor in hen- drerit in vulputate velit esse molestie consequat, vel illum dolore eu feugiat nulla facilisis at vero eros et accumsan et iusto odio dignissim qui blandit prae- sent luptatum zzril delenit augue duis dolore te feugait nulla facilisi. Lorem ipsum dolor sit amet, consectetuer adipiscing elit, sed diam nonummy nibh euismod tincidunt ut laoreet dolore magna aliquam erat volutpat. Ut wisi enim ad minim veni- am, quis nostrud exerci tation ullamcorper suscipit

lobortis nisl ut aliquip ex ea commodo consequat. Duis autem vel eum iriure dolor in hendrerit in vulputate velit esse molestie consequat, vel illum dolore eu feugiat nulla facilisis at vero eros et feugiat nulla facilisi. Nam liber tempor cum soluta nobis eleifend option congue nihil imperdiet dom- ing id quod mazim placerat facer possim assum. Lorem ipsum dolor sit amet, consectetuer adipisc- ing elit, sed diam nonummy nibh euismod tin- cidunt ut laoreet dolore magna aliquam erat volut- pat. Ut wisi enim ad minim veniam, quis nostrud exerci tation ullamcorper suscipit lobortis nisl ut aliquip ex ea commodo consequat. Duis autem vel eum iriure dolor in hendrerit in vulputate velit esse molestie consequat, vel illum dolore eu feugiat nulla facilisis at vero eros et accumsan et iusto odio dignissim qui blandit praesent luptatum zzril delenit augue duis dolore te feugait nulla facilisi. Lorem ipsum dolor sit amet, consectetuer adipisc- ing elit, sed diam nonummy nibh euismod tin- cidunt ut laoreet dolore magna aliquam erat volut- pat. Ut wisi enim ad minim veniam, quis nostrud exerci tation ullamcorper suscipit lobortis nisl ut

3-column layout

Lorem ipsum dolor sit amet

Lorem ipsum dolor sit amet, consectetuer adipiscing elit, sed diam nonummy nibh euismod tincidunt ut laoreet dolore magna aliquam erat volutpat. Ut wisi enim ad minim veniam, quis nostrud exerci tation ullamcorper suscipit lobortis nisl ut aliquip ex ea commodo consequat. Duis autem vel eum iriure dolor in hendrerit in vulputate velit esse molestie consequat, vel illum dolore eu feugiat nulla facilisis at vero eros et accumsan et iusto odio dignissim qui blandit praesent luptatum zzril delenit augue duis dolore te feugait nulla facilisi. Lorem ipsum dolor sit amet, consectetuer adipiscing elit, sed diam nonummy nibh euismod tincidunt ut laoreet dolore magna aliquam erat volutpat. Ut wisi enim ad minim veniam, quis nostrud exerci tation ullamcorper suscipit lobortis nisl ut aliquip ex ea commodo consequat. Duis autem vel eum iriure dolor in hendrerit in vulputate velit esse molestie consequat, vel illum dolore eu feugiat nulla facilisis at vero eros et accumsan et iusto odio dignissim qui blandit praesent luptatum zzril delenit augue duis dolore te feugait nulla facilisi. Nam liber tempor cum soluta nobis eleifend option congue nihil imperdiet doming id quod mazim placerat facer possim assum. Lorem ipsum dolor sit amet, consectetuer adipiscing elit, sed diam nonummy nibh euismod tincidunt ut laoreet dolore magna aliquam erat volutpat. Ut wisi enim ad minim veniam, quis nostrud exerci tation ullamcorper suscipit lobortis nisl ut aliquip ex ea commodo consequat. Duis autem vel eum iriure dolor in hendrerit in vulputate velit esse molestie consequat, vel illum

dolore eu feugiat nulla facilisis at vero eros et accumsan et iusto odio dignissim qui blandit praesent luptatum zzril delenit augue duis dolore te feugait nulla facilisi. Lorem ipsum dolor sit amet, consectetuer adip iscing elit, sed diam nonummy nibh euismod tincidunt ut laoreet dolore magna aliquam erat volutpat. Ut wisi enim ad minim veniam, quis nostrud exerci tation ullamcorper suscipit lobortis nisl ut aliquip ex ea commodo consequat. Duis autem vel eum iriure dolor in hendrerit in vulputate velit esse molestie consequat, vel illum dolore eu feugiat nulla facilisis at vero eros et accumsan et iusto odio dignissim qui blandit praesent luptatum zzril delenit augue duis dolore te feugait nulla facilisi. Lorem ipsum dolor sit amet, consectetuer adipiscing elit, sed diam nonummy nibh euismod tincidunt ut laoreet dolore magna aliquam erat volutpat. Ut wisi enim ad minim veniam, quis nostrud exerci tation ullamcorper suscipit lobortis nisl ut aliquip ex ea commodo consequat. Duis autem vel eum iriure dolor in hendrerit in vulputate velit esse molestie consequat, vel illum dolore eu feugiat nulla facilisis at vero eros et accumsan et iusto odio dignissim qui blandit praesent luptatum zzril delenit augue duis dolore te feugait nulla facilisi. Nam liber tempor cum soluta nobis eleifend option congue nihil imperdiet doming id quod mazim placerat facer possim assum. Lorem ipsum dolor sit amet, consectetuer adipiscing elit, sed diam nonummy nibh euismod tincidunt ut laoreet dolore magna aliquam erat volutpat. Ut

5-column layout

Lorem ipsum dolor sit amet

Lorem ipsum dolor sit amet, consectetuer adipisc ing elit, sed diam nonummy nibh euismod tin cidunt ut laoreet dolore magna aliquam erat volut pat. Ut wisi enim ad minim veniam, quis nostrud exerci tation ullamcorper suscipit lobortis nisl ut aliquip ex ea commodo consequat. Duis autem vel eum iriure dolor in hendrerit in vulputate velit esse molestie consequat, vel illum dolore eu feugiat nulla facilisis at vero eros et accumsan et iusto odio dignissim qui blandit praesent luptatum zzril delenit augue duis dolore te feugait nulla facilisi. Lorem ipsum dolor sit amet, consectetuer adipisc ing elit, sed diam nonummy nibh euismod tin cidunt ut laoreet dolore magna aliquam erat volut pat. Ut wisi enim ad minim veniam, quis nostrud exerci tation ullamcorper suscipit lobortis nisl ut aliquip ex ea commodo consequat. Duis autem vel eum iriure dolor in hendrerit in vulputate velit esse molestie consequat, vel illum dolore eu feugiat nulla facilisis at vero eros et accumsan et iusto odio dignissim qui blandit praesent luptatum zzril delenit augue duis dolore te feugait nulla facilisi. Nam liber tempor cum soluta nobis eleifend option congue nihil imperdiet doming id quod mazim placerat facer possim assum. Lorem ipsum dolor sit amet, consectetuer adipiscing elit, sed

diam nonummy nibh euismod tincidunt ut laoreet dolore magna aliquam erat volutpat. Ut wisi enim ad minim veniam, quis nostrud exerci tation ullam corper suscipit lobortis nisl ut aliquip ex ea com modo consequat. Duis autem vel eum iriure dolor in hendrerit in vulputate velit esse molestie conse quat, vel illum dolore eu feugiat nulla facilisis at vero eros et accumsan et iusto odio dignissim qui blandit praesent luptatum zzril delenit augue duis dolore te feugait nulla facilisi. Lorem ipsum dolor sit amet, consectetuer adipiscing elit, sed diam nonummy nibh euismod tincidunt ut laoreet dolore magna aliquam erat volutpat. Ut wisi enim ad minim veniam, quis nostrud exerci tation ullam corper suscipit lobortis nisl ut aliquip ex ea com modo consequat. Duis autem vel eum iriure dolor in hendrerit in vulputate velit esse molestie conse quat, vel illum dolore eu feugiat nulla facilisis at vero eros et accumsan et iusto odio dignissim qui blandit praesent luptatum zzril delenit augue duis dolore te feugait nulla facilisi. Lorem ipsum dolor sit amet, consectetuer adipiscing elit, sed diam nonummy nibh euismod tincidunt ut laoreet dolore magna aliquam erat volutpat. Ut wisi enim ad minim veniam, quis nostrud exerci tation ullam

6-column layout

Six columns allow for two wide fields and two narrow fields per page, which can be useful in heavily annotated documents.

Lorem ipsum dolor sit amet

Lorem ipsum dolor sit amet

Most often, text layouts will involve spreads (two facing pages) and not single sheets. Always keep the spread in mind when you're setting up your page. You can see here how different a spread of horizontal pages (top) feels from a spread of vertical pages (bottom).

Lorem ipsum dolor sit amet

Lorem ipsum dolor sit amet

Lorem ipsum dolor sit amet, consecteuer adipiscing elit, sed diam nonummy nibh euismod tincidunt ut laoreet dolore magna aliquam erat volutpat. Ut wisi enim ad minim veniam, quis nostrud exerci tation ullamcorper suscipit lobortis nisl ut aliquip ex ea commodo consequat. Duis autem vel eum iriure dolor in hendrerit in vulputate velit esse molestie consequat, vel illum dolore eu feugiat nulla facilisis at vero eros et accumsan et iusto odio dignissim qui blandit praesent luptatum zzril delenit augue duis dolore te feugait nulla facilisi. Lorem ipsum dolor sit amet, consectetuer adipiscing elit, sed diam nonummy nibh euismod tincidunt ut laoreet dolore magna aliquam erat volutpat. Ut wisi enim ad minim veniam, quis nostrud exerci tation ullamcorper suscipit lobortis nisl ut aliquip ex ea commodo consequat. Duis autem vel eum iriure dolor in hendrerit in vulputate velit esse molestie consequat, vel illum dolore eu feugiat nulla facilisis at vero eros et accumsan et iusto odio dignissim qui blandit praesent luptatum zzril delenit augue duis dolore te feugait nulla facilisi. Nam liber tempor cum soluta nobis eleifend option congue nihil imperdiet doming id quod mazim placerat facer possim assum. Lorem ipsum dolor sit amet, consectetuer adipiscing elit, sed diam nonummy

Consecteter adipiscing elit

Nibh euismod tincidunt ut laoreet dolore magna aliquam erat volutpat. Ut wisi enim ad minim veniam, quis nostrud exerci tation ullamcorper suscipit lobortis nisl ut aliquip ex ea commodo consequat. Duis autem vel eum iriure dolor in hendrerit in vulputate velit esse molestie consequat, vel illum dolore eu feugiat nulla facilisis at vero eros et accumsan et iusto odio dignissim qui blandit praesent luptatum zzril delenit augue duis dolore te feugait nulla facilisi. Lorem ipsum dolor sit amet, consectetuer adip Lorem ipsum dolor sit amet, consectetuer adipiscing elit, sed diam nonummy nibh euismod

Sed diam nonummy nibh

Tincidunt ut laoreet dolore magna aliquam erat volutpat. Ut wisi enim ad minim veniam, quis nostrud exerci tation ullamcorper suscipit lobortis nisl ut aliquip ex ea commodo consequat. Duis autem vel eum iriure dolor in hendrerit in vulputate velit esse molestie consequat, vel illum dolore eu feugiat nulla facilisis at vero eros et accumsan et iusto odio dignissim qui blandit praesent luptatum zzril delenit augue duis dolore te feugait nulla facilisi. Lorem ipsum dolor sit amet, consectetuer adipiscing elit, sed diam nonummy nibh euismod tincidunt ut laoreet dolore magna aliquam erat volutpat. Ut wisi enim ad minim veniam, quis nostrud exerci tation ullamcorper suscipit

Ut wisi enim ad minim

Lobortis nisl ut aliquip ex ea commodo consequat. Duis autem vel eum iriure dolor in hendrerit in vulputate velit esse molestie consequat, vel illum dolore eu feugiat nulla facilisis at vero eros et accumsan et iusto odio dignissim qui blandit

Veniam quis nostrud exerci tati

Praesent luptatum zzril delenit augue duis dolore te feugait nulla facilisi. Nam liber tempor cum soluta nobis eleifend option congue nihil imperdiet doming id quod mazim placerat facer possim assum. Lorem ipsum dolor sit amet, consectetuer adipiscing elit, sed diam nonummy nibh euismod tincidunt ut laoreet dolore magna aliquam erat volutpat. Ut wisi enim ad minim veniam, quis nostrud exerci tation ullamcorper suscipit lobortis nisl ut aliquip ex ea commodo consequat. Duis autem vel eum iriure dolor in hendrerit in vulputate velit esse molestie consequat, vel illum dolore eu feugiat nulla facilisis at vero eros et accumsan et iusto odio dignissim qui blandit praesent luptatum zzril delenit augue duis dolore te feugait nulla facilisi. Lorem ipsum dolor sit amet, consectetuer adip Lorem ipsum dolor sit amet, consectetuer adipiscing elit, sed diam nonummy nibh euismod tincidunt ut laoreet dolore magna aliquam erat volutpat. Ut

Columnar layouts are effective for many different formats. Above, a 3-column layout is applied to each of the three panels on an 8 1/2 x 11" (216 x 279 mm) sheet.

132 In most circumstances, a designer's first goal is to make material comprehensible to a reader. In other words, you should understand the material well enough to know how someone else needs to read it to make the best sense out of it. This understanding happens on two levels: content and form.

The recipe opposite is a fairly straightforward presentation of the making of an apple tart. With the exception of one or two terms specific to cooking, its content does not require any special knowledge. However, in its form—the manner in which information is set and placed on a page—the process it describes can be made clearer than it appears as plain typescript.

To understand the form, you must first understand the kinds of infor- mation the recipe contains and then rank it according to levels of impor- tance, thereby creating a hierarchy. In this recipe there are the following levels of information:
title (1)
subtitles (2)
text (3).
Within the text there are
ingredient lists (3A)
oven temperature instructions (3B)
directions (3C).

Successfully setting this recipe in type requires that you make each of these distinctions clear to the reader. Using some of the kinds of contrast discussed on pages 60–61 will help you express these distinctions.

Apple tart

The shell

7 tablespoons frozen butter*
1 cup frozen flour*
3 tablespoons ice-cold water*
1 teaspoon cider vinegar
A pinch of kosher salt
* It is important to have these ingredients as cold as possible.

Preheat the oven to 400°.

In a food processor fitted with a steel blade, combine all the ingredients until they form a solid mass that rises above the blade. You can add extra water by the tablespoon if the mass does not congeal within the first minute. Tiny pieces of butter should still be visible in the dough when it's done. Remove the dough from the bowl and work it quickly into a ball on a lightly floured surface. Cover with plastic wrap and refrigerate for at least half an hour.

After the dough has rested in the refrigerator, roll it out on a lightly floured surface until it forms a circle approximately 13 inches in diameter. Center the circle of dough in a 10-inch tart pan with a removeable bottom. Use your knuckles to make sure that the dough tucks neatly against the edge of the pan and run the rolling pin around the rim to remove the excess. Cover and refrigerate again for at least half an hour.

Line the tart shell with aluminum foil, being careful to cover the edges. Pierce the aluminum and the dough several times with a fork and fill the shell with dried lentils. Bake for 20 minutes. Remove the aluminum and the lentils and continue baking until the shell is golden brown, about 15 minutes more.

The apples

6 Granny Smith apples
Juice of one lemon
Cinnamon to taste
Nutmeg to taste

Peel, core and halve the apples. Either by hand or with a food processor, cut the apple halves crosswise into thin (less than 1/4") slices. In a large bowl, toss the apples in the lemon juice, cinnamon and nutmeg. Cover and set aside.

The pastry cream

1/4 cup sugar
1 tablespoon flour
2 teaspoons cornstarch
1 large egg
1 cup milk
3 tablespoons unsalted butter
1/4 teaspoon vanilla extract

Sift the sugar, flour and cornstarch together in a mixing
bowl. Add the egg and beat until light. In a heavy-
bottomed saucepan, bring the milk to a boil. Stir half
the milk into the egg mixture, then pour the whole
mixture back into the saucepan. Cook over high heat,
stirring constantly, until the center bubbles and the
mixture is very thick. Remove from heat and stir in the
vanilla and the butter. Pour the pastry cream into a
bowl, cover tightly with plastic wrap and refrigerate.
(Be sure to press the plastic wrap right onto the cream
to prevent a skin from forming.)

The assembly and baking

2 tablespoons sugar
8 ounces currant jelly

Preheat the oven to 375°.

Spread the pastry cream over the bottom of the shell.
Arrange the apple slices in a circle around the outer
edge of the shell, making sure the slices overlap. When
the outer circle is completed, make a smaller circle,
overlapping about half of the outer circle. If there's
room, make a third circle. Fill the hole in the center
with pieces of a few slices--let them stand upright.
Cover the tart with a circle of wax paper and bake for
25 minutes. Remove the wax paper and sprinkle the sugar
over the apples. Bake uncovered for 5-10 minutes more,
until the sugar melts.

Boil the currant jelly until it reduces by one-third.
With a pastry brush, paint the top of the tart with the
currant glaze. Allow time for the glaze to set and the
tart to cool before serving (10 minutes).

Apple tart

The shell

Preheat the oven to 400°.

7 tablespooons frozen butter*
1 cup frozen flour*
3 tablespoons ice-cold water*
1 teaspoon cider vinegar
A pinch of kosher salt
* It is important to have these ingredients
as cold as possible.

In a food processor fitted with a steel blade, combine all the ingredients until they form a solid mass that rises above the blade. You can add extra water by the tablespoon if the mass does not congeal within the first minute. Tiny pieces of butter should still be visible in the dough when it's done. Remove the dough from the bowl and work it quickly it into a ball on a lightly floured surface. Cover with plastic wrap and refrigerate for at least half an hour.

After the dough has rested in the refrigerator, roll it out on a lightly floured surface until it forms a circle approximately 13" in diameter. Center the circle of dough in a 10-inch tart pan with a removeable bottom. Use your knuckles to make sure that the dough tucks neatly against the edge of the pan and run the rolling pin around the rim to remove the excess. Cover and refrigerate again for at least half an hour.

Line the tart shell with aluminum foil, being careful to cover the edges. Pierce the aluminum and the dough several times with a fork and fill the shell with dried lentils. Bake for 20 minutes. Remove the aluminum and the lentils and continue baking until the shell is golden brown, about 15 minutes more.

The apples

6 Granny Smith apples
Juice of one lemon
Cinammon to taste
Nutmeg to taste

Peel, core and halve the apples. Either by hand or with a food processor, cut the apple halves crosswise into thin (less than ¼") slices. In a large bowl, toss the appples in the lemon juice, cinammon and nutmeg. Cover and set aside.

The pastry cream

¼ cup sugar
1 tablespoon flour
2 teaspoons cornstarch
1 large egg
1 cup milk
3 tablespoons unsalted butter
¼ teaspoon vanilla extract

Sift the sugar, flour and cornstarch together in a mixing bowl. Add the egg and beat until light. In a heavy-bottomed saucepan, bring the milk to a boil. Stir half the milk into the egg mixture, then pour the whole mixture back into the saucepan. Cook over high heat, stirring constantly, until the center bubbles and the mixture is very thick. Remove from heat and stir in the vanilla and the butter. Pour the pastry cream into a bowl, cover tightly with plastic wrap and refrigerate. (Be sure to press the plastic wrap right onto the cream to prevent a skin from forming.)

The assembly and baking

Preheat the oven to 375°.

2 tablespoons sugar
8 ounces currant jelly

Spread the pastry cream over the bottom of the shell. Arrange the apple slices in a circle around the outer edge of the shell, making sure the slices overlap. When the outer circle is completed, make a smaller circle, overlapping about half of the outer circle. If there's room, make a third circle. fill the hole in the center with pieces of a few slices—let them stand upright. Cover the tart with a circle of wax paper and bake for 25 minutes. Remove the wax paper and sprinkle the sugar over the apples. Bake uncovered for 5-10 minutes more, until the sugar melts.

Boil the currant jelly until it reduces by one-third. With a pastry brush, paint the top of the tart with the currant glaze. Allow time for the glaze to set before serving (10 minutes).

Option 1
One typeface, one size
throughout

9/11 Adobe Garamond

Establishing a format

After analyzing and organizing the content, devise a format that expresses differences within the text. In Option 1 (opposite), all the ingredients are separated from the directions. Because the line length required for easy reading of directions is more or less twice the line length required for a list of ingredients, the area within the margins of the sheet is divided vertically into three intervals, or columns. Ingredients occupy the first column, directions the second and third. Groups of ingredients cross-align with the directions that refer to them.

Establishing a hierarchy

Single line spaces indicate breaks between paragraphs. Double line spaces indicate breaks between sections of text.

Typeface choice

When numbers and fractions occur frequently in the text, choose a typeface with an expert set that includes lowercase numerals and fraction characters. (See page 6 for a brief discussion of lowercase numerals.)

Ligatures

Virtually all text typefaces have ligatures for fi and fl combinations. Some also have ligatures for ff, ffi, and ffl.

Apple tart

The shell

Preheat the oven to 400°.

7 tablespooons frozen butter*
1 cup frozen flour*
3 tablespoons ice-cold water*
1 teaspoon cider vinegar
A pinch of kosher salt
* It is important to have these ingredients as
cold as possible.

In a food processor fitted with a steel blade, combine all the ingredients until they form a solid mass that rises above the blade. You can add extra water by the tablespoon if the mass does not congeal within the first minute. Tiny pieces of butter should still be visible in the dough when it's done. Remove the dough from the bowl and work it quickly it into a ball on a lightly floured surface. Cover with plastic wrap and refrigerate for at least half an hour.

After the dough has rested in the refigerator, roll it out on a lightly floured surface until it forms a circle approximately 13" in diameter. Center the circle of dough in a 10-inch tart pan with a removeable bottom. Use your knuckles to make sure that the dough tucks neatly against the edge of the pan and run the rolling pin around the rim to remove the excess. Cover and refrigerate again for at least half an hour.

Line the tart shell with aluminum foil, being careful to cover the edges. Pierce the aluminum and the dough several times with a fork and fill the shell with dried lentils. Bake for 20 minutes. Remove the aluminum and the lentils and continue baking until the shell is golden brown, about 15 minutes more.

The apples

6 Granny Smith apples
Juice of one lemon
Cinammon to taste
Nutmeg to taste

Peel, core and halve the apples. Either by hand or with a food processor, cut the apple halves crosswise into thin (less than ¼") slices. In a large bowl, toss the appples in the lemon juice, cinammon and nutmeg. Cover and set aside.

The pastry cream

¼ cup sugar
1 tablespoon flour
2 teaspoons cornstarch
1 large egg
1 cup milk
3 tablespoons unsalted butter
¼ teaspoon vanilla extract

Sift the sugar, flour and cornstarch together in a mixing bowl. Add the egg and beat until light. In a heavy-bottomed saucepan, bring the milk to a boil. Stir half the milk into the egg mixture, then pour the whole mixture back into the saucepan. Cook over high heat, stirring constantly, until the center bubbles and the mixture is very thick. Remove from heat and stir in the vanilla and the butter. Pour the pastry cream into a bowl, cover tightly with plastic wrap and refrigerate. (Be sure to press the plastic wrap right onto the cream to prevent a skin from forming.)

The assembly and baking

2 tablespoons sugar
8 ounces currant jelly

Preheat the oven to 375°.

Spread the pastry cream over the bottom of the shell. Arrange the apple slices in a circle around the outer edge of the shell, making sure the slices overlap. When the outer circle is completed, make a smaller circle, overlapping about half of the outer circle. If there's room, make a third circle. Fill the hole in the center with pieces of a few slices—let them stand upright. Cover the tart with a circle of wax paper and bake for 25 minutes. Remove the wax paper and sprinkle the sugar over the apples. Bake uncovered for 5-10 minutes more, until the sugar melts.

Boil the currant jelly until it reduces by one-third. With a pastry brush, paint the top of the tart with the currant glaze. Allow time for the glaze to set before serving (10 minutes).

Option 2
Type set flush right and flush left

9/11 Adobe Garamond

Apple tart

The shell

Preheat the oven to 400°.

7 tablespooons frozen butter*
1 cup frozen flour*
3 tablespoons ice-cold water*
1 teaspoon cider vinegar
A pinch of kosher salt
* It is important to have these ingredients as
cold as possible.

In a food processor fitted with a steel blade, combine all the ingredients until they form a solid mass that rises above the blade. You can add extra water by the tablespoon if the mass does not congeal within the first minute. Tiny pieces of butter should still be visible in the dough when it's done. Remove the dough from the bowl and work it quickly it into a ball on a lightly floured surface. Cover with plastic wrap and refrigerate for at least half an hour.

After the dough has rested in the refigerator, roll it out on a lightly floured surface until it forms a circle approximately 13" in diameter. Center the circle of dough in a 10-inch tart pan with a removeable bottom. Use your knuckles to make sure that the dough tucks neatly against the edge of the pan and run the rolling pin around the rim to remove the excess. Cover and refrigerate again for at least half an hour.

Line the tart shell with aluminum foil, being careful to cover the edges. Pierce the aluminum and the dough several times with a fork and fill the shell with dried lentils. Bake for 20 minutes. Remove the aluminum and the lentils and continue baking until the shell is golden brown, about 15 minutes more.

The apples

6 Granny Smith apples
Juice of one lemon
Cinammon to taste
Nutmeg to taste

Peel, core and halve the apples. Either by hand or with a food processor, cut the apple halves crosswise into thin (less than ¼") slices. In a large bowl, toss the appples in the lemon juice, cinammon and nutmeg. Cover and set aside.

The pastry cream

¼ cup sugar
1 tablespoon flour
2 teaspoons cornstarch
1 large egg
1 cup milk
3 tablespoons unsalted butter
¼ teaspoon vanilla extract

Sift the sugar, flour and cornstarch together in a mixing bowl. Add the egg and beat until light. In a heavy-bottomed saucepan, bring the milk to a boil. Stir half the milk into the egg mixture, then pour the whole mixture back into the saucepan. Cook over high heat, stirring constantly, until the center bubbles and the mixture is very thick. Remove from heat and stir in the vanilla and the butter. Pour the pastry cream into a bowl, cover tightly with plastic wrap and refrigerate. (Be sure to press the plastic wrap right onto the cream to prevent a skin from forming.)

The assembly and baking

2 tablespoons sugar
8 ounces currant jelly

Preheat the oven to 375°.

Spread the pastry cream over the bottom of the shell. Arrange the apple slices in a circle around the outer edge of the shell, making sure the slices overlap. When the outer circle is completed, make a smaller circle, overlapping about half of the outer circle. If there's room, make a third circle. Fill the hole in the center with pieces of a few slices—let them stand upright. Cover the tart with a circle of wax paper and bake for 13 minutes. Remove the wax paper and sprinkle the sugar over the apples. Bake uncovered for 5-10 minutes more, until the sugar melts.

Boil the currant jelly until it reduces by one-third. With a pastry brush, paint the top of the tart with the currant glaze. Allow time for the glaze to set before serving (10 minutes).

Reinforcing structure

Setting the ingredients flush right against the gutter between the first and second columns strengthens the formal organization of the page. Keep in mind, setting type flush right causes one to read the shape created by the type before one reads the actual text. Similarly, the counterform created by the gutter between the two kinds of text (ingredients and directions) becomes a dominant, possibly intrusive element on the page.

Apple tart

The shell

Preheat the oven to 400°.

7 tablespooons frozen butter*
1 cup frozen flour*
3 tablespoons ice-cold water*
1 teaspoon cider vinegar
A pinch of kosher salt

* *It is important to have these ingredients as cold as possible.*

In a food processor fitted with a steel blade, combine all the ingredients until they form a solid mass that rises above the blade. You can add extra water by the tablespoon if the mass does not congeal within the first minute. Tiny pieces of butter should still be visible in the dough when it's done. Remove the dough from the bowl and work it quickly it into a ball on a lightly floured surface. Cover with plastic wrap and refrigerate for at least half an hour.

After the dough has rested in the refrigerator, roll it out on a lightly floured surface until it forms a circle approximately 13" in diameter. Center the circle of dough in a 10-inch tart pan with a removeable bottom. Use your knuckles to make sure that the dough tucks neatly against the edge of the pan and run the rolling pin around the rim to remove the excess. Cover and refrigerate again for at least half an hour.

Line the tart shell with aluminum foil, being careful to cover the edges. Pierce the aluminum and the dough several times with a fork and fill the shell with dried lentils. Bake for 20 minutes. Remove the aluminum and the lentils and continue baking until the shell is golden brown, about 15 minutes more.

The apples

6 Granny Smith apples
Juice of one lemon
Cinammon to taste
Nutmeg to taste

Peel, core and halve the apples. Either by hand or with a food processor, cut the apple halves crosswise into thin (less than 1/4") slices. In a large bowl, toss the appples in the lemon juice, cinammon and nutmeg. Cover and set aside.

The pastry cream

1/4 cup sugar
1 tablespoon flour
2 teaspoons cornstarch
1 large egg
1 cup milk
3 tablespoons unsalted butter
1/4 teaspoon vanilla extract

Sift the sugar, flour and cornstarch together in a mixing bowl. Add the egg and beat until light. In a heavy-bottomed saucepan, bring the milk to a boil. Stir half the milk into the egg mixture, then pour the whole mixture back into the saucepan. Cook over high heat, stirring constantly, until the center bubbles and the mixture is very thick. Remove from heat and stir in the vanilla and the butter. Pour the pastry cream into a bowl, cover tightly with plastic wrap and refrigerate. (Be sure to press the plastic wrap right onto the cream to prevent a skin from forming.)

The assembly and baking

2 tablespoons sugar
8 ounces currant jelly

Preheat the oven to 375°.

Spread the pastry cream over the bottom of the shell. Arrange the apple slices in a circle around the outer edge of the shell, making sure the slices overlap. When the outer circle is completed, make a smaller circle, overlapping about half of the outer circle. If there's room, make a third circle. Fill the hole in the center with pieces of a few slices—let them stand upright. Cover the tart with a circle of wax paper and bake for 25 minutes. Remove the wax paper and sprinkle the sugar over the apples. Bake uncovered for 5-10 minutes more, until the sugar melts.

Boil the currant jelly until it reduces by one-third. With a pastry brush, paint the top of the tart with the currant glaze. Allow time for the glaze to set before serving (10 minutes).

Apple tart

The shell

Preheat the oven to 400°.

In a food processor fitted with
solid mass that rises above the b
does not congeal within the firs

Line the tart shell with alumini
and the dough several times wi
utes. Remove the aluminum an
brown, about 15 minutes more.

The apples

Peel, core and halve the apples.
crosswise into thin (less than 1/
cinammon and nutmeg. Cover

7 tablespooons frozen butter*
1 cup frozen flour*
3 tablespoons ice-cold water*
1 teaspoon cider vinegar
A pinch of kosher salt

* *It is important to have these ingr
as cold as possible.*

Title treatment
Enlarging the size of the title not
only reinforces hierarchy, but also
provides an unambiguous starting
point for reading.

Secondary heads
Using italic for secondary heads
reinforces their place in the overall
hierarchy already indicated by the
additional line space.

Italic within the text
Italic within the list of ingredients
indicates information that affects the
items in use. Note also how the
exdented asterisk (see page 102)
strengthens the left margin of the
type. Compare with Option 1.

Apple tart

The shell

Preheat the oven to 400°.

7 tablespooons frozen butter*
1 cup frozen flour*
3 tablespoons ice-cold water*
1 teaspoon cider vinegar
A pinch of kosher salt

* *It is important to have these ingredients as cold as possible.*

In a food processor fitted with a steel blade, combine all the ingredients until they form a solid mass that rises above the blade. You can add extra water by the tablespoon if the mass does not congeal within the first minute. Tiny pieces of butter should still be visible in the dough when it's done. Remove the dough from the bowl and work it quickly it into a ball on a lightly floured surface. Cover with plastic wrap and refrigerate for at least half an hour.

After the dough has rested in the refrigerator, roll it out on a lightly floured surface until it forms a circle approximately 13" in diameter. Center the circle of dough in a 10-inch tart pan with a removable bottom. Use your knuckles to make sure that the dough tucks neatly against the edge of the pan and run the rolling pin around the rim to remove the excess. Cover and refrigerate again for at least half an hour.

Line the tart shell with aluminum foil, being careful to cover the edges. Pierce the aluminum and the dough several times with a fork and fill the shell with dried lentils. Bake for 20 minutes. Remove the aluminum and the lentils and continue baking until the shell is golden brown, about 15 minutes more.

The apples

6 Granny Smith apples
Juice of one lemon
Cinammon to taste
Nutmeg to taste

Peel, core and halve the apples. Either by hand or with a food processor, cut the apple halves crosswise into thin (less than $1/4$") slices. In a large bowl, toss the appples in the lemon juice, cinammon and nutmeg. Cover and set aside.

The pastry cream

$1/4$ cup sugar
1 tablespoon flour
2 teaspoons cornstarch
1 large egg
1 cup milk
3 tablespoons unsalted butter
$1/4$ teaspoon vanilla extract

Sift the sugar, flour and cornstarch together in a mixing bowl. Add the egg and beat until light. In a heavy-bottomed saucepan, bring the milk to a boil. Stir half the milk into the egg mixture, then pour the whole mixture back into the saucepan. Cook over high heat, stirring constantly, until the center bubbles and the mixture is very thick. Remove from heat and stir in the vanilla and the butter. Pour the pastry cream into a bowl, cover tightly with plastic wrap and refrigerate. (Be sure to press the plastic wrap right onto the cream to prevent a skin from forming.)

The assembly and baking

2 tablespoons sugar
8 ounces currant jelly

Preheat the oven to 375°.

Spread the pastry cream over the bottom of the shell. Arrange the apple slices in a circle around the outer edge of the shell, making sure the slices overlap. When the outer circle is completed, make a smaller circle, overlapping about half of the outer circle. If there's room, make a third circle. Fill the hole in the center with pieces of a few slices—let them stand upright. Cover the tart with a circle of wax paper and bake for 25 minutes. Remove the wax paper and sprinkle the sugar over the apples. Bake uncovered for 5-10 minutes more, until the sugar melts.

Boil the currant jelly until it reduces by one-third. With a pastry brush, paint the top of the tart with the currant glaze. Allow time for the glaze to set before serving (10 minutes).

with a removeable bottom.

against the edge of the pan

Cover and refrigerate again

Line the tart shell with alun

and the dough several times

utes. Remove the aluminum

brown, about 15 minutes m

The apples

Peel, core and halve the app

crosswise into thin (less thai

cinammon and nutmeg. Co

Title treatment
Introducing a sans serif boldface for
secondary heads increases contrast
and adds color to the page.

Apple tart

The shell

7 tablespooons frozen butter*
1 cup frozen flour*
3 tablespoons ice-cold water*
1 teaspoon cider vinegar
A pinch of kosher salt

It is important to have these ingredients as cold as possible.

In a food processor fitted with a steel blade, combine all the ingredients until they form a solid mass that rises above the blade. You can add extra water by the tablespoon if the mass does not congeal within the first minute. Tiny pieces of butter should still be visible in the dough when it's done. Remove the dough from the bowl and work it quickly it into a ball on a lightly floured surface. Cover with plastic wrap and refrigerate for at least half an hour.

Preheat the oven to 400°.

After the dough has rested in the refigerator, roll it out on a lightly floured surface until it forms a circle approximately 13" in diameter. Center the circle of dough in a 10-inch tart pan with a removeable bottom. Use your knuckles to make sure that the dough tucks neatly against the edge of the pan and run the rolling pin around the rim to remove the excess. Cover and refrigerate again for at least half an hour.

Line the tart shell with aluminum foil, being careful to cover the edges. Pierce the aluminum and the dough several times with a fork and fill the shell with dried lentils. Bake for 20 minutes. Remove the aluminum and the lentils and continue baking until the shell is golden brown, about 15 minutes more.

The apples

6 Granny Smith apples
Juice of one lemon
Cinammon to taste
Nutmeg to taste

Peel, core and halve the apples. Either by hand or with a food processor, cut the apple halves crosswise into thin (less than $1/4$") slices. In a large bowl, toss the apples in the lemon juice, cinammon and nutmeg. Cover and set aside.

The pastry cream

$1/4$ cup sugar
1 tablespoon flour
2 teaspoons cornstarch
1 large egg
1 cup milk
3 tablespoons unsalted butter
$1/4$ teaspoon vanilla extract

Sift the sugar, flour and cornstarch together in a mixing bowl. Add the egg and beat until light. In a heavy-bottomed saucepan, bring the milk to a boil. Stir half the milk into the egg mixture, then pour the whole mixture back into the saucepan. Cook over high heat, stirring constantly, until the center bubbles and the mixture is very thick. Remove from heat and stir in the vanilla and the butter. Pour the pastry cream into a bowl, cover tightly with plastic wrap and refrigerate. (Be sure to press the plastic wrap right onto the cream to prevent a skin from forming.)

The assembly and baking

2 tablespoons sugar
8 ounces currant jelly

Spread the pastry cream over the bottom of the shell. Arrange the apple slices in a circle around the outer edge of the shell, making sure the slices overlap. When the outer circle is completed, make a smaller circle, overlapping about half of the outer circle. If there's room, make a third circle. Fill the hole in the center with pieces of a few slices—let them stand upright. Cover the tart with a circle of wax paper and bake for 25 minutes. Remove the wax paper and sprinkle the sugar over the apples. Bake uncovered for 5-10 minutes more, until the sugar melts.

Preheat the oven to 375°.

Boil the currant jelly until it reduces by one-third. With a pastry brush, paint the top of the tart with the currant glaze. Allow time for the glaze to set before serving (10 minutes).

Revised format

Dividing the type area into seven columns provides a new, separate column for oven settings, creates a narrower (and easier to read) line length for instructions, and increases white space on the page.

■ Set instructional text of your choosing in a way that makes the different levels of copy clearly distinguishable from each other. The goal is to find out how much differentiation you feel is necessary. All the text must fit on an 8½ x 11" (216 x 279 mm) or A4 sheet.

Be sure to document several options within one approach.

The five small steps shown on these preceding pages provide a point of departure. As you work on your sketches, explore the use of several typefaces (possibly one for each level of text), the addition of rules to indicate sections, size changes, etc. The aim of the process is to sensitize yourself to the options available within this simple problem. You will also start to sense what is and is not appropriate to—even necessary for—the material at hand. Finally, keep alert to what makes the page feel like yours and no one else's—an expression of your typographic sensibility.

144 Designers often encounter typographic problems that are not based on narrative or instructions ('This happened, then this happened' or 'Do this, then do this'). Timetables, financial statements, lists of dates, weather charts—many kinds of information design—often need to accommodate reading in two directions simultaneously. Setting up columns and rows that read clearly requires a thorough understanding of working with tabs.

The timetable opposite (actual size: 6" or 152 mm square) demonstrates many of the problems with overdesigning tabular matter. Extraneous rules, both vertical and horizontal, have been imposed on the basic typographic organization to correct for unfortunate first choices about type size, leading, and placement.

SATURDAYS AND SUNDAYS

INBOUND	1204	1208	1212	1216	1220	1224
READ DOWN	A.M.	A.M.	P.M.	P.M.	P.M.	P.M.
Dep: Haverhill	7 15	10 15	1 15	4 15	7 15	10 15
Bradford	7 17	10 17	1 17	4 17	7 17	10 17
Lawrence	7 26	10 26	1 26	4 26	7 26	10 26
Andover	7 31	10 31	1 31	4 31	7 31	10 31
Ballardvale	f7 36	f10 36	f1 36	f4 36	f7 36	f10 36
North Wilmington	f7 42	f10 42	f1 42	f4 42	f7 42	f10 42
Reading	7 51	10 51	1 51	4 51	7 51	10 51
Wakefield	7 57	10 57	1 57	4 57	7 57	10 57
Greenwood	f8 00	f11 00	f2 00	f5 00	f8 00	f11 00
Melrose Highlands	8 02	11 02	2 02	5 02	8 02	11 02
Melrose/Cedar Park	f8 04	f11 04	f2 04	f5 04	f8 04	f11 04
Wyoming Hill	f8 06	f11 06	f2 06	f5 06	f8 06	f11 06
Malden Center	8 09	11 09	2 09	5 09	8 09	11 09
Arr: North Station	8 19	11 19	2 19	5 19	8 19	11 19

OUTBOUND	1205	1209	1213	1217	1221	1225
READ DOWN	A.M.	A.M.	P.M.	P.M.	P.M.	P.M.
Dep: North Station	8 45	11 45	2 45	5 45	8 45	11 30
Malden Center	8 55	11 55	2 55	5 55	8 55	11 40
Wyoming Hill	f8 58	f11 58	f2 58	f5 58	f8 58	f11 43
Melrose/Cedar Park	f9 00	f12 00	f3 00	f6 00	f9 00	f11 45
Melrose Highlands	9 02	12 02	3 02	6 02	9 02	11 47
Greenwood	f9 04	f12 04	f3 04	f6 04	f9 04	f11 49
Wakefield	9 08	12 08	3 08	6 08	9 08	11 53
Reading	9 14	12 14	3 14	6 14	9 14	11 59
North Wilmington	f9 22	f12 22	f3 22	f6 22	f9 22	f12 07
Ballardvale	f9 28	f12 28	f3 28	f6 28	f9 28	f12 13
Andover	9 33	12 33	3 33	6 33	9 33	12 18
Lawrence	9 38	12 38	3 38	6 38	9 38	12 23
Bradford	9 47	12 47	3 47	6 47	9 47	12 32
Arr: Haverhill	9 49	12 49	3 49	6 49	9 49	12 34

HOLIDAYS

SATURDAY SERVICE

July 4 and New Year's Eve contact Customer Service for service updates at 617-222-3200

Presidents' Day
Independence Day
New Year's Day
f *stops only on request*

SUNDAY SERVICE

Memorial Day • Labor Day
Thanksgiving Day • Christmas Day

145

Saturdays and Sundays

Inbound	1204	1208	1212	1216	1220	1224
Dep: Haverhill	7:15	10:15	1:15	4:15	7:15	10:15
Bradford	7:17	10:17	1:17	4:17	7:17	10:17
Lawrence	7:26	10:26	1:26	4:26	7:26	10:26
Andover	7:31	10:31	1:31	4:31	7:31	10:31
Ballardvale	7:36*	10:36*	1:36*	4:36*	7:36*	10:36*
North Wilmington	7:42*	10:42*	1:42*	4:42*	7:42*	10:42*
Reading	7:51	10:51	1:51	4:51	7:51	10:51
Wakefield	7:57	10:57	1:57	4:57	7:57	10:57
Greenwood	8:00*	11:00*	2:00*	5:00*	8:00*	11:00*
Melrose Highlands	8:02	11:02	2:02	5:02	8:02	11:02
Melrose/Cedar Park	8:04*	11:04*	2:04*	5:04*	8:04*	11:04*
Wyoming Hill	8:06*	11:06*	2:06*	5:06*	8:06*	11:06*
Malden Center	8:09	11:09	2:09	5:09	8:09	11:09
Arr: North Station	8:19	11:19	2:19	5:19	8:19	11:19

Outbound	1205	1209	1213	1217	1221	1225
Dep: North Station	8:45	11:45	2:45	5:45	8:45	11:30
Malden Center	8:55	11:55	2:55	5:55	8:55	11:40
Wyoming Hill	8:58*	11:58*	2:58*	5:58*	8:58*	11:43*
Melrose/Cedar Park	9:00*	12:00*	3:00*	6:00*	9:00*	11:45*
Melrose Highlands	9:02	12:02	3:02	6:02	9:02	11:47
Greenwood	9:04*	12:04*	3:04*	6:04*	9:04*	11:49*
Wakefield	9:08	12:08	3:08	6:08	9:08	11:53
Reading	9:14	12:14	3:14	6:14	9:14	11:59
North Wilmington	9:22*	12:22*	3:22*	6:22*	9:22*	12:07*
Ballardvale	9:28*	12:28*	3:28*	6:28*	9:28*	12:13*
Andover	9:33	12:33	3:33	6:33	9:33	12:18
Lawrence	9:38	12:38	3:38	6:38	9:38	12:23
Bradford	9:47	12:47	3:47	6:47	9:47	12:32
Arr: Haverhill	9:49	12:49	3:49	6:49	9:49	12:34

Holidays

Weekend service Presidents' Day • Independence Day • New Year's Day • Memorial Day • Labor Day • Thanksgiving Day • Christmas Day

July 4 and New Year's Eve contact Customer Service for service updates at 617-222-3200

* stops only on request

As with the previous exercise, the first step is to set all the material in one size of one typeface in order to uncover the internal logic of the information.

Here a sans serif typeface (Univers 45) is chosen because the relatively large x-height and open counters aid reading at smaller sizes. The horizontal rules used on the original schedule have been replaced by line spaces. Vertical rules and the 'frame' of the original have been eliminated altogether. Centered type has been reformatted to flush left/ragged right. The term 'READ DOWN' has

been eliminated and the 'f' before some entries in the schedule has been replaced with an asterisk after.

From this point, the goal is to reinforce the two directions of reading (across and down) without introducing elements that supersede the information itself.

Saturdays and Sundays

Inbound	1204	1208	1212	1216	1220	1224
Dep: Haverhill	7:15	10:15	**1:15**	**4:15**	**7:15**	**10:15**
Bradford	7:17	10:17	**1:17**	**4:17**	**7:17**	**10:17**
Lawrence	7:26	10:26	**1:26**	**4:26**	**7:26**	**10:26**
Andover	7:31	10:31	**1:31**	**4:31**	**7:31**	**10:31**
Ballardvale	7:36*	10:36*	**1:36***	**4:36***	**7:36***	**10:36***
North Wilmington	7:42*	10:42*	**1:42***	**4:42***	**7:42***	**10:42***
Reading	7:51	10:51	**1:51**	**4:51**	**7:51**	**10:51**
Wakefield	7:57	10:57	**1:57**	**4:57**	**7:57**	**10:57**
Greenwood	8:00*	11:00*	**2:00***	**5:00***	**8:00***	**11:00***
Melrose Highlands	8:02	11:02	**2:02**	**5:02**	**8:02**	**11:02**
Melrose/Cedar Park	8:04*	11:04*	**2:04***	**5:04***	**8:04***	**11:04***
Wyoming Hill	8:06*	11:06*	**2:06***	**5:06***	**8:06***	**11:06***
Malden Center	8:09	11:09	**2:09**	**5:09**	**8:09**	**11:09**
Arr: North Station	8:19	11:19	**2:19**	**5:19**	**8:19**	**11:19**

Outbound	1205	1209	1213	1217	1221	1225
Dep: North Station	8:45	11:45	**2:45**	**5:45**	**8:45**	**11:30**
Malden Center	8:55	11:55	**2:55**	**5:55**	**8:55**	**11:40**
Wyoming Hill	8:58*	11:58*	**2:58***	**5:58***	**8:58***	**11:43***
Melrose/Cedar Park	9:00*	**12:00***	**3:00***	**6:00***	**9:00***	**11:45***
Melrose Highlands	9:02	**12:02**	**3:02**	**6:02**	**9:02**	**11:47**
Greenwood	9:04*	**12:04***	**3:04***	**6:04***	**9:04***	**11:49***
Wakefield	9:08	**12:08**	**3:08**	**6:08**	**9:08**	**11:53**
Reading	9:14	**12:14**	**3:14**	**6:14**	**9:14**	**11:59**
North Wilmington	9:22*	**12:22***	**3:22***	**6:22***	**9:22***	12:07*
Ballardvale	9:28*	**12:28***	**3:28***	**6:28***	**9:28***	12:13*
Andover	9:33	**12:33**	**3:33**	**6:33**	**9:33**	12:18
Lawrence	9:38	**12:38**	**3:38**	**6:38**	**9:38**	12:23
Bradford	9:47	**12:47**	**3:47**	**6:47**	**9:47**	12:32
Arr: Haverhill	9:49	**12:49**	**3:49**	**6:49**	**9:49**	12:34

Holidays

Weekend service	Presidents' Day • Independence Day • New Year's Day • Memorial Day • Labor Day • Thanksgiving Day • Christmas Day
July 4 and New Year's Eve	contact Customer Service for service updates at 617-222-3200

*** stops only on request**

Two weights of boldface (Univers 65 and 75) are added both to indicate hierarchy (days of the week, trains' numbers and directions, ends of the line) and to distinguish morning and afternoon/evening times at a glance. This latter use of boldface is more an issue with 12-hour American time systems than with 24-hour European systems. Still, the distinction between before and after noon can be useful for quick orientation.

SATURDAYS AND SUNDAYS

Inbound	1204	1208	1212	1216	1220	1224
Dep: Haverhill	7:15	10:15	1:15	4:15	7:15	10:15
Bradford	7:17	10:17	1:17	4:17	7:17	10:17
Lawrence	7:26	10:26	1:26	4:26	7:26	10:26
Andover	7:31	10:31	1:31	4:31	7:31	10:31
Ballardvale	7:36*	10:36*	1:36*	4:36*	7:36*	10:36*
North Wilmington	7:42*	10:42*	1:42*	4:42*	7:42*	10:42*
Reading	7:51	10:51	1:51	4:51	7:51	10:51
Wakefield	7:57	10:57	1:57	4:57	7:57	10:57
Greenwood	8:00*	11:00*	2:00*	5:00*	8:00*	11:00*
Melrose Highlands	8:02	11:02	2:02	5:02	8:02	11:02
Melrose/Cedar Park	8:04*	11:04*	2:04*	5:04*	8:04*	11:04*
Wyoming Hill	8:06*	11:06*	2:06*	5:06*	8:06*	11:06*
Malden Center	8:09	11:09	2:09	5:09	8:09	11:09
Arr: North Station	8:19	11:19	2:19	5:19	8:19	11:19

Outbound	1205	1209	1213	1217	1221	1225
Dep: North Station	8:45	11:45	2:45	5:45	8:45	11:30
Malden Center	8:55	11:55	2:55	5:55	8:55	11:40
Wyoming Hill	8:58*	11:58*	2:58*	5:58*	8:58*	11:43*
Melrose/Cedar Park	9:00*	12:00*	3:00*	6:00*	9:00*	11:45*
Melrose Highlands	9:02	12:02	3:02	6:02	9:02	11:47
Greenwood	9:04*	12:04*	3:04*	6:04*	9:04*	11:49*
Wakefield	9:08	12:08	3:08	6:08	9:08	11:53
Reading	9:14	12:14	3:14	6:14	9:14	11:59
North Wilmington	9:22*	12:22*	3:22*	6:22*	9:22*	12:07*
Ballardvale	9:28*	12:28*	3:28*	6:28*	9:28*	12:13*
Andover	9:33	12:33	3:33	6:33	9:33	12:18
Lawrence	9:38	12:38	3:38	6:38	9:38	12:23
Bradford	9:47	12:47	3:47	6:47	9:47	12:32
Arr: Haverhill	9:49	12:49	3:49	6:49	9:49	12:34

HOLIDAYS

Weekend service	Presidents' Day • Independence Day • New Year's Day • Memorial Day • Labor Day • Thanksgiving Day • Christmas Day
July 4 and New Year's Eve	contact Customer Service for service updates at 617-222-3200

*** stops only on request**

Hierarchy is reinforced by introducing rules to signify major breaks in information. Major heads are reversed out of wide black rules, secondary heads follow hairlines.

SATURDAYS AND SUNDAYS

Inbound	1204	1208	1212	1216	1220	1224
Dep: Haverhill	7:15	10:15	1:15	4:15	7:15	10:15
Bradford	7:17	10:17	1:17	4:17	7:17	10:17
Lawrence	7:26	10:26	1:26	4:26	7:26	10:26
Andover	7:31	10:31	1:31	4:31	7:31	10:31
Ballardvale	7:36*	10:36*	1:36*	4:36*	7:36*	10:36*
North Wilmington	7:42*	10:42*	1:42*	4:42*	7:42*	10:42*
Reading	7:51	10:51	1:51	4:51	7:51	10:51
Wakefield	7:57	10:57	1:57	4:57	7:57	10:57
Greenwood	8:00*	11:00*	2:00*	5:00*	8:00*	11:00*
Melrose Highlands	8:02	11:02	2:02	5:02	8:02	11:02
Melrose/Cedar Park	8:04*	11:04*	2:04*	5:04*	8:04*	11:04*
Wyoming Hill	8:06*	11:06*	2:06*	5:06*	8:06*	11:06*
Malden Center	8:09	11:09	2:09	5:09	8:09	11:09
Arr: North Station	8:19	11:19	2:19	5:19	8:19	11:19

Outbound	1205	1209	1213	1217	1221	1225
Dep: North Station	8:45	11:45	2:45	5:45	8:45	11:30
Malden Center	8:55	11:55	2:55	5:55	8:55	11:40
Wyoming Hill	8:58*	11:58*	2:58*	5:58*	8:58*	11:43*
Melrose/Cedar Park	9:00*	12:00*	3:00*	6:00*	9:00*	11:45*
Melrose Highlands	9:02	12:02	3:02	6:02	9:02	11:47
Greenwood	9:04*	12:04*	3:04*	6:04*	9:04*	11:49*
Wakefield	9:08	12:08	3:08	6:08	9:08	11:53
Reading	9:14	12:14	3:14	6:14	9:14	11:59
North Wilmington	9:22*	12:22*	3:22*	6:22*	9:22*	12:07*
Ballardvale	9:28*	12:28*	3:28*	6:28*	9:28*	12:13*
Andover	9:33	12:33	3:33	6:33	9:33	12:18
Lawrence	9:38	12:38	3:38	6:38	9:38	12:23
Bradford	9:47	12:47	3:47	6:47	9:47	12:32
Arr: Haverhill	9:49	12:49	3:49	6:49	9:49	12:34

HOLIDAYS

Weekend service	Presidents' Day • Independence Day • New Year's Day • Memorial Day • Labor Day • Thanksgiving Day • Christmas Day
July 4 and New Year's Eve	contact Customer Service for service updates at 617-222-3200

*** stops only on request**

The space between columns of times already supports vertical reading. Screened wide horizontal rules, added between alternating lines of arrival/departure times, aids readability across the timetable.

SATURDAYS AND SUNDAYS

Inbound	1204	1208	1212	1216	1220	1224
Dep: Haverhill	7:15	10:15	1:15	4:15	7:15	10:15
Bradford	7:17	10:17	1:17	4:17	7:17	10:17
Lawrence	7:26	10:26	1:26	4:26	7:26	10:26
Andover	7:31	10:31	1:31	4:31	7:31	10:31
Ballardvale	7:36*	10:36*	1:36*	4:36*	7:36*	10:36*
North Wilmington	7:42*	10:42*	1:42*	4:42*	7:42*	10:42*
Reading	7:51	10:51	1:51	4:51	7:51	10:51
Wakefield	7:57	10:57	1:57	4:57	7:57	10:57
Greenwood	8:00*	11:00*	2:00*	5:00*	8:00*	11:00*
Melrose Highlands	8:02	11:02	2:02	5:02	8:02	11:02
Melrose/Cedar Park	8:04*	11:04*	2:04*	5:04*	8:04*	11:04*
Wyoming Hill	8:06*	11:06*	2:06*	5:06*	8:06*	11:06*
Malden Center	8:09	11:09	2:09	5:09	8:09	11:09
Arr: North Station	8:19	11:19	2:19	5:19	8:19	11:19

Outbound	1205	1209	1213	1217	1221	1225
Dep: North Station	8:45	11:45	2:45	5:45	8:45	11:30
Malden Center	8:55	11:55	2:55	5:55	8:55	11:40
Wyoming Hill	8:58*	11:58*	2:58*	5:58*	8:58*	11:43*
Melrose/Cedar Park	9:00*	12:00*	3:00*	6:00*	9:00*	11:45*
Melrose Highlands	9:02	12:02	3:02	6:02	9:02	11:47
Greenwood	9:04*	12:04*	3:04*	6:04*	9:04*	11:49*
Wakefield	9:08	12:08	3:08	6:08	9:08	11:53
Reading	9:14	12:14	3:14	6:14	9:14	11:59
North Wilmington	9:22*	12:22*	3:22*	6:22*	9:22*	12.07*
Ballardvale	9:28*	12:28*	3:28*	6:28*	9:28*	12:13*
Andover	9:33	12:33	3:33	6:33	9:33	12:18
Lawrence	9:38	12:38	3:38	6:38	9:38	12:23
Bradford	9:47	12:47	3:47	6:47	9:47	12:32
Arr: Haverhill	9:49	12:49	3:49	6:49	9:49	12:34

HOLIDAYS

Weekend service	Presidents' Day • Independence Day • New Year's Day • Memorial Day • Labor Day • Thanksgiving Day • Christmas Day
July 4 and New Year's Eve	contact Customer Service for service updates at 617-222-3200

* **stops only on request**

A second color reinforces existing organization both by highlighting primary and secondary information and by calling attention to exceptions to the regular schedule. The hairline rule signifying outbound trains (rendered redundant by the use of color) is removed.

■ **Redesign an existing piece of tabular information. Pay particular attention to ease of use. Organize the type to make both readings of the message—horizontal and vertical—as clear as possible.**

Grid systems

152 Up to this point, we've looked at text organization in terms of columnar arrangement. More complex information often requires expression of not only vertical but also horizontal organization. In those situations, a grid is an essential tool.

A grid is a pattern of horizontal and vertical lines that intersect at regular intervals. In typographic design, a grid system is a method for organizing and clarifying text on a page, and amplifying its meaning.

A grid is not about painting a page— creating the perfect composition within the frame of the paper trim. Rather, it is about building a page— providing a framework within which visual and typographic elements work to reinforce meaning.

This sense of building the page comes directly from the days when type itself was physical. Lines of lead type built upon other lines of type—not unlike courses of bricks standing one upon the other—to create the page. And, as with bricks, the stronger the construction, the more durable the results.

It's important to remember that a grid is a system, not an object in itself. For that system to be effective it has to be both organic and responsive. In other words, before you can devise a grid, you have to understand clearly
• the amount of text/images
• the kinds of text/images
• the levels of meaning and importance within the text/images
• the relationship between text and images
• the relationship between text/images and the reader.

Another way to describe the grid system is to see it as a way of providing distinct articulation to the different voices expressed within the text through both color and position on the page. Or you might prefer thinking of a grid as Josef Müller-Brockmann described it: a means of expressing both the architecture (or structure) and the music (or rhythm) inherent in the material. No matter how you look at it, the underlying principle behind any grid is that it is most successful as an expression of content.

Going through the following section, you're going to encounter some terminology and a lot of rules. As with any system, perhaps the most important thing to keep in mind is when it's necessary to break those rules. Beyond the usual employment of contrast within the system, always be on the lookout for opportunities to contrast the order of the system itself with its opposite—the seeming lack of order.

You will learn that the kinds of grid that follow are described as establishing starting points on a page, never ending points. A clear expression of that notion is the use of flush left, ragged right text—type that articulates a strong left axis and a strong top axis, but weak edges to the right and below. Therefore, in the examples that follow I have only used flush left, ragged right type.

An example

The 96-field grid used to design
this book allows for six horizontal
intervals and 16 vertical intervals.
The height of the vertical intervals
is based on three lines of text type,
8 pt. Akzidenz Grotesk leaded
to a 10.25 pt. line—
8/10.25 Akzidenz Grotesk.

154

A nine-field grid
on an 8½ x 11"
(216 x 279 mm) page

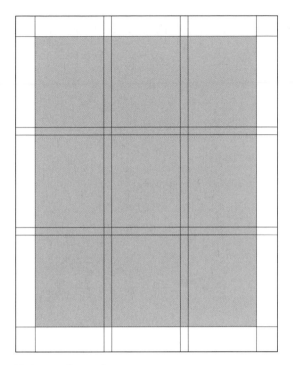

Text page (in gray)

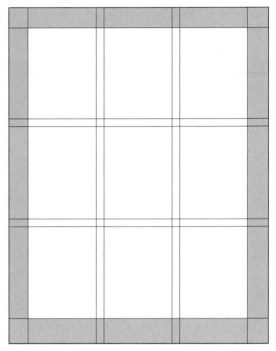

Margins

There are a few specific terms we use when talking about grids. They are:

Text page
Also known as the type or text area, the area on a page where type appears. The text page contains the fields and gutters that make up the grid.

Margin
The space that distinguishes the text page from the paper around it.

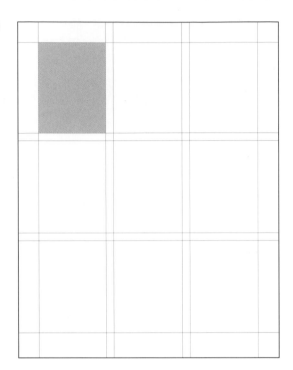

Field

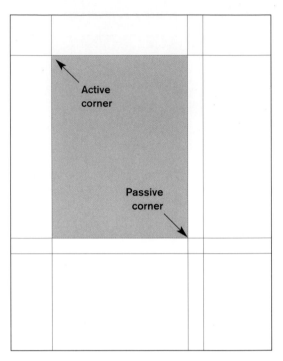

Field (detail)

Field

The basic component of any grid.
The height of a field is calculated as
a multiple of the text leading. Its
width is determined by the length of
a line of text. (See Creating a grid
for text, pages 164–173.) For the
kinds of grids we'll be working with,
it's useful to remember that the
upper left corner of any field is
considered the strong or 'active
corner.' The lower right corner is the
weak or 'passive corner.'

In a grid system, folios and running feet (like the text) always appear flush left. They therefore never appear symmetrical to each other on a spread.

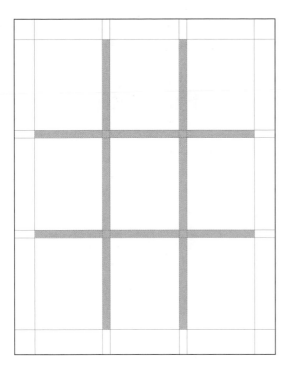

Vertical and horizontal gutters

Folio and running foot

Vertical/horizontal gutter
The area separating fields from each other. The height of a horizontal gutter is typically based on the leading of the text type. The width of a vertical gutter is a distance sufficiently larger than an em space (the width of an uppercase M in the text type) to distinguish columns of text from each other. (See Creating a grid for text, pages 164–173.)

Folio
The page number. This typically sits outside the text page, but should always relate to it either vertically or horizontally.

Running head/running foot
In longer documents, a guide for readers to show them where they are in the manuscript. They may contain the title of the book, the title of a section of the book, or the author's name. Like folios, they sit outside the text page, but should always relate to it either vertically or horizontally. Running heads appear above the text page, running feet below it.

158

Grids are particularly useful for creating a sense of simultaneity on the page, as this simple exercise demonstrates. We have here a title page for a catalog. Page size is 9" (229 mm) square. Copy consists of a title, a subtitle, and a publisher—three levels of information, each in three languages (English, German, and French).

First, the type is set in three weights of a typeface (here, Akzidenz Grotesk Regular, Medium, and Bold), in three sizes based on a Fibonacci sequence (13, 21, and 34 pt., each with 2 pts. of leading). Certainly, it is possible to articulate the hierarchy of information by changing just the size or the weight. As you know by now, these are the decisions that make each designer's work personal.

Word and image

Posters from the collection

Museum of Modern Art New York

Wort und Bild

Plakate von der Sammlung

Museum der Moderne Kunst New York

La parole et l'image

Les affiches de la collection

Musée d'art moderne New York

The page is then arranged in a nine-field grid, three fields by three fields (3 x 3)—mirroring the three levels of information presented in three languages. Note that because all our type is essentially display type, not text, the gutters are not specifically keyed into leading or ems.

Word and image **Wort und Bild** **La parole et l'image**

Posters from the collection / Plakate von der Sammlung / Les affiches de la collection

Museum of Modern Art New York / Museum des Moderne Kunst New York / Musée d'art moderne New York

Example 1

Word and image **Wort und Bild** **La parole et l'image**

Posters from the collection / Plakate von der Sammlung / Les affiches de la collection

Museum of Modern Art New York / Museum der Moderne Kunst New York / Musée d'art moderne New York

Posters from the collection / Plakate von der Sammlung / Les affiches de la collection

Word and image **Wort und Bild** **La parole et l'image**

Museum of Modern Art New York / Museum der Moderne Kunst New York / Musée d'art moderne New York

Posters from the collection / Plakate von der Sammlung / Les affiches de la collection

Word and image **Wort und Bild** **La parole et l'image**

Museum of Modern Art New York / Museum der Moderne Kunst New York / Musée d'art moderne New York

Example 2

Even with only nine fields, there are many possibilities for placing the information on the grid. In the examples on this page, each language reads down. Levels of hierarchy read across.

Word and image Posters from the collection Museum of Modern Art New York

Wort und Bild Plakate von der Sammlung Museum der Moderne Kunst New York

La parole et l'image Les affiches de la collection Musée d'art moderne New York

Example 3

Posters from the collection **Word and image** Museum of Modern Art New York

Plakate von der Sammlung **Wort und Bild** Museum der Moderne Kunst New York

Les affiches de la collection **La parole et l'image** Musée d'art moderne New York

Example 4

In the examples on this page, the reading is reversed from the previous examples—languages read across, hierarchies read down.

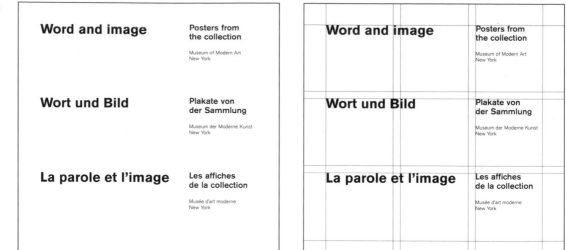

Example 5

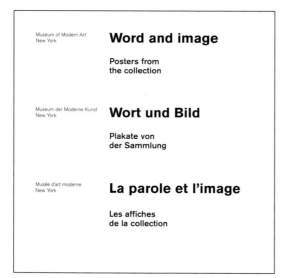

Example 6

Here, horizontal reading is stressed by extending the title on one line and connecting two levels of information in one type block. In Example 5, we connect the subtitle and the publisher. In Example 6, we connect the title and subtitle.

You are probably going to find some of these solutions more successful, more expressive, more dynamic, or maybe just 'prettier' than others. Or you may find them all too obvious, too simple. A grid of 3 x 3 may not provide enough options. It certainly does not take into account the pages of material that would follow the title.

The point of this beginning exercise is to sensitize you to the possibilities for both organization and expression that the grid offers. Where you take it next—however many more fields you think the page requires, whatever typeface, size, and weight you deem appropriate—is up to you. What's most important is to follow through the process and to explore a fair number of possibilities within each system.

A 5 x 5 grid
10, 26, and 42 pt. Janson

A 6 x 5 grid
10, 26, and 42 pt. Didot

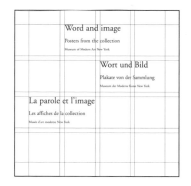

A 4 x 4 grid
13, 21, and 36 pt. Adobe Garamond

Lorem ipsum dolor sit amet, consectetuer adipiscing elit, sed diam nonummy nibh euismod tincidunt ut laoreet dolore magna aliquam erat volutpat. Ut wisi enim ad minim veniam, quis nostrud exerci tation ullamcorper suscipit lobortis nisl ut aliquip ex ea commodo consequat. Duis autem vel eum iriure dolor in hendrerit in vulputate velit esse molestie consequat, vel illum dolore eu feugait nulla facilisis at vero eros et accumsan et iusto odio dignissim qui blandit praesent luptatum zzril delenit augue duis dolore te feugait nulla facilisi. Lorem ipsum dolor sit amet, consectetuer adipiscing elit, sed diam nonummy nibh euismod tincidunt ut laoreet dolore magna aliquam erat volutpat. Ut wisi enim ad minim veniam, quis nostrud exerci tation ullamcorper suscipit lobortis nisl ut aliquip ex ea commodo consequat. Duis autem vel eum iriure dolor in hendrerit in vulputate velit esse molestie consequat, vel illum dolore eu feugiat nulla facilisis at vero eros et accumsan et iusto odio dignissim qui blandit praesent luptatum zzril delenit augue duis dolore te feugait nulla facilisi. Nam liber tempor cum soluta nobis eleifend option congue nihil imperdiet doming id quod mazim placerat facer possim assum. Lorem ipsum dolor sit amet, consectetuer adipiscing elit, sed diam nonummy nibh euismod tincidunt ut laoreet dolore magna aliquam erat volutpat. Ut wisi enim ad minim veniam, quis nostrud exerci tation ullamcorper suscipit lobortis nisl ut aliquip ex ea commodo consequat. Duis autem vel eum iriure dolor in hendrerit in

Lorem ipsum dolor sit amet, consectetuer adipiscing elit, sed diam nonummy nibh euismod tincidunt ut laoreet dolore magna aliquam erat volutpat. Ut wisi enim ad minim veniam, quis nostrud exerci tation ullamcorper suscipit lobortis nisl ut aliquip ex ea commodo consequat. Duis autem vel eum iriure dolor in hendrerit in vulputate velit esse molestie consequat, vel illum dolore eu feugait nulla facilisis at vero eros et accumsan et iusto odio dignissim qui blandit praesent luptatum zzril delenit augue duis dolore te feugait nulla facilisi. Lorem ipsum dolor sit amet, consectetuer adipiscing elit, sed diam nonummy nibh euismod tincidunt ut laoreet dolore magna aliquam erat volutpat. Ut wisi enim ad minim veniam, quis nostrud exerci tation ullamcorper suscipit lobortis nisl ut aliquip ex ea commodo consequat. Duis autem vel eum iriure dolor in hendrerit in vulputate velit esse molestie consequat, vel illum dolore eu feugiat nulla facilisis at vero eros et accumsan et iusto odio dignissim qui blandit praesent luptatum zzril delenit augue duis dolore te feugait nulla facilisi. Nam liber tempor cum soluta nobis eleifend option congue nihil imperdiet doming id quod mazim placerat facer possim assum. Lorem ipsum dolor sit amet, consectetuer adipiscing elit, sed diam nonummy nibh euismod tincidunt ut laoreet dolore magna aliquam erat volutpat. Ut wisi enim ad minim veniam, quis nostrud exerci tation ullamcorper suscipit lobortis nisl ut aliquip ex ea commodo consequat. Duis autem vel eum iriure dolor in hendrerit in

Place a column of text type on an 8½ x 11" (216 x 279 mm) page.

Examine the horizontal relationship of white space to text. Be sure to include left and right margins. (For this exercise, assume that the left and right margins are 3 picas each.)

Most grids—like the material they illuminate—are not so straightforward as those we've just worked with. Working with text demands solutions that are less pictorial and more organic—coming more from within the text itself, and less from without.

±3 ±3 ±2

Lorem ipsum dolor sit amet, consectetuer adipiscing elit, sed diam nonummy nibh euismod tincidunt ut laoreet dolore magna aliquam erat volutpat. Ut wisi enim ad minim veniam, quis nostrud exerci tation ullamcorper suscipit lobortis nisl ut aliquip ex ea commodo consequat. Duis autem vel eum iriure dolor in hendrerit in vulputate velit esse molestie consequat, vel illum dolore eu feugiat nulla facilisis at vero eros et accumsan et iusto odio dignissim qui blandit praesent luptatum zzril delenit augue duis dolore te feugait nulla facilisi. Lorem ipsum dolor sit amet, consectetuer adipiscing elit, sed diam nonummy nibh euismod tincidunt ut laoreet dolore magna aliquam erat volutpat. Ut wisi enim ad minim veniam, quis nostrud exerci tation ullamcorper suscipit lobortis nisl ut aliquip ex ea commodo consequat. Duis autem vel eum iriure dolor in hendrerit in vulputate velit esse molestie consequat, vel illum dolore eu feugiat nulla facilisis at vero eros et accumsan et iusto odio dignissim qui blandit praesent luptatum zzril delenit augue duis dolore te feugait nulla facilisi. Nam liber tempor cum soluta nobis eleifend option congue nihil imperdiet doming id quod mazim placerat facer possim assum. Lorem ipsum dolor sit amet, consectetuer adipiscing elit, sed diam nonummy nibh euismod tincidunt ut laoreet dolore magna aliquam erat volutpat. Ut wisi enim ad minim veniam, quis nostrud exerci tation ullamcorper suscipit lobortis nisl ut aliquip ex ea commodo consequat. Duis autem vel eum iriure dolor in hendrerit in

Lorem ipsum dolor sit amet, consectetuer adipiscing elit, sed diam nonummy nibh euismod tincidunt ut laoreet dolore magna aliquam erat volutpat. Ut wisi enim ad minim veniam, quis nostrud exerci tation ullamcorper suscipit lobortis nisl ut aliquip ex ea commodo consequat. Duis autem vel eum iriure dolor in hendrerit in vulputate velit esse molestie consequat, vel illum dolore eu feugiat nulla facilisis at vero eros et accumsan et iusto odio dignissim qui blandit praesent luptatum zzril delenit augue duis dolore te feugait nulla facilisi. Lorem ipsum dolor sit amet, consectetuer adipiscing elit, sed diam nonummy nibh euismod tincidunt ut laoreet dolore magna aliquam erat volutpat. Ut wisi enim ad minim veniam, quis nostrud exerci tation ullamcorper suscipit lobortis nisl ut aliquip ex ea commodo consequat. Duis autem vel eum iriure dolor in hendrerit in vulputate velit esse molestie consequat, vel illum dolore eu feugiat nulla facilisis at vero eros et accumsan et iusto odio dignissim qui blandit praesent luptatum zzril delenit augue duis dolore te feugait nulla facilisi. Nam liber tempor cum soluta nobis eleifend option congue nihil imperdiet doming id quod mazim placerat facer possim assum. Lorem ipsum dolor sit amet, consectetuer adipiscing elit, sed diam nonummy nibh euismod tincidunt ut laoreet dolore magna aliquam erat volutpat. Ut wisi enim ad minim veniam, quis nostrud exerci tation ullamcorper suscipit lobortis nisl ut aliquip ex ea commodo consequat. Duis autem vel eum iriure dolor in hendrerit in

Determine the horizontal ratios. These horizontal ratios are perhaps best described as the ratios between line length of the text and the width of white space to either side of it. In the example shown, it happens that the line length of the text is more or less the same as the width of the white space to the left (1:1), and more or less one and a half times as wide as the white space on the right (3:2). Hence, ± 3 and ± 2 neatly approximate the distances shown.

Draw in all the vertical axes that express the horizontal ratios, being sure to include gutters. The general rule of thumb for vertical gutters is ± 2 ems of the text typeface (8 pt. text = 16 pt. gutter, 10 pt. text = 20 pt. gutter, etc.). This decision really hangs on making sure there's no danger of reading on from text in one column to text in the next. In the example shown, we've used 1p6.

Determine a top margin (again, assume 3 picas). Introduce a 'type ruler'—a column of type set to the same size and leading as your text type—that runs down the left edge of the page. Adjust your text type vertically until it aligns with the type ruler.

Determine vertical intervals. In the example shown above, these intervals grow out of the position of the type in relation to the top of the text page.

When you set up your horizontal gutters, remember that the height of the gutter is determined by the leading of one line of text type.

Lorem ipsum dolor sit amet, consectetuer adipiscing elit, sed diam nonummy nibh euismod tincidunt ut laoreet dolore magna aliquam erat volutpat. Ut wisi enim ad minim veniam, quis nostrud exerci tation ullamcorper suscipit lobortis nisl ut aliquip ex ea commodo consequat. Duis autem vel eum iriure dolor in hendrerit in vulputate velit esse molestie consequat, vel illum dolore eu feugiat nulla facilisis at vero eros et accumsan et iusto odio dignissim qui blandit praesent luptatum zzril delenit augue duis dolore te feugait nulla facilisi. Lorem ipsum dolor sit amet, consectetuer adipiscing elit, sed diam nonummy nibh euismod tincidunt ut laoreet dolore magna aliquam erat volutpat.

Ut wisi enim ad minim veniam, quis nostrud exerci tation ullamcorper suscipit lobortis nisl ut aliquip ex ea commodo consequat. Duis autem vel eum iriure dolor in hendrerit in vulputate velit esse molestie consequat, vel illum dolore eu feugiat nulla facilisis at vero eros et accumsan et iusto odio dignissim qui

Lorem ipsum dolor sit amet, consectetuer adipiscing elit, sed diam nonummy nibh euismod tincidunt ut laoreet dolore magna aliquam erat volutpat. Ut wisi enim ad minim veniam, quis nostrud exerci tation ullamcorper suscipit lobortis nisl ut aliquip ex ea commodo consequat. Duis autem vel eum iriure dolor in hendrerit in vulputate velit esse molestie consequat, vel illum dolore eu feugiat nulla facilisis at vero eros et accumsan et iusto odio dignissim qui blandit praesent luptatum zzril delenit augue duis dolore te feugait nulla facilisi. Lorem ipsum dolor sit amet, consectetuer adipiscing elit, sed diam nonummy nibh euismod tincidunt ut laoreet dolore magna aliquam erat volutpat, quis nostrud exerci tation ullamcorper suscipit lobortis nisl ut aliquip ex ea commodo consequat. Duis autem vel eum iriure dolor in hendrerit in vulputate velit esse molestie consequat, vel illum dolore eu feugiat nulla facilisis at vero eros et accumsan et iusto odio dignissim qui blandit praesent luptatum zzril delenit augue duis dolore te feugait nulla facilisi. Lorem ipsum dolor sit amet, consectetuer adipiscing elit, sed diam nonummy nibh euismod tincidunt ut laoreet dolore magna aliquam erat volutpat. Ut wisi enim ad minim veniam, quis nostrud exerci tation ullamcorper suscipit lobortis nisl ut aliquip ex ea commodo consequat. Duis autem vel eum iriure dolor in hendrerit in

Draw in all the horizontal axes that express the vertical intervals, being sure to include gutters. Your bottom horizontal axis defines the bottom margin.

Remove the type ruler and the dummy type.

In the process shown here, you can see the development of a 40-field grid, based upon the text width and leading of your original text type. This means that you have 40 active corners on your page for placing type or images.

Once you have devised your grid, find out what size and line length type has to be to feel like a caption. What is smaller/shorter enough? What is too small? Most important, what works within the grid? Finally, devise the optimum headline. What is big enough? Or, in both cases, is a shift in size required at all?

As you establish your type samples, keep in mind that both the caption and headline lengths should be multiples of the text length. The caption and headline leadings should also be multiples of the text type and leading (and seldom something so simple as 1:2—see Cross-alignment, pages 112-113). Every few lines, all three components should cross-align with each other. Do yours? Work with them until they do.

In application, text grids often have to accommodate two or more levels of text in two or more sizes. In this hypothetical example, sidebars (or 'feature' boxes) are required to highlight individuals or incidents touched upon in the main text.

First, typeface, size, leading, and line length are determined for the text and the sidebars.

Lorem ipsum dolor sit amet, consectetuer adipiscing elit, sed diam nonummy nibh euismod tincidunt ut laoreet dolore magna aliquam erat volutpat. Ut wisi enim ad minim veniam, quis nostrud exerci tation ullamcorper suscipit lobortis nisl ut aliquip ex ea commodo consequat. Duis autem vel eum iriure dolor in hendrerit in vulputate velit esse molestie consequat, vel illum dolore eu feugiat nulla facilisis at vero eros et accumsan et iusto odio dignissim qui blandit praesent luptatum zzril delenit augue duis dolore te feugait nulla facilisi. Lorem ipsum dolor sit amet, consectetuer adipiscing elit, sed diam nonummy nibh euismod tincidunt ut laoreet dolore magna aliquam erat volutpat. Ut wisi enim ad minim veniam, quis nostrud exerci tation ullamcorper suscipit lobortis nisl ut aliquip ex ea commodo consequat. Duis autem vel eum iriure dolor in hendrerit in vulputate velit esse molestie consequat, vel illum dolore eu feugiat

Text
10/13 Adobe Caslon x 20p, fl, rr

Lorem ipsum dolor sit amet, consectetuer adipiscing elit, sed diam nonummy nibh euismod tincidunt ut laoreet dolore magna aliquam erat volutpat. Ut wisi enim ad minim veniam, quis nostrud exerci tation ullamcorper suscipit lobortis nisl ut aliquip ex ea commodo consequat. Duis autem vel eum iriure dolor in hendrerit in vulputate velit esse molestie consequat, vel illum dolore eu feugiat nulla facilisis at vero eros et accumsan et iusto odio dignissim qui blandit praesent luptatum zzril delenit augue.

Sidebar ('feature' box)
8/9.5 Adobe Caslon Italic x 9p3, fl, rr

Based on the line lengths, horizontal fields are established. Five intervals most closely match the text as set, but adjustments to the line lengths are necessary.

Lorem ipsum dolor sit amet, consectetuer adipiscing elit, sed diam nonummy nibh euismod tincidunt ut laoreet dolore magna aliquam erat volutpat. Ut wisi enim ad minim veniam, quis nostrud exerci tation ullamcorper suscipit lobortis nisl ut aliquip ex ea commodo consequat. Duis autem vel eum iriure dolor in hendrerit in vulputate velit esse molestie consequat, vel illum dolore eu feugiat nulla facilisis at vero eros et accumsan et iusto odio dignissim qui blandit praesent luptatum zzril delenit augue duis dolore te feugait nulla facilisi. Lorem ipsum dolor sit amet, consectetuer adipiscing elit, sed diam nonummy nibh euismod tincidunt ut laoreet dolore magna aliquam erat volutpat. Ut wisi enim ad minim veniam, quis nostrud exerci tation ullamcorper suscipit lobortis nisl ut aliquip ex ea commodo consequat. Duis autem vel eum iriure dolor in hendrerit in vulputate velit esse molestie consequat, vel illum dolore eu feugiat nulla facilisis at vero eros et accumsan et iusto odio dignissim qui blandit praesent luptatum zzril delenit augue duis dolore te feugait nulla facilisi. Nam liber tempor cum soluta nobis eleifend option congue nihil imperdiet doming id quod mazim placerat facer possim assum. Lorem ipsum dolor sit amet, consectetuer adipiscing elit, sed diam nonummy nibh euismod tincidunt ut laoreet dolore magna aliquam erat volutpat.

Lorem ipsum dolor sit amet, consectetuer adipiscing elit, sed diam nonummy nibh euismod tincidunt ut laoreet dolore magna aliquam erat volutpat. Ut wisi enim ad minim veniam, quis nostrud exerci tation ullamcorper suscipit lobortis nisl ut aliquip ex ea commodo consequat. Duis autem vel eum iriure dolor in hendrerit in vulputate velit esse molestie consequat, vel illum dolore eu feugiat nulla facilisis at vero eros et accumsan et iusto odio dignissim qui blandit praesent luptatum zzril delenit augue duis dolore te feugait nulla facilisi. Lorem ipsum dolor sit amet, consectetuer adipiscing elit, sed diam nonummy nibh euismod tincidunt ut laoreet dolore magna aliquam erat volutpat. Ut wisi enim ad minim veniam, quis nostrud exerci tation ullamcorper suscipit lobortis nisl ut aliquip ex ea commodo consequat. Duis autem vel eum iriure dolor in hendrerit in vulputate velit esse molestie consequat, vel illum dolore eu feugiat nulla facilisis at vero eros et accumsan et iusto odio dignissim qui blandit praesent luptatum zzril delenit augue duis dolore te feugait nulla facilisi. Nam liber tempor cum soluta nobis eleifend option congue nihil

Line lengths are adjusted to match
the five horizontal fields. Text is
checked for readability.

Lorem ipsum dolor sit amet, consectetuer adipisc-
ing elit, sed diam nonummy nibh euismod tin-
cidunt ut laoreet dolore magna aliquam erat volut-
pat. Ut wisi enim ad minim veniam, quis nostrud
exerci tation ullamcorper suscipit lobortis nisl ut
aliquip ex ea commodo consequat. Duis autem vel
eum iriure dolor in hendrerit in vulputate velit esse
molestie consequat, vel illum dolore eu feugiat
nulla facilisis at vero eros et accumsan et iusto odio
dignissim qui blandit praesent luptatum zzril
delenit augue duis dolore te feugait nulla facilisi.
Lorem ipsum dolor sit amet, consectetuer adipisc-
ing elit, sed diam nonummy nibh euismod tin-
cidunt ut laoreet dolore magna aliquam erat volut-
pat. Ut wisi enim ad minim veniam, quis nostrud
exerci tation ullamcorper suscipit lobortis nisl ut
aliquip ex ea commodo consequat. Duis autem vel
eum iriure dolor in hendrerit in vulputate velit esse
molestie consequat, vel illum dolore eu feugiat
nulla facilisis at vero eros et accumsan et iusto odio
dignissim qui blandit praesent luptatum zzril
delenit augue duis dolore te feugait nulla facilisi.
Nam liber tempor cum soluta nobis eleifend

Lorem ipsum dolor sit amet,
consectetuer adipiscing elit, sed
diam nonummy nibh euismod
tincidunt ut laoreet dolore
magna aliquam erat volutpat.
Ut wisi enim ad minim veni-
am, quis nostrud exerci tation
ullamcorper suscipit lobortis
nisl ut aliquip ex ea commodo
consequat. Duis autem vel eum
iriure dolor in hendrerit in
vulputate velit esse molestie
consequat, vel illum dolore eu
feugiat nulla facilisis at vero
eros et accumsan et iusto odio
dignissim qui blandit praesent
luptatum zzril delenit augue
duis dolore te feugait nulla
facilisi. Lorem ipsum dolor sit
amet, consectetuer adipiscing
elit, sed diam nonummy nibh
euismod tincidunt ut laoreet
dolore magna aliquam erat
volutpat. Ut wisi enim ad
minim veniam, quis nostrud
exerci tation ullamcorper sus-
cipit lobortis nisl ut aliquip ex
ea commodo consequat. Duis
autem vel eum iriure dolor in
hendrerit in vulputate velit
esse molestie consequat, vel
illum dolore eu feugiat nulla
facilisis at vero eros et accum-
san et iusto odio dignissim qui
blandit praesent luptatum

Leading is adjusted to allow for cross-alignment (0p5 is added to the text, 0p5 is removed from the sidebar). Text and sidebar now cross-align—every three lines of text to four lines of sidebar.

m dolor sit amet, consectetuer adipisc-
diam nonummy nibh euismod tin-
oreet dolore magna aliquam erat volut-
enim ad minim veniam, quis nostrud
a ullamcorper suscipit lobortis nisl ut
a commodo consequat. Duis autem vel
lolor in hendrerit in vulputate velit esse
nsequat, vel illum dolore eu feugiat
ls at vero eros et accumsan et iusto odio
ui blandit praesent luptatum zzril
le duis dolore te feugait nulla facilisi.
m dolor sit amet, consectetuer adipisc-
diam nonummy nibh euismod tin-
oreet dolore magna aliquam erat volut-
enim ad minim veniam, quis nostrud
a ullamcorper suscipit lobortis nisl ut
a commodo consequat. Duis autem vel

Lorem ipsum dolor sit amet, consectetuer adipiscing elit, sed diam nonummy nibh euismod tincidunt ut laoreet dolore magna aliquam erat volutpat. Ut wisi enim ad minim veni- am, quis nostrud exerci tation ullamcorper suscipit lobortis nisl ut aliquip ex ea commodo consequat. Duis autem vel eum iriure dolor in hendrerit in vulputate velit esse molestie consequat, vel illum dolore eu feugiat nulla facilisis at vero eros et accumsan et iusto odio dignissim qui blandit praesent luptatum zzril delenit augue duis dolore te feugait nulla facilisi. Lorem ipsum dolor sit amet, consectetuer adipiscing elit, sed diam nonummy nibh euismod tincidunt ut laoreet dolore magna aliquam erat volutpat. Ut wisi enim ad minim veniam, quis nostrud

10/13.5 Adobe Caslon
x 17p3, fl, rr

8/9 Adobe Caslon Italic
x 8p, fl, rr

Based on cross-alignment, vertical fields are established. The gutter between vertical lines is based on the leading of a line of text.

Lorem ipsum dolor sit amet, consectetuer adipiscing elit, sed diam nonummy nibh euismod tincidunt ut laoreet dolore magna aliquam erat volutpat. Ut wisi enim ad minim veniam, quis nostrud exerci tation ullamcorper suscipit lobortis nisl ut aliquip ex ea commodo consequat. Duis autem vel eum iriure dolor in hendrerit in vulputate velit esse molestie consequat, vel illum dolore eu feugiat nulla facilisis at vero eros et accumsan et iusto odio dignissim qui blandit praesent luptatum zzril delenit augue duis dolore te feugait nulla facilisi.

Lorem ipsum dolor sit amet, consectetuer adipiscing elit, sed diam nonummy nibh euismod tincidunt ut laoreet dolore magna aliquam erat volutpat. Ut wisi enim ad minim veniam, quis nostrud exerci tation ullamcorper suscipit lobortis nisl ut aliquip ex ea commodo consequat. Duis autem vel eum iriure dolor in hendrerit in vulputate velit esse molestie consequat, vel illum dolore eu feugiat nulla facilisis at vero eros et accumsan et iusto odio dignissim qui blandit praesent luptatum zzril delenit augue duis dolore te feugait nulla facilisi. Nam liber tempor cum soluta nobis eleifend

Lorem ipsum dolor sit amet, consectetuer adipiscing elit, sed diam nonummy nibh euismod tincidunt ut laoreet dolore magna aliquam erat volutpat. Ut wisi enim ad minim veniam, quis nostrud exerci tation ullamcorper suscipit lobortis nisl ut aliquip ex ea commodo consequat. Duis autem vel eum iriure dolor in hendrerit in vulputate velit esse molestie consequat, vel illum dolore eu feugiat nulla facilisis at vero eros et accumsan et iusto odio dignissim qui blandit praesent luptatum zzril delenit augue duis dolore te feugait nulla facilisi. Lorem ipsum dolor sit amet, consectetuer adipiscing elit, sed diam nonummy nibh euismod tincidunt ut laoreet dolore magna aliquam erat volutpat. Ut wisi enim ad minim veniam, quis nostrud exerci tation ullamcorper suscipit lobortis nisl ut aliquip ex ea commodo consequat. Duis autem vel eum iriure dolor in hendrerit in vulputate velit esse molestie consequat, vel illum dolore eu feugiat nulla facilisis at vero eros et accumsan et iusto odio dignissim qui blandit praesent luptatum

Finally, the grid is tested by setting up possible layouts. Headlines for the sidebars are introduced, running flush bottom in their grid fields to reinforce the horizontal axis created by the columns of text beneath.

Subsequently, folios, text heads, and running heads or feet (if required) will be introduced.

1798

Lorem ipsum dolor sit amet, consectetuer adipiscing elit, sed diam nonummy nibh euismod tincidunt ut laoreet dolore magna aliquam erat volutpat. Ut wisi enim ad minim veniam, quis nostrud exerci tation ullamcorper suscipit lobortis nisl ut aliquip ex ea commodo consequat. Duis autem vel eum iriure dolor in hendrerit in vulputate velit esse molestie consequat, vel illum dolore eu feugiat nulla facilisis at vero eros et accumsan et iusto odio dignissim qui blandit praesent luptatum zzril delenit augue duis dolore te feugait nulla facilisi. Lorem ipsum dolor sit amet, consectetuer adipiscing elit, sed diam nonummy nibh euismod tincidunt ut laoreet dolore magna aliquam erat volutpat. Ut wisi enim ad minim veniam, quis nostrud exerci tation ullamcorper sus-cipit lobortis nisl ut aliquip ex ea commodo consequat. Duis autem vel eum iriure dolor in hendrerit in vulputate velit esse molestie consequat, vel illum dolore eu feugiat nulla facilisis at vero eros et accum-san et iusto odio dignissim qui blandit praesent luptatum zzril delenit augue duis dolore te feugait nulla facilisi. Nam

Nam liber tempor cum soluta nobis eleifend option congue nihil imperdiet doming id quod mazim placerat facer possim assum. Lorem ipsum dolor sit amet, consectetuer adipiscing elit, sed diam nonummy nibh euismod tincidunt ut laoreet dolore magna aliquam erat volutpat. Ut wisi enim ad minim veniam, quis nostrud exerci tation ullamcorper suscipit lobortis nisl ut aliquip ex ea commodo consequat. Duis autem vel eum iriure dolor in hendrerit in vulputate velit esse molestie consequat, vel illum dolore eu feugiat nulla facilisis at vero eros et accumsan et iusto odio dignissim qui blandit praesent luptatum zzril delenit augue duis dolore te feugait nulla facilisi. Nam liber tempor cum soluta nobis eleifend option congue nihil imperdiet doming id quod mazim placerat facer possim assum. Lorem ipsum dolor sit amet, consectetuer adipiscing

Facilisi. Lorem ipsum dolor sit amet, consectetuer adipiscing elit, sed diam nonummy nibh euismod tincidunt ut laoreet dolore magna aliquam erat volutpat. Ut wisi enim ad minim veniam, quis nostrud exerci tation ullamcorper sus-cipit lobortis nisl ut aliquip ex ea commodo consequat. Duis autem vel eum iriure dolor in hendrerit in vulputate velit esse molestie consequat, vel illum dolore eu feugiat nulla facilisis at vero eros et accum-san et iusto odio dignissim qui blandit praesent luptatum zzril delenit augue duis dolore te feugait nulla facilisi. Nam liber tempor cum soluta nobis eleifend option congue nihil imperdiet doming id quod mazim placerat facer possim assum. Lorem ipsum dolor sit amet, consectetuer adipiscing

Lorem ipsum dolor sit amet, consectetuer adipiscing elit, sed diam nonummy nibh euismod tincidunt ut laoreet dolore magna aliquam erat volutpat. Ut wisi enim ad minim veniam, quis nostrud exerci tation ullamcorper suscipit lobortis nisl ut aliquip ex ea commodo consequat. Duis autem vel eum iriure dolor in hendrerit in vulputate velit esse molestie consequat, vel illum dolore eu feugiat nulla facilisis at vero eros et accumsan et iusto odio dignissim qui blandit praesent luptatum zzril delenit augue duis dolore te feugait nulla facilisi.

William Wordsworth

174 Most grids are developed to accom-
modate both text and images. Here,
the goal is to devise a grid for a
book on design principles.

The bulk of the images are square,
displaying various dot/line composi-
tions (right). Images are presented
singly or in sequences of five. Text
serves as introduction and explana-
tion of the compositions.

The page size is B5 (7 x $9\frac{7}{8}$"/176
x 250 mm) horizontal. Approximate
margins are established (opposite),
allowing a bit more space toward the
outside of the page, away from the
spine of the book. Sample text is set
to determine type size, line length,
and leading (in this case, all text and
captions are the same size and lead-
ing; line lengths vary).

Typical art

Page with margins

Lorem ipsum dolor sit amet, consectetuer adipiscing elit, sed diam nonummy nibh euismod tincidunt ut laoreet dolore magna aliquam erat volutpat. Ut wisi enim ad minim veniam, quis nostrud exerci tation ullamcorper suscipit lobortis nisl ut aliquip ex ea commodo consequat. Lorem ipsum dolor sit amet, consectetuer adipiscing elit, sed diam nonummy nibh euismod tincidunt ut laoreet dolore magna aliquam erat volutpat.

Sample text
Akzidenz Grotesk Light
8/10.25 x 11p, fl, rr

176 Different sizes of the square art are tried out within the page size, and certain relationships begin to emerge. A square that is more or less the full height of the text page is more or less two-thirds the width of the page. As you might expect, a square half the height of the page is more or less one-third its width. A square more or less half the width of the page is more or less three-quarters its height. And a square one-quarter the height of the page is approximately one-sixth its width.

These simple arrangements immediately suggest six intervals across. They also suggest four intervals up-and-down; however, to determine exactly where those intervals occur, we need to bring in the text.

Possible sizes for art

Determining horizontal intervals

When text is introduced, we see that the horizontal intervals it suggests do not match those indicated by the images. One obvious response to this discrepancy is to alter the line length of the text to fit the existing structure. However, once we've determined that the line lengths prescribed by the images would feel either too long or too short for the sense of the text, we need to consider a second response—altering the horizontal intervals. In this case, changing the number of intervals from six to twelve provides a format that accommodates both image and text.

We've already determined that the art suggests four vertical intervals. Our text as set allows for between 30 and 40 lines of text per page. Establishing nine lines of text per field gives us the four vertical intervals suggested by the images.

Note that the text grid and the art as placed do not exactly coincide. The art tends to fall short of the bottom of the fields. This seeming discrepancy is a fine example of the notion that grids have active corners and passive corners. There is no need for the art to fill the fields.

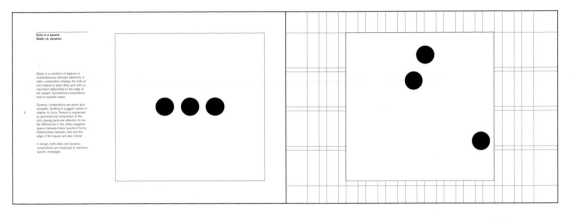

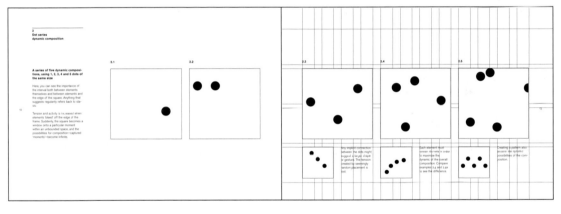

Here, the grid is applied. Notice how the placement of the folios activates the least used horizontal axis.

The placement of identification ('2.1,' etc.) for the images in the second spread above demonstrates when it is appropriate to break the rules—the numbers fall flush bottom in their fields. If they appeared at the top of their respective fields, their connection to the art would be lost. Clarity of meaning and ease of reading always trump the formal restraints of working with grids.

At the same time, placing the identification at the bottom of a field strengthens the structure of the page—the sense of the grid—even though specific placement works against one of the grid's seeming requirements.

180 It is perhaps inevitable that a primer like this—a book of first steps—does not reach a genuine conclusion. Instead, if it's been successful, it seems to stop in mid-course, and the student pushes on to explore the subject further elsewhere.

If time and space allowed, this book would include more examples of type as image, at least one extensive example of using type as both image and information, and examples of placing silhouetted images within a grid. That may happen another time, but for now, I urge you to find out what other people have to say. As much as I've tried to keep this book objective, I'm fully aware that some of my personal preferences and idiosyncrasies—the product of my experience working with type—have crept into the text. It seems not only logical but necessary that you quickly test my conclusions against those of other authors and then decide what's most appropriate for you.

If there were just one idea that I would want you to carry away from this book, it would be what I stated in the Introduction—type is physical. Even though it is likely that you will seldom be called upon to 'make' type (and despite the fact that emerging software allows users to bend, twist, and stretch type into an infinite number of shapes), your best work will always carry in it the sense of a typographic tradition dating back to Gutenberg and Janson. Respecting the physical limits of the letterform will not only make for clearer, stronger messages, but also produce compositions that please both the eye and the mind.

Finally, it is important that you never forget the intimate connection between typography and written language. Always respect the words.

Appendices and bibliography

184 **Basic fonts**

These charts show the characters available on the Macintosh keyboard for most typefaces. Some of the typefaces may vary. Search under Key Caps in the Apple Menu to find which characters are available in a specific font.

To use a type font effectively on a Windows platform, check the Character Map and make note of the 'alt +' number required to enter specific characters. Note that not all characters available on a Mac platform are accessible in Windows.

Basic keyboard

+ Shift key

+ Option key

+ Shift *and* Option keys

Typeface shown: Adobe Garamond

Expert sets

Increasingly, type designers and manufacturers are providing expert sets for typefaces that include small caps, lowercase numerals, fractions, ligatures, as well as other special letterforms.

In addition, some typefaces have alternate sets that offer unusual ligatures ('ct') and secondary versions of some letterforms:

cte
Adobe
Garamond

cte
Adobe
Garamond
Alternate

Others also provide swash forms for certain oldstyle italics:

T
Adobe Caslon
Italic

T
Adobe Caslon
Italic Swash

Still others feature tilting caps or ornaments. Keep in mind that, while most expert sets are laid out on the keyboard as shown here, there are important differences between one typeface and another. And there may be additional sets beyond expert sets. Be sure to look over the Key Caps display on your screen for a font's particular array.

Basic keyboard

`	I	2	3	4	5	6	7	8	9	0	-	—	delete
tab	Q	W	E	R	T	Y	U	I	O	P	()	
caps lock	A	S	D	F	G	H	J	K	L	;	'		return
shift	Z	X	C	V	B	N	M	,	.	/	shift		
control	option	⌘	space bar	⌘	option	control							

+ Shift key

~	!		¢	$	$	^	&	..	()	-	.	delete
tab	fi				ffi		¾	⅔		₡	Rp	1	
caps lock			Đ		¼	½	⅛	⅜	⅝	:	"		return
shift	ffl	fl		ff		⅓	⅞			?	shift		
control	option	⌘	space bar	⌘	option	control							

+ Option key

`	1	2	3	4	5	6	7	8	9	0	—	delete
tab	Œ					Ý	¨	n	Ø	Þ		
caps lock	Å	Š	$		¢	·		o	Ł	,	Æ	return
shift	Ž		Ç			m		,	.	i	shift	
control	option	⌘	space bar	⌘	option	control						

+ Shift *and* Option keys

`	1	2	3	4	5	6	7	8	9	0	-	delete
tab			e			¨	n	o				
caps lock	a	s	d					l	ˇ	,	return	
shift		¢		b	m	r	,	.	¿	shift		
control	option	⌘	space bar	⌘	option	control						

186 Once you know what you're doing with type, your own taste will lead you to certain personal choices. This compilation of typefaces is the result of a survey I conducted among designers and educators I know, in order to find out where their choices lead them most often. This list provides a useful point of departure for further study.

I have divided the typefaces into sections corresponding to the classification on pages 47–49, and have left out typefaces already discussed in the chapter on Development. (As you might expect, no one chose a blackletter or script form to be part of his or her indispensable array.)

I have shown small caps and lowercase numerals where available, but, due to limitations of space, have not shown italic, boldface, swash, or (where applicable) condensed, or expanded versions.

Oldstyle

Dante
1954 Giovanni Mardersteig and Charles Malin

ABCDEFGHIJKLMNOPQRSTUVWXYZ
1234567890
ABCDEFGHIJKLMNOPQRSTUVWXYZ
abcdefghijklmnopqrstuvwxyz
1234567890

ABCDEFGHIJKLMNOPQRSTUVWXYZ
1234567890
abcdefghijklmnopqrstuvwxyz
1234567890

Adobe Jenson
1995 Robert Slimbach

ABCDEFGHIJKLMNOPQRSTUVWXYZ
1234567890
ABCDEFGHIJKLMNOPQRSTUVWXYZ
abcdefghijklmnopqrstuvwxyz
1234567890

ABCDEFGHIJKLMNOPQRSTUVWXYZ
1234567890
abcdefghijklmnopqrstuvwxyz
1234567890

Palatino
1948 Hermann Zapf

ABCDEFGHIJKLMNOPQRSTUVWXYZ
1234567890
abcdefghijklmnopqrstuvwxyz

ABCDEFGHIJKLMNOPQRSTUVWXYZ
1234567890
abcdefghijklmnopqrstuvwxyz

Transitional

Century Expanded
1900 Morris Fuller Benton

ABCDEFGHIJKLMNOPQRSTUVWXYZ
1234567890
abcdefghijklmnopqrstuvwxyz

ABCDEFGHIJKLMNOPQRSTUVWXYZ
1234567890
abcdefghijklmnopqrstuvwxyz

Joanna
1930 Eric Gill

ABCDEFGHIJKLMNOPQRSTUVWXYZ
1234567890
abcdefghijklmnopqrstuvwxyz

ABCDEFGHIJKLMNOPQRSTUVWXYZ
1234567890
abcdefghijklmnopqrstuvwxyz

Perpetua
1925 Eric Gill

ABCDEFGHIJKLMNOPQRSTUVWXYZ
1234567890
ABCDEFGHIJKLMNOPQRSTUVWXYZ
abcdefghijklmnopqrstuvwxyz
1234567890

ABCDEFGHIJKLMNOPQRSTUVWXYZ
1234567890
abcdefghijklmnopqrstuvwxyz
1234567890

Times New Roman
1932 Victor Lardent, Stanley Morison

ABCDEFGHIJKLMNOPQRSTUVWXYZ
1234567890
abcdefghijklmnopqrstuvwxyz

ABCDEFGHIJKLMNOPQRSTUVWXYZ
1234567890
abcdefghijklmnopqrstuvwxyz

Modern

Bodoni
1908–1915 Morris Fuller Benton

ABCDEFGHIJKLMNOPQRSTUVWXYZ
1234567890
abcdefghijklmnopqrstuvwxyz

ABCDEFGHIJKLMNOPQRSTUVWXYZ
1234567890
abcdefghijklmnopqrstuvwxyz

Didot
1783 Firmin Didot (revived, 1992 Adrian Frutiger)

ABCDEFGHIJKLMNOPQRSTUVWXYZ
1234567890
ABCDEFGHIJKLMNOPQRSTUVWXYZ
abcdefghijklmnopqrstuvwxyz
1234567890

ABCDEFGHIJKLMNOPQRSTUVWXYZ
1234567890
abcdefghijklmnopqrstuvwxyz
1234567890

Square serif

Clarendon
1845 Robert Besley

ABCDEFGHIJKLMNOPQRSTUVWXYZ
1234567890
abcdefghijklmnopqrstuvwxyz

Rockwell
1910 Inland type foundry (revised, 1920s Morris Fuller Benton)

ABCDEFGHIJKLMNOPQRSTUVWXYZ
1234567890
abcdefghijklmnopqrstuvwxyz

ABCDEFGHIJKLMNOPQRSTUVWXYZ
1234567890
abcdefghijklmnopqrstuvwxyz

Sans serif

Grotesque
1926 Monotype Corporation

ABCDEFGHIJKLMNOPQRSTUVWXYZ
1234567890
abcdefghijklmnopqrstuvwxyz

ABCDEFGHIJKLMNOPQRSTUVWXYZ
1234567890
abcdefghijklmnopqrstuvwxyz

Franklin Gothic
1902 Morris Fuller Benton

ABCDEFGHIJKLMNOPQRS TUVWXYZ 1234567890 abcdefghijklmnopqrstuvwxyz

Frutiger
1974 Adrian Frutiger

ABCDEFGHIJKLMNOPQRSTUVWXYZ
1234567890
abcdefghijklmnopqrstuvwxyz

ABCDEFGHIJKLMNOPQRSTUVWXYZ
1234567890
abcdefghijklmnopqrstuvwxyz

Helvetica
1956 Max Miedinger

ABCDEFGHIJKLMNOPQRSTUVWXYZ
1234567890
abcdefghijklmnopqrstuvwxyz

ABCDEFGHIJKLMNOPQRSTUVWXYZ
1234567890
abcdefghijklmnopqrstuvwxyz

Meta
1990 Erik Spiekermann

ABCDEFGHIJKLMNOPQRSTUVWXYZ
1234567890
ABCDEFGHIJKLMNOPQRSTUVWXYZ
abcdefghijklmnopqrstuvwxyz
1234567890

ABCDEFGHIJKLMNOPQRSTUVWXYZ
1234567890
abcdefghijklmnopqrstuvwxyz
1234567890

News Gothic
1908 Morris Fuller Benton

ABCDEFGHIJKLMNOPQRSTUVWXYZ
1234567890
abcdefghijklmnopqrstuvwxyz

ABCDEFGHIJKLMNOPQRSTUVWXYZ
1234567890
abcdefghijklmnopqrstuvwxyz

Optima
1958 Hermann Zapf

ABCDEFGHIJKLMNOPQRSTUVWXYZ
1234567890
abcdefghijklmnopqrstuvwxyz

ABCDEFGHIJKLMNOPQRSTUVWXYZ
1234567890
abcdefghijklmnopqrstuvwxyz

Syntax
1968 Hans Eduard Meier

ABCDEFGHIJKLMNOPQRSTUVWXYZ
1234567890
abcdefghijklmnopqrstuvwxyz

ABCDEFGHIJKLMNOPQRSTUVWXYZ
1234567890
abcdefghijklmnopqrstuvwxyz

Trade Gothic
1948 Jackson Burke

ABCDEFGHIJKLMNOPQRSTUVWXYZ
1234567890
abcdefghijklmnopqrstuvwxyz

ABCDEFGHIJKLMNOPQRSTUVWXYZ
1234567890
abcdefghijklmnopqrstuvwxyz

Selected bibliography

194 Bringhurst, Robert. *The Elements of Typographic Style.* 2nd rev. ed. Point Roberts, WA: Hartley & Marks, 1996.

Carter, Rob, Ben Day, and Philip Meggs. *Typographic Design: Form and Communication.* 2nd ed. New York: Van Nostrand Reinhold, 1993.

Chappell, Warren. *A Short History of the Printed Word.* New York: Alfred A. Knopf, 1970.

Craig, James. *Basic Typography: A Design Manual.* New York: Watson-Guptill, 1990.
——, and Bruce Barton. *Thirty Centuries of Graphic Design.* New York: Watson-Guptill, 1987.

Dair, Carl. *Design with Type.* Toronto: University of Toronto Press, 1967.

Diethelm, Walter (in collaboration with Dr. Marion Diethelm). *Signet, Signal, Symbol: Handbook of International Symbols.* 3rd ed. Zürich: ABC Books, 1976.
——. *Visual Transformation.* Zürich: ABC Books, 1982.

Friedman, Dan. *Dan Friedman: Radical Modernism.* New Haven: Yale University Press, 1994.

Frutiger, Adrian. *Type Sign Symbol.* Zürich: ABC Books, 1980.

Gill, Eric. *An Essay on Typography.* Boston: David R. Godine, 1988.

Grosvenor, Jonathan, Kaye Morrison, and Alexandra Pim (eds.). *The Postscript Font Handbook: A Directory of Type 1 Fonts.* Workingham: Addison Wesley, 1992.

Hochuli, Jost, and Robin Kinross. *Designing Books: Practice and Theory.* London: Hyphen Press, 1996.

Hofmann, Armin. *Graphic Design Manual: Principles and Practice.* New York: Reinhold, 1965.

Hollis, Richard. *Graphic Design: A Concise History.* London: Thames and Hudson, 1994.

Kunz, Willi. *Typography: Macro- + Micro-Aesthetics.* Sulgen: Niggli, 1998.

Lieberman, J. Ben. *Type and Typefaces.* 2nd ed. New Rochelle: Myriade Press, 1978.

Maier, Manfred. *Basic Principles of Design.* New York: Van Nostrand Reinhold, 1980.

McLean, Ruari. *Jan Tschichold: A Life in Typography.* New York: Princeton Architectural Press, 1997.

Meggs, Philip. *A History of Graphic Design.* 3rd ed. New York: John A. Wiley & Sons, 1998.

Morison, Stanley. *Four Centuries of Fine Printing.* 4th rev. ed. New York: Barnes & Noble, 1960.

Müller-Brockmann, Josef. *The Graphic Artist and His Design Problems.* Teufen: Arthur Niggli, 1961.
——. *Grid Systems in Graphic Design: A Visual Communication Manual for Graphic Designers, Typographers and Three-Dimensional Designers.* Niederteufen: Arthur Niggli, 1981.
——. *Josef Müller-Brockmann, Designer: Pioneer of Swiss Graphic Design.* Baden: Lars Müller, 1995.

The Pierpont Morgan Library. *Art of the Printed Book 1455–1955.* With an essay by Joseph Blumenthal. New York: The Pierpont Morgan Library; Boston: David R. Godine, 1973.

Rand, Paul. *From Lascaux to Brooklyn.* New Haven: Yale University Press, 1996.
——. *Thoughts on Design.* New York: Van Nostrand Reinhold, 1970.

Rosen, Ben. *Type and Typography: The Designer's Type Book.* New York: Van Nostrand Reinhold, 1963.

Ruder, Emil. *Typography: A Manual of Design.* Teufen: Arthur Niggli, 1967.

Updike, Daniel Berkeley. *Printing Types: Their History, Forms and Use.* 3rd. ed., 2 vols. Cambridge, MA: Harvard University Press, Belknap Press, 1962.

Wingler, Hans M. *The Bauhaus: Weimar, Dessau, Berlin, Chicago.* 1st paperback ed. Cambridge, MA: MIT Press, 1978.

www.adobe.com/type/main.html

www.bertholdtypes.com

www.thefoundrystudio.co.uk

abc.planet-typography.com

Index